Historic Artists' Homes & Studios

GUIDE TO
Historic Artists' Homes & Studios

A PROGRAM OF THE
National Trust *for* Historic Preservation

Valerie A. Balint

———

PRINCETON ARCHITECTURAL PRESS

NEW YORK

Published by
Princeton Architectural Press
202 Warren Street
Hudson, New York 12534
www.papress.com

Editor: Alexandra T. Anderson

For Princeton Architectural Press:
Editor: Kristen Hewitt
Designer: Paul Wagner

Library of Congress
Cataloging-in-Publication Data
—
Names: Balint, Valerie A., author. | National Trust
 for Historic Preservation in the United States.
Title: Historic artists' homes and studios :
 a guide : a program of the National Trust for
 Historic Preservation / Valerie A. Balint.
Description: First edition. | Hudson, New York :
 Princeton Architectural Press, 2020. | Includes
 bibliographical references. | Summary: "The
 Historic Artists' Homes & Studios program
 (HAHS) of the National Trust for Historic
 Preservation is a nationwide consortium of
 44 sites that are open to the public, drawing
 a total of more than one million visitors a
 year. This guidebook provides an overview of
 the life and work of the artists as well as the
 architecture and landscape of their homes,
 representing a broad range of aesthetic and
 domestic trends. Among the artists are both
 famous figures, such as Winslow Homer,
 Georgia O'Keeffe, Jackson Pollock, and
 Donald Judd, and those who ought to be
 better known, including photographer Alice
 Austen and muralist Clementine Hunter"—
 Provided by publisher.
Identifiers: LCCN 2019027115 (print) | LCCN
 2019027116 (ebook) | ISBN 9781616897734
 (paperback) | ISBN 9781616897734 (ebook)
Subjects: LCSH: Artists—Homes and haunts—
 United States—Guidebooks. | Artists'
 studios—United States—Guidebooks. |
 Historic house museums—United States—
 Guidebooks.
Classification: LCC NA7195.A75 B36 2020 (print) |
 LCC NA7195.A75 (ebook) | DDC 720.973—dc23
LC record available at https://lccn.loc.
 gov/2019027115
LC ebook record available at https://lccn.loc.
 gov/2019027116

Contents

Northeast Region

Southern Region

Midwest Region

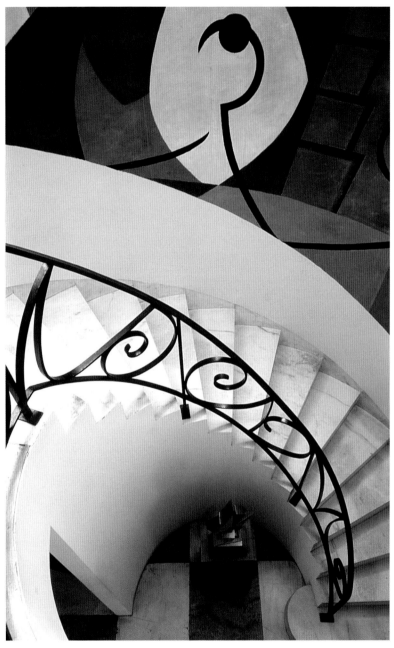

Detail of entry foyer and staircase at the Frelinghuysen Morris House & Studio, Lenox, Massachusetts. Photograph Geoffrey Goss, courtesy FMH&S.

FOREWORD

When it comes to artist homes and studios, I am like a birder. I seek out new sites and try to add at least two to my life list each year. My affection for them began in the early 1960s when I was discovering art history and in Europe for the first time. Visiting Paul Cézanne's countryside studio in Aix-en-Provence, I found myself breathless standing alone in an intimate space where so much hard work and innovation had transpired. Familiar objects dotted this dusty ground-floor room where the artist worked and stored his paintings: I took in the well-worn wooden tables and chairs his sitters occupied along with the decorative jars, fruit bowls, and plaster sculpture of Cupid that he arranged in still lifes. The ordinariness of these props taught me a valuable lesson: it was the artist's intelligence and his brush, not the inherent majesty of the objects, that had transformed these things into crown jewels.

That day I also saw Mont Sainte-Victoire for the first time. Seeing it in the distance, as the artist did, miles away from his studio, I was again surprised by the humility of the motif. The mountain did not tower spectacularly over neighboring ridges, nor was it the highest point in the range. It was Cézanne's high-level conversation with its folds and irregular contours that had given the peak its contemporary grandeur. His great paintings conferred fame and familiarity on Mont Sainte-Victoire and bestowed upon modern Provence a logo known around the world.

It is the artist's vision that elevates a mountain, wave, mesa, hillside, or steeple into a memorable signature for a particular locale. "Place" is not a timeless absolute; it is a constructed identity, and artists are often the ones who produce visual representations defining particular topographical spaces. Not all artists, of course, draw upon their environs, but when they do, one of the great takeaways of visiting their homes and studios is firsthand experience of what inspired them.

Looking out the window of Charles Demuth's home in Lancaster, Pennsylvania, you can see the church steeple and, not far away, the factories that he transformed into cubist rhapsodies; in Chadds Ford, Pennsylvania, you experience many moments of recognition, coming

upon a particular hill, a country farmhouse, or a beech tree that Andrew Wyeth and, before him, his father, N. C. Wyeth, painted. And in Prouts Neck on the rocky coast of southern Maine, where Winslow Homer converted a carriage house into an efficient studio and dwelling, visitors experience the artist's intimacy with the sea. In his last decade, Homer reinvented the painted seascape, eschewing panoramic views in favor of close-up depictions of one or two powerful, foam-crested waves crashing down upon russet ledges of shale. He could see them from the balcony of his home and, even better, walk a dozen yards to greet and study them up close. Even on days when the singular waves hitting the rough-hewn rocks are puny, their unstoppable drive and relentless regularity are not. The artist created Homeric heroes of those breakers, their paint-crusted thrusts and parries expressing the indomitable nature of the sea. His imperious waves are also self-portraits, metaphors for Homer's unconventional lifestyle and dogged independence from mainstream American life. When I visit his strip of coastline, I reflect not only upon Homer's canvases but on an aging man's political resistance to Gilded Age values.

Georgia O'Keeffe was also site-specific in her art, but it often takes trained guides or locals to point out which rock formation or dry waterfall or bend in the road inspired a particular painting. O'Keeffe could paint the obvious—the flat-topped Cerro Pedernal, for example, a landmark mountain that can be seen for miles around. But as a modern artist who valued flowing lines, abstract shapes, strong colors, and zones of emptiness, she routinely found compositional promise in unassuming fragments of landscapes. When she selected a motif, she would so severely crop or change its scale that visitors to her landscape seldom see the original stimulus without guidance.

O'Keeffe's home and studio in Abiquiú, New Mexico, with their picture windows and sparse modern furnishings, also present an intense application of her abstract design principles, this time to low lying adobe architecture. What one learns from visiting such personalized spaces is that some artists devised functional, no-nonsense homes, like Winslow Homer, for example. But others, like O'Keeffe, built dream houses, expending considerable time and capital to create works of art commensurate with their well-defined tastes and aesthetic principles. The lushest example is Olana, Frederic Church's 250-acre landscape featuring a

man-made lake, five miles of carriage drives, and a fully furnished late-Victorian mansion high above the Hudson River all carefully mapped out and executed by a celebrity artist in his prime. The starkest is Donald Judd's multistoried, loft-style SoHo home and studio in New York City. Retrofitting a cast-iron industrial building, Judd built minimalist furniture, bought dishes and kitchenware that fit his rigorous aesthetic, and lived in enviable emptiness.

Other great furniture designers and makers, like Wharton Esherick and Sam Maloof, built and furnished homes that dazzle visitors with their unique staircases, myriad textures, and creative decor. The painters Suzy Frelinghuysen and George L. K. Morris furnished their pristine white, high-modern creation in the Berkshires with art deco furniture and murals by their own hands. Russel Wright, a renowned product designer, partnered with nature and carefully fit his flowing midcentury wooden home into the walls of an abandoned quarry, taking advantage of views into the woods and beyond to the Hudson River.

And then there are *sui generis* homes, like the one David Ireland created at 500 Capp Street in an ordinary San Francisco Victorian in the Mission District, or Roger Brown's storefront property in Chicago. These offer such unique living spaces and personal belongings that it would be a spoiler to say more; you need to experience them for yourself!

So keep this volume close at hand and join me in seeking out the artist spaces that make up Historic Artists' Homes and Studios (HAHS). Spread across the country, some of these sites tell stories of a single artist, some of artist-couples, some of artist colonies, and some of generations of artists who worked in the same space. The HAHS motto is "Witness Creativity," and creativity knows no bounds. Each and every one of these sites makes me thankful that these places are now being acknowledged, cared for, and interpreted as part of this country's art history and heritage.

Wanda M. Corn
Robert and Ruth Halperin Professor of Art History Emerita,
Stanford University
Chair, Historic Artists' Homes and Studios Advisory Committee

PREFACE

Twenty years ago, the National Trust for Historic Preservation created the Historic Artists' Homes and Studios (HAHS) network, with lead support from the Henry Luce Foundation and the Jessie Ball duPont Fund. Today, HAHS comprises forty-four preserved artists' homes and studios throughout the country—all of them open to the public. This guidebook celebrates two decades of HAHS's advocacy for the preservation and interpretation of artists' homes and studios, as well as the program's role in advancing scholarship and building public awareness around art, design, and cultural heritage in the United States. Collectively, HAHS sites draw more than one million visitors annually.

Each HAHS site is the former home and studio of an American visual artist and is an exemplar of best practices in stewardship and preservation. Chesterwood—the only artist's home also among the National Trust's portfolio of historic sites— is the administrative base for the HAHS program. It is one of the locations where sculptor Daniel Chester French worked on the seated figure of Abraham Lincoln that graces the Lincoln Memorial in Washington, DC. It is also one of the earliest artist homes and studios to be preserved and one of the most intact.

With more sites in the nomination process, the growth of the HAHS program evidences the powerful connection between historic preservation and the arts. Each is a vital tool and accelerator for the other. To visit a HAHS site is to experience these vibrant connections. We are grateful to each sites' staff for their exemplary stewardship and for partnering with HAHS. This guidebook could not have become a reality without their cooperation and enthusiasm.

We are also deeply grateful to the Henry Luce Foundation for funding this guidebook and to the Wyeth Foundation for American Art for providing support to obtain updated site images for the guidebook. Indeed, the HAHS network would not be poised to plan and strategize for its third decade without recent support from the Luce Foundation. The Wyeth Foundation, too, has been a steady partner, supporting many of the HAHS program initiatives. Thanks to the support of our newest

sponsor, the Terra Foundation for American Art, and collaborators such as the Paul Mellon Centre and Henry Moore Foundation, we have embarked on initiatives that foster international exchange.

For two decades, the HAHS program has been cultivated by the successful leadership of Wanda M. Corn, the Robert and Ruth Halperin Professor of Art History Emerita, Stanford University, as chair of the HAHS Advisory Committee. As a fellow at the National Collection of Fine Arts, Smithsonian Institution, it was Corn who first alerted Frank Sanchez, former Vice-President of Historic Sites of the National Trust for Historic Preservation, about the impending sale of the Alice Pike Barney House on Embassy Row owned by the Institution, spearheading a new initiative to form a consortium of historic artists' homes and studios.

Over the past twenty years a host of leading art historians, landscape architects, historians, and site directors have also served on the advisory committee. With the continued guidance of our colleagues, the HAHS network will continue to expand, building an increasingly inclusive historical narrative that deepens the legacies of individual artists and expands our collective identity.

Valerie A. Balint, program manager of HAHS, deserves special mention for her tireless efforts toward making this guidebook a reality as its primary author and editor. It is the first such publication to highlight a collection of sites that cover such breadth and depth of American art. This project has benefited from the steadfast guidance of the staff at Princeton Architectural Press, for which we offer our sincere thanks. We hope that this publication, highlighting the diversity of sites from Maine to California, will prove invaluable to our understanding of where American artists lived, how they worked, and the powerful influence of place on their art.

Donna Hassler
Executive Director, Chesterwood
Administrator, Historic Artists' Homes and Studios Program of the
National Trust for Historic Preservation

Katherine Malone-France
Chief Preservation Officer, National Trust for Historic Preservation

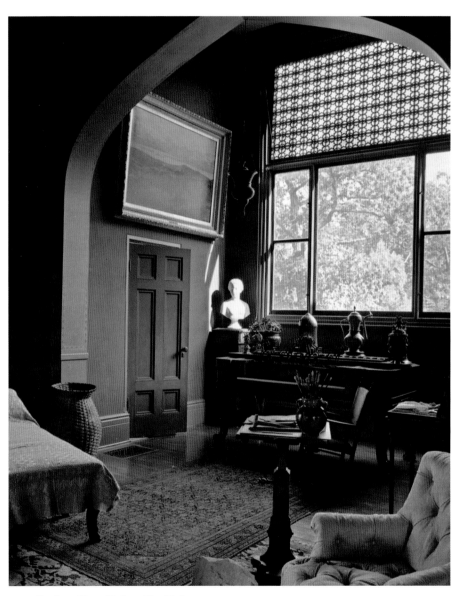

Studio at Olana, Hudson, New York. Photograph Don Freeman, courtesy of the artist.

INTRODUCTION

I am delighted to present the stories of these extraordinary sites in this guidebook, which reflects the current members of the Historic Artists' Homes and Studios network. The narratives of the artists and the distinctive places associated with them are the equivalent of any introductory American art college survey class, tracing the evolution and legacy of visual arts in the United States. These sites represent a range of American art: from the nineteenth-century Hudson River School landscape painters, whose iconic images linked nature's splendor to ideas of national identity, to twentieth-century artists who were instrumental in the transformation of the very definition of art as it widened to embrace folk art, handcrafted furniture, industrial design, and Abstract Expressionism.

Each of these artists and their respective homes are worthy of exploration beyond the scope of this guidebook. My hope is that these short profiles will encourage readers to seek out these special places. Moreover, my wish is that they serve as an enticement to learn more about the individuals who created there and to view their artworks in museums. These artists and their spaces provide an opportunity to explore the broader history of this country and how it has been represented artistically.

I visited an artist's home for the first time when I was eleven, touring Chesterwood, the summer home and studio of sculptor Daniel Chester French, with a school art class. Many years later, the name was mentioned to me in passing, and powerful images of the studio—with its models for the Lincoln Memorial, the smell of the autumn Berkshire leaves, and the sound of the garden fountain—flooded back to me in an instant. Today, I am a seasoned visitor of such sites throughout the world. I recall with the same childlike awe and wonder the arid heat of the southwestern climate at the Couse-Sharp Historic Site in New Mexico, the intoxicating fragrance of Gari Melchers's picturesque floral plantings at the Belmont estate in Virginia, and the exotic opulence of Frederic Church's Olana in New York's Hudson River Valley.

These encounters represent the power of place, the *genius loci*, that each of the homes and studios uniquely promises to its visitors. When

William Chadwick Studio, Florence Griswold Museum, Old Lyme, Connecticut.
Photograph Jeff Yardis, courtesy Florence Griswold Museum.

we are young, we are all creative in some sense. We experiment with art, music, writing, and other forms of expression and do not question it as part of our nature. As we grow older, however, most of us set aside this part of ourselves. Visiting the sites of individuals who made creativity their life's work returns us to that primordial human impulse to make something. Henry Mercer's utterly experimental concrete castle at Fonthill, begun at midlife, reminds us all that art is as much a journey as a destination. By contrast, the small, modest cottage shared by Arthur Dove and Helen Torr illustrates that artistic innovation does not always require a grand studio space in order to emerge.

In an increasingly virtual world, these places offer a tangible, immersive experience. Art is the result of both a physical and mental practice, but what is displayed in a museum represents only the results. Artists' homes and studios help us imagine the form of this rigorous process by allowing us to see where art was actually made and exposing us to the same input as the artists: they reveal not only an artist's process, but what in the environment inspired it. The working spaces, the objects the artists chose to surround themselves with, the books they read, and the views they regarded beyond their studio walls all inform what they created.

The contents of Sam Maloof's California workshop enlighten any visitor on this master furniture-maker's methods, while looking up at the San Gabriel Mountains from the house he designed connects the visitor directly to the landscape that nurtured him throughout his career.

Artists and their homes reveal and reflect the current issues of the era and push the boundaries of creative expression. Their artworks are representations of their individual experiences and ideas, as passed through their own artistic prism. All art is contemporary to the time it is made, and all artists are contemporary in their own lifetimes. Artists such as Roger Brown, Thomas Hart Benton, and Alice Austen confronted uncomfortable social issues while also establishing a more expansive visual cultural identity. Visiting their homes reveals much about the personal beliefs that influenced their work.

The places where artists lived and worked allow us to see more deeply into the impulses and stimuli that informed the artworks we have seen in the world at large. Homes like those of Augustus Saint-Gaudens, Thomas and Mary Nimmo Moran, and Grant Wood are deeply personal and served as incubators for their inhabitants' explorations and experimentations, extending beyond the visual arts into architecture, landscape design, collecting, and assemblage, a reminder that creative endeavor is neither linear nor confined.

Many, like Grace Hudson, were astute collectors, while others acquired artworks from their colleagues to display in their own homes. Their domestic and working spaces evolved into personal museums containing furniture, decorative arts, ethnographic objects, or fine arts from their travels, all artfully arranged within their environs.

The ultimate magic of these homes is that each is a unique expression of the artist who lived there. Frequently, they are works of art in and of themselves, as is the case with Frederic Church's Olana, Russel Wright's Manitoga, and David Ireland's 500 Capp Street, among others. All bear the unmistakable imprint of the artist's desires, design philosophies, and zeal for art-making.

The studios at these sites are the very crucible of creativity. To stand on the densely paint-stained floor at the Pollock-Krasner studio is a transformative experience even if you have seen Jackson Pollock's paintings in museums hundreds of times. If you have never understood

how complex his painting process was, when you stand immersed in it, this complexity is revelatory. It is an experience that cannot be replicated outside of this particular place. Such encounters transpire again and again at these sites.

Beyond offering insight into the imagination and the aesthetic sensibilities of individual artists, these places are hallmarks of the major artistic movements in the United States and demonstrate their interconnectedness. These artists were linked through professional as well as deeply personal ties, such as between friends Charles Demuth and Georgia O'Keeffe. In some instances, they studied with each other: Thomas Hart Benton taught Jackson Pollock, and Rockwell Kent and Edward Hopper were classmates. They also reacted to and built on the artistic expression of their peers or their artistic forbearers; for instance, abstraction advocates George L. K. Morris and Suzy Frelinghuysen eschewed figurative works of art by artists of earlier eras such as Gari Melchers in favor of new aesthetic modes.

As with living artists today, these artists strove to reflect and respond to the issues of their time. The places they chose to live, the styles of their homes, and the objects on their bedside tables all offer us glimpses into the eras that inspired their art, as in the portrait of John F. Kennedy that hangs near the bed of African American self-taught artist Clementine Hunter.

Ultimately, these homes are where their inhabitants lived out their lives with family and friends, rivals and colleagues—all with the trials, tribulations, and triumphs that made them human. So often, we place artists and their talents at a distance, but these personal encounters break down that barrier. The stories of Albin Polasek's and Chaim Gross's immigration and self-determination, Frederic Church's loss of two young children at the height of his career, and the perseverance of Charles Demuth during his lifelong struggle with diabetes are both deeply personal and universal.

The wonderful paradox of artists' homes is that they are at once unique and representative. They capture a historical moment, but they also, through preservation efforts and innovative programming and interpretation, form a bridge from past to present to future. For instance, the plaster models of memorials to Southern heroes created during the

Detail of artist's materials in studio of Ann Norton, Ann Norton Sculpture Gardens, West Palm Beach, Florida.
Photograph Capehart Photography, courtesy Ann Norton Sculpture Gardens.

Jim Crow era that are on view in the studio of sculptor Edward Valentine provide a unique opportunity to examine contemporary issues relating to memorialization, history-making, racism, and the powerful emotions that art can provoke.

Historic Artists' Homes and Studios was begun twenty years ago, in part to draw attention to spaces that so often have been in danger of disappearing. In truth, the network can represent only artistic narratives that have been preserved, and this has often excluded less-mainstream artists and diverse populations. Much progress has been and continues to be made, as the recent restoration of the home of deaf and self-taught artist James Castle in Boise, Idaho, demonstrates. But there is still so much more to do. To preserve these places is to preserve the stories of ourselves and our cultural legacy. In all their varied expression, these properties are fragile and irreplaceable and require champions to ensure their future.

May this guidebook begin your own journey of discovery to the abundant riches these sites have to offer.

Valerie A. Balint
Program Manager, Historic Artists' Homes and Studios

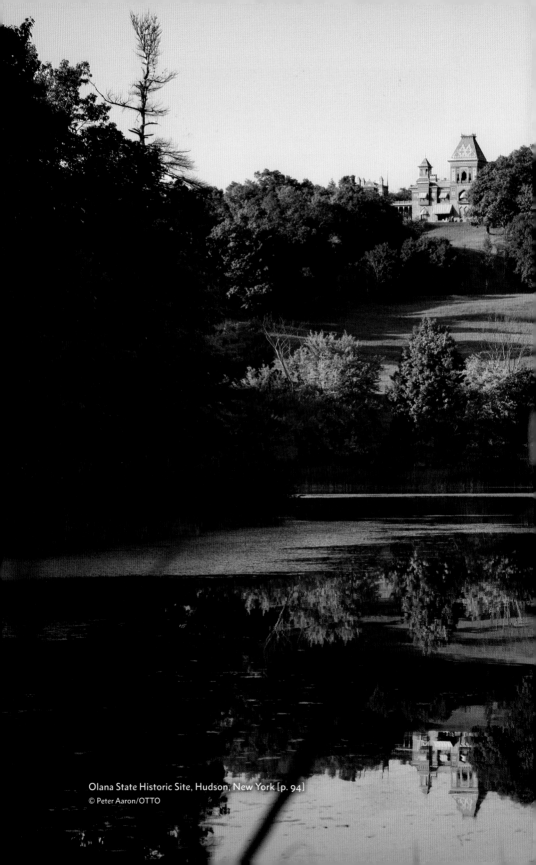

Olana State Historic Site, Hudson, New York [p. 94]
© Peter Aaron/OTTO

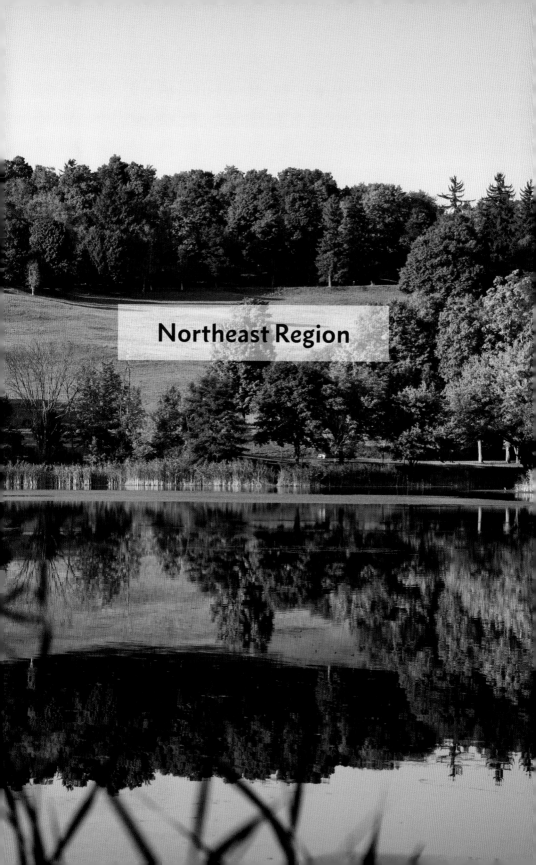

Northeast Region

Bush-Holley House
Greenwich Historical Society

Theodore Robinson (1852–1896)
Julian Alden Weir (1852–1919)
John Henry Twachtman (1853–1902)
Frederick Childe Hassam (1859–1935)
Ernest Lawson (1873–1939)
Elmer Livingston MacRae (1875–1953)

47 Strickland Road, Cos Cob, CT 06807
203-869-6899 **greenwichhistory.org**

The shining brass knocker upon the broad front door…the steep
pitch of the rear roof and the massive chimney, all tell their
story of long ago. The Holley House was a great, rambling,
beautiful old accident.

—LINCOLN STEFFENS, JOURNALIST & BUSH-HOLLEY
GUEST

When the railway arrived in Connecticut in 1848, New Yorkers could easily, quickly, and affordably escape the city for the quaint, historic village of Cos Cob, at the intersection of a millpond and the Mianus River where it flows into Long Island Sound. Among the throngs of visitors came the artists and writers who formed the Cos Cob art colony, the first Impressionist art colony in Connecticut, although certainly not the last [see p. 26 and p. 32]. This group ultimately comprised more than 125 artists and writers who changed the course of American art.

With the influx of tourists, Josephine and Edward Holley recognized an opportunity. The couple owned an eighteenth-century saltbox house on an idyllic site just uphill from the water's edge. By the late nineteenth century, renovations expanded the home into an impressive residence, mingling romantic touches like the old Dutch doors with the newer gracious

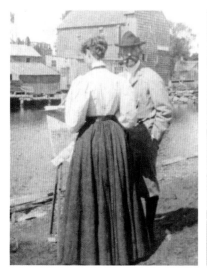
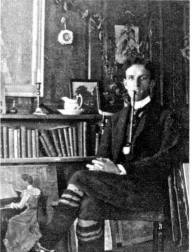
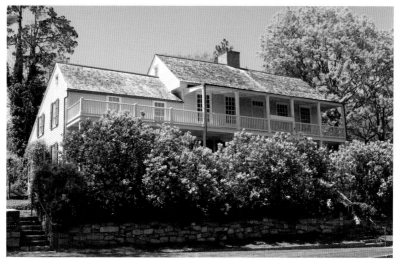

porches. The Holleys transformed it into a boarding house, creating a convivial atmosphere that ultimately drew the leading Impressionist artists of the day to teach and discuss their works and the future of American art. Although these artists embraced the Impressionist ideas coming out of France, they set about adapting them to American subject matter. The group included Ernest Lawson, Theodore Robinson (who knew Monet personally and had stayed at Giverny), John Henry Twachtman (the first

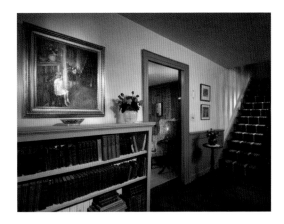

artist of this era to teach classes in Cos Cob, p. 23, above left), Julian Alden Weir (known as a leader of American Impressionism) [see p. 32], and the iconic Childe Hassam, who dubbed them the Cos Cob Clapboard School and whose status earned him the best room in the house.

Cos Cob provided an encounter with the nostalgia and romanticism of an earlier time, one that these artists captured eagerly in their work. The nearby harbor, the charming village, and the picturesque farmland lay just beyond the property's expansive gardens. For eight to ten dollars per week, painters could take a room, paint all day, and surround themselves with like-minded artists all evening.

Among them also was painter Elmer MacRae (p. 23, above right), who came to study under Twachtman, married the Holley's daughter Constant, and became the site's longest resident. The couple succeeded Constant's parents in running the boardinghouse. Upstairs, visitors can see Elmer's studio, where an easel holds a canvas depicting his wife. Like others in his circle, MacRae was interested in Japanese art and culture, and his studio is adorned with hanging paper cranes and Asian ceramics and textiles.

Works by MacRae and others decorate the house, including a painting of a hallway by Childe Hassam hanging in the very hallway it depicts (above). Additionally, Hassam's series of thirty etchings of the house and its environs amply display what drew artists here for decades. Over the years, the Cos Cob artists evolved along with the art scene, and some paintings show how these artists absorbed new paradigms. MacRae was

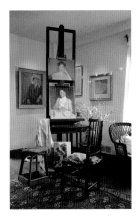
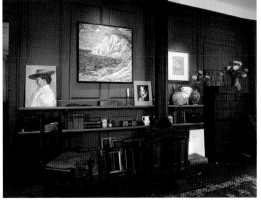

an organizer and the treasurer of the revolutionary 1913 Armory Show in New York that introduced Americans to modern art.

Constant Holley sold the property to the Greenwich Historical Society in 1957. The organization acquired the original Cos Cob post office and built museum galleries, library, and archives adjoined to a restored hotel and saloon, now the store and café. Together, these depict the larger story of the Cos Cob coastal community and provide a taste of the landscape and buildings that inspired the Cos Cob art colony. The Bruce Museum in Greenwich boasts an impressive collection of works by the Cos Cob Impressionists. Nearby are the Florence Griswold Museum in Old Lyme [p. 26] and Weir Farm in Wilton [p. 32], where many of the same artists also painted.

Florence Griswold Museum

————

Henry Ward Ranger (1858–1916)
Willard Leroy Metcalf (1858–1925)
Robert William Vonnoh (1858–1933)
Frederick Childe Hassam (1859–1935)
Frank Vincent DuMond (1865–1951)
Matilda Browne (later Van Wyck; 1869–1947)
William Chadwick (1879–1962)

96 Lyme Street, Old Lyme, CT 06371
860-434-5542 **florencegriswoldmuseum.org**

———

So you see, at first the artists adopted Lyme, then Lyme adopted the artists, and now, today, Lyme and art are synonymous.
—FLORENCE GRISWOLD

You should see [my studio] here, just the place for high thinking and low living.
—CHILDE HASSAM

The seasonal denizens of the Florence Griswold House returned every summer for three decades to this bucolic twelve-acre site on the banks of the Lieutenant River in the historic village of Old Lyme. These artists sought the inspiring seaside light, abundant rustic and pastoral scenery, and convivial society—often marked by spirited discussions of the art world. Many came hoping to emulate experiences they'd had in Europe with collective living and painting outdoors, *en plein air*. They executed thousands of works and established the Lyme Art Colony, one of the country's most enduring artistic communities and a center of American Impressionism.

At its heart was a late-Georgian mansion, its welcoming yellow facade highlighted by Ionic columns and green shutters, originally built

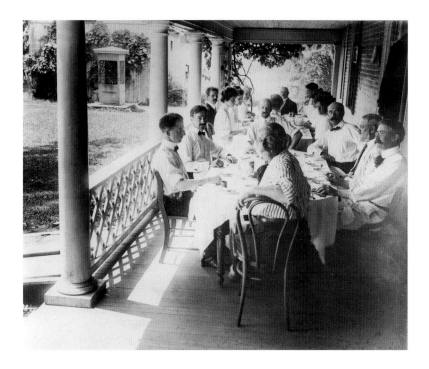

in 1817. Presiding over what became a seasonal boarding house for artists was the gracious and enterprising Florence Griswold, who had grown up in the house with her siblings. To adapt to the town's declining shipping industry and their own diminished circumstances after Griswold's father retired from the transatlantic packet ship trade, the family first opened a girls' school in their home and later the boarding house. Griswold, unmarried, eventually became the only one left to maintain the property.

When artist Henry Ward Ranger, whose tonalist landscapes emulated the moody contrasts of the Barbizon style, arrived in Old Lyme in 1899 and installed himself at Florence Griswold's ("Miss Florence's") boarding house, he became enraptured, declaring that the landscape was "waiting to be painted." He shared his discovery with his artist friends, who began arriving at her front door the following summer.

As Impressionist artists such as Robert Vonnoh, Willard Metcalf, William Chadwick, and Childe Hassam arrived in the ensuing years, the Old Lyme circle underwent a stylistic and practical transformation. To create the desired atmosphere, for instance, the colony's informal

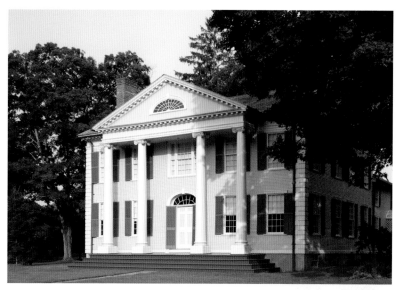

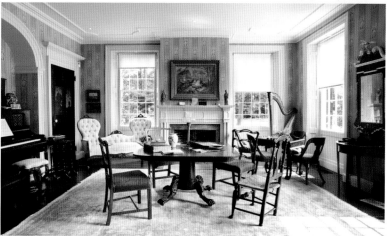

leadership insisted that only professional artists could stay at Griswold House, although students were allowed on the grounds to paint. The colony comprised mostly men; however, some women artists gained access, including Matilda Browne and Bessie Potter Vonnoh.

The preserved Florence Griswold House is a window into a time when boisterous laughter, artistic and political debate, and the sounds of Griswold's harp playing filled the communal front parlor. While new

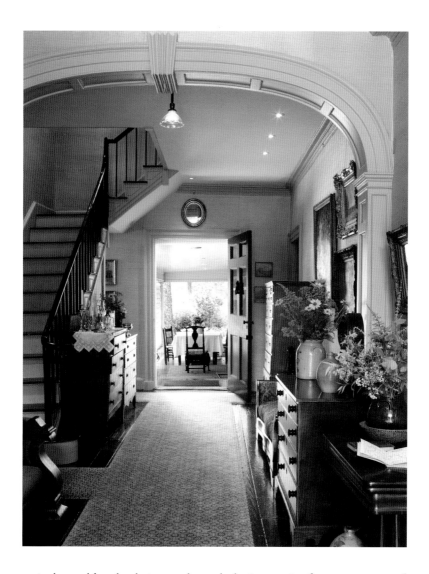

arrivals would make their way through the impressive front entrance and into the hallway hung with paintings (a makeshift sales gallery), veterans came and went via the side porch that led through vibrant floral gardens and orchards to the landscape beyond. This porch was the setting for many an alfresco meal taken by the self-described Hot Air Club, a reference to both the weather and the group's pontifications. But their chats were more than just hot air—the group's commitment to their profession

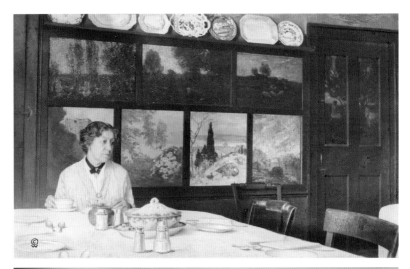

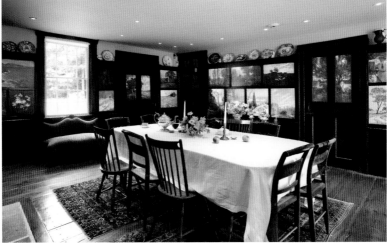

was evidenced in the artists' program of annual summer exhibitions and their establishment, in 1914, of the Lyme Art Association. Their gallery, built in 1921, still exists today on land donated for that purpose by Florence Griswold.

The first-floor parlor of the Florence Griswold House maintains the appearance it had when artists filled the home. The paneled dining room was the site of daily meals, a community tradition. The dozens of painted panels adorning the walls were executed by those artists whose work the

group judged worthy of being permanently installed. Above the mantel is a parody by Henry Rankin Poore of a traditional foxhunt depicting numerous identifiable members of the colony. Another highlight is the painted panels on the door, including Childe Hassam's *The Bathers* (1903), which depicts a favored subject of his and conveys the freshness of having been painted on the spot. Upstairs, former bedrooms are now galleries featuring paintings, photographs, art materials, and sketchbooks that chronicle the colony's emergence and stylistic evolution.

Every day these artists set off to nearby locales to paint, often on the property. Although most painted outside, the outbuildings became studios for those who required them. While these outbuildings were eventually dismantled, today, visitors can view a studio moved from William Chadwick's nearby property to experience how these spaces functioned. The recently established Robert F. Schumann Artists' Trail leads through gardens, hedgerows, riverfront meadows, woodland thickets, and forgotten corners along the estate's edges where these artists ventured.

The Florence Griswold Museum offers the rare opportunity to experience firsthand these sites of inspiration and then see the very paintings depicting them. The house displays many such works, and the adjacent Robert and Nancy Krieble Gallery presents an exceptional collection of American art with Connecticut ties from the eighteenth through the twentieth centuries. Works depicting the area are discovered regularly, such as Childe Hassam's newly acquired *Apple Trees in Bloom, Old Lyme* (1904, above left and right).

Weir Farm National Historic Site
National Parks Service

—

Julian Alden Weir (1852–1919)
Mahonri Mackintosh Young (1877–1957)
Dorothy Weir Young (1890–1947)
Sperry Andrews (1917–2005)
Doris Bass Andrews (1920–2003)

735 Nod Hill Road, Wilton, CT 06897
203-834-1896 **nps.gov/wefa/index.htm**

*One cannot help but feel that wonderful something that
the landscape in nature suggests, somewhat like the soul of
a human being.*
—JULIAN ALDEN WEIR

No sculpture at all is better than bad sculpture.
—MAHONRI YOUNG

The visual splendors that signify traditional New England pastoral life abound at Weir Farm, conjuring the emblematic descriptions penned by iconic American poet Robert Frost. The picturesque, tranquil views calm and stir the soul equally, beckoning one to discover ubiquitous stone walls, formal gardens, orchards, a pond, and pastureland surrounded by forests. This beloved landscape complements a series of red, wood-sided houses, studios, and barns where three generations of American artists lived and worked, starting with patriarch Julian Alden Weir (p. 33, above left), known as a leader of American Impressionism.

Weir, whose father and brother were also artists, was a successful painter and educator in New York City when, in 1882, he purchased the 153-acre Connecticut farm, acquiring the property from owner Erwin

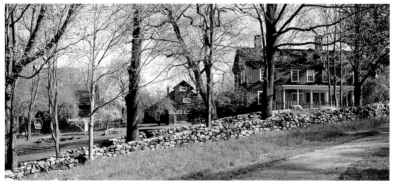

Davis in exchange for parting with a coveted painting he owned and paying Davis an additional meager purchase price of ten dollars. Weir was one of many New Yorkers who sought an escape from the oppressive summers in the city. Many of the painter's artist friends visited him and his family here, including Albert Pinkham Ryder, John Henry Twachtman, and Childe Hassam, artists who also painted at Cos Cob [see p. 22]. Frustrated that their embrace of Impressionism was met with hostility from the conservative American art establishment, Weir, Twachtman, and Hassam, along with other artist colleagues, ultimately formed a group called The Ten American Painters to exhibit their work together.

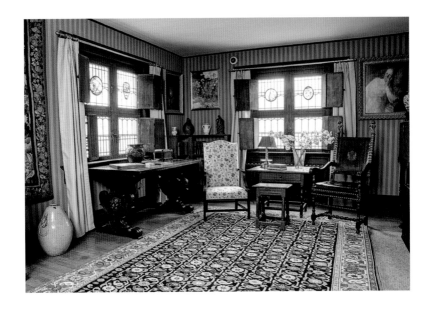

The landscape at Weir's farm became a frequent subject of their paintings and etchings.

The interior of Weir's home features rooms lovingly appointed with an artist's eye. Amid the dense color and rich, patterned wallpapers, the diverse array of objects on display, some of which he used in his paintings, includes original artwork by the three generations of artists, antique Flemish tapestries, Delft tiles, a Bavarian staghorn chandelier, and a collection of nineteenth-century pewter. A bust of Weir by sculptor and friend Olin Warner greets visitors in the library, and powder horns and firearms rest over fireplace mantels. Elsewhere are the trappings of daily life, including a 1917 Victrola, a 1942 GE refrigerator, and a ca. 1900 coal and woodburning kitchen stove. The whole ensemble aptly reflects the inscription over the front door: "Here we shall rest and call content our home."

Leaded glass windows with sixteenth-century stained glass offer peeks of the landscape that provided Weir with constant inspiration. Author Royal Cortissoz extolled: "Give Weir a straggling stone wall or rail fence enclosing a Connecticut pasture, a farmer at his plow, the bridge over a New England stream...and he could translate it all into incomparable beauty." Weir was as likely to be seen painting outdoors as he was in

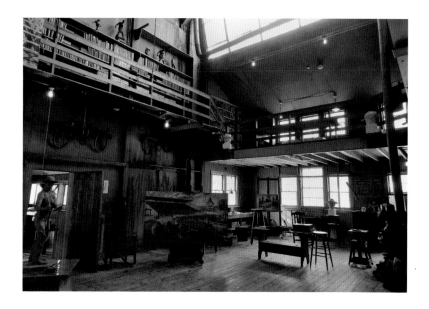

his studio, whose ceiling he painted blue-green and adorned with gilded plaster stars. He proclaimed, "[Here] I feel that I can enjoy studying any phase of nature, which before I had restricted to preconceived notions of what it ought to be."

Weir's daughter Dorothy, an accomplished artist herself, married sculptor Mahonri Mackintosh Young (p. 33, above right), who built his own impressive two-story studio on the property. Here Young executed the small figurative works he was best known for as well as his largest commission, the monolithic *This Is the Place Monument*, erected outside Salt Lake City, Utah, to commemorate the centennial of the 1847 arrival of the Mormons in the Salt Lake Valley. Young eventually was befriended by artists Doris and Sperry Andrews, who bought part of the property and lived and worked there for many years. Together with Weir's daughter Cora Weir Burlingham, they secured the farm's long-term preservation. The now sixty-acre site includes the house, studios, barn, visitor center and gallery, and numerous hiking trails, including a mile-long path to Weir Pond.

Two other artistic enclaves that inspired many of the same artists, the Bush-Holley House in Greenwich [see p. 22] and the Florence Griswold Museum in Old Lyme [see p. 26], are also in Connecticut.

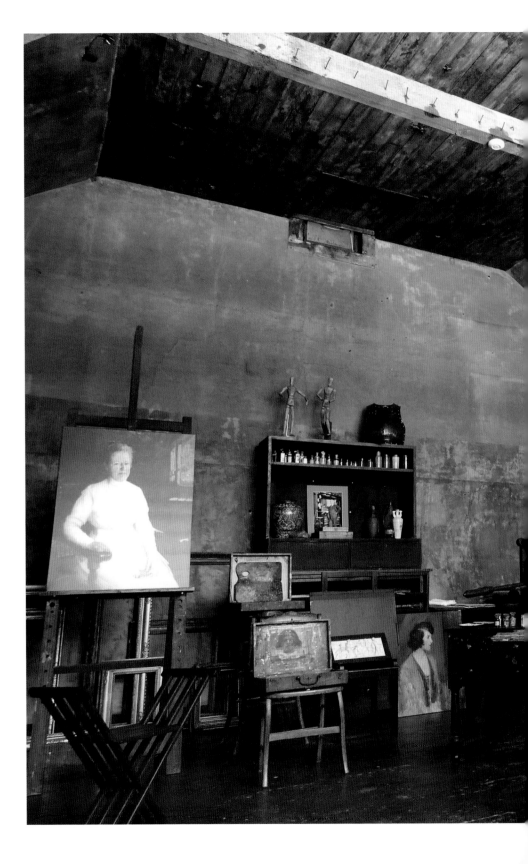

Rockwell Kent–James Fitzgerald
House & Studio
Monhegan Museum of Art & History

—

Rockwell Kent (1882–1971)
Alice Kent Stoddard (c. 1883–1976)
James Edward Fitzgerald (1899–1971)

1 Lighthouse Hill, Monhegan Island, ME 04852
207-596-7003 **monheganmuseum.org**

It seems to me now that I'd like to paint here always.
—ROCKWELL KENT

*I would love to go to college in order to play hockey, but perhaps
I had better be the uneducated member of the family and go
to art school.*
—ALICE KENT STODDARD

*Artistic creation springs from the formative impulse and the
craving for emotional expression.*
—JAMES FITZGERALD

Monhegan Island's ethereal beauty envelopes visitors in its timelessness
from the moment the ferry departs the coast of Maine. During the hour-
long journey over twelve nautical miles, only water is visible ahead until
the island rises up as the boat approaches land. From its rocky perch atop
the village, a lighthouse that now houses the Monhegan Museum over-
looks the harbor, where lobster traps are heaped at the water's edge and
artists are hard at work before their easels. Everyone walks on the unpaved
roads because cars are forbidden. The beguiling environment may make

one wonder if they've stumbled on New England's version of Brigadoon and explains why artists and writers have been drawn to this remote locale since the 1850s.

In 1905, twenty-three-year-old Rockwell Kent (above left) traveled to Monhegan at the suggestion of his teacher, realist painter Robert Henri. Fellow students George Bellows and Edward Hopper [p. 80] visited as well a few years later. Kent was so entranced that he decided to stay and built himself a two-room cottage and, later, a nearby studio. He intended to establish an art school and sited both buildings to afford an unobstructed view of the harbor. On this patch of rugged earth, Kent painted some of his best-known works, and his home and studio later served two other artists.

Kent moved away from the island in 1910, likely intending to return shortly. Although he returned for the summer of 1917 and lived in the house he had built for his mother, he then stayed away for three decades. His cousin, painter Alice Kent Stoddard (p. 39, bottom), spent every summer in Kent's studio from 1912 until 1946, eventually buying it following her marriage to fellow artist Joseph Pearson. Stoddard, a portrait artist and landscape painter who served as a combat artist during World War II, was a much-loved member of the Monhegan community and is one of many of the women artists who have lived and painted on the island.

In 1948, Kent returned and repurchased his home. He met painter James Fitzgerald (p. 39, above right), who had first visited Monhegan in the 1920s and retreated there in the 1940s after becoming disenchanted with the commercial art world, despite having received critical acclaim. Ultimately, he settled in Kent's former studio and pursued his own artistic credo, which espoused that art should not seek strict realism and that "pure painting is concerned with timelessness." After Kent left Monhegan for a final time in 1953, Fitzgerald acquired the house, too. Upon his death in 1971, Fitzgerald left both buildings and their contents to friends who later bequeathed the site to the Monhegan Museum of Art & History.

Today, visitors to the house and studio see it as it was furnished when Kent lived there during his first interlude on Monhegan. The hardscrabble architecture was meant to withstand the island's harsh climate, and, like other buildings throughout the island, its materials and contents

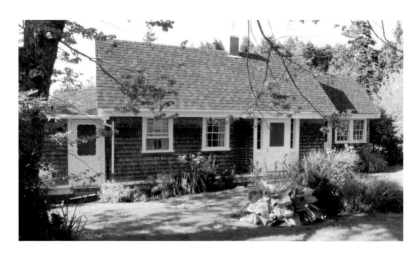

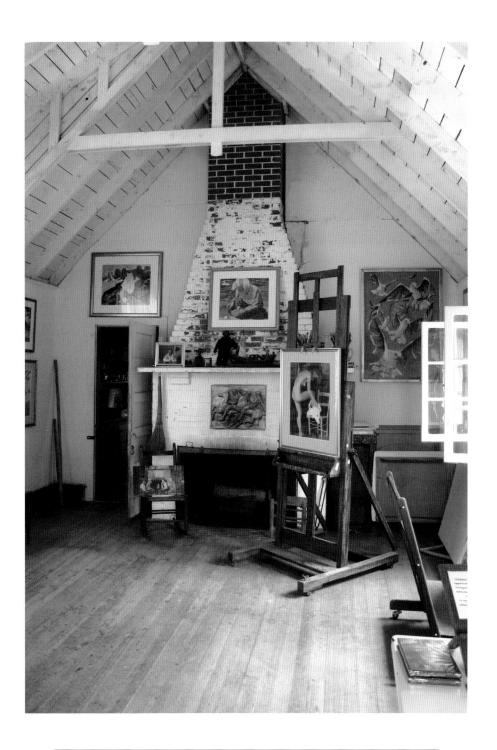

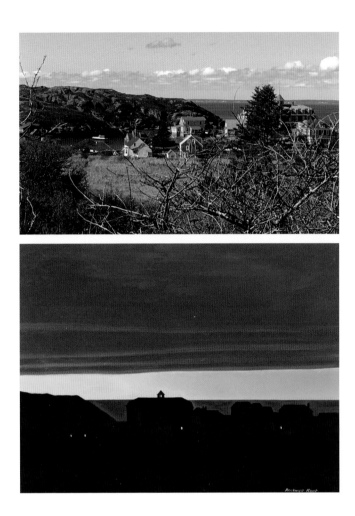

had to be brought over from the mainland. Inside are many original Kent furnishings including the piano and Victorian sofa received as wedding gifts, a rocking chair he built, and a fireplace inset placed by Kent, made of a commercial plaster cast after Renaissance artist Luca della Robbia. Because it requires just as much effort to remove things as it does to bring them to the island, a house's contents often remain when owners change and possessions are repurposed through neighborly exchange.

Just beyond the cottage doors are plantings introduced by the artists. Kent, a vegetarian, planted a vegetable garden that is still used and that retains its original appearance. He also planted the apple and cherry

trees, as well as many of the peonies. From his painting trips to a camp at Lake Katahdin in northern Maine, Fitzgerald brought back the rhubarb that still grows at the house.

The nearby studio affords visitors an unchanged view of the harbor. The studio remains as Fitzgerald left it not long before his death and offers a veritable feast for those interested in artistic process. All his art materials are here, including brushes, carved models, paints, palettes, unused Whatman paper, framing and gilding materials, and even original paint flecks on the floor. The space is also the site for a rotating exhibition of the hundreds of works in the permanent collection. Artifacts from Stoddard's and Kent's tenures include a room added by Stoddard and a reproduction plaster cast after a section of the Parthenon frieze that Kent installed in the fireplace.

Whether visitors stay only a day or linger longer, walking the rest of the island is a must. Take in the majestic Cathedral Woods, the seaside cliffs that have inspired generations of artists, and the private artists' studios that dot the landscape. Another must-see is the Monhegan Museum, which includes twenty-three Kent drawings dating from his original stay and several oil paintings from his tenure in the 1950s.

Departing the island, visitors may observe a poignant local tradition in which residents offer flowers from their gardens for visitors to toss into the harbor as the ferry leaves the shore. Monhegan lore holds that the floating blossoms will ensure a return to this magical place.

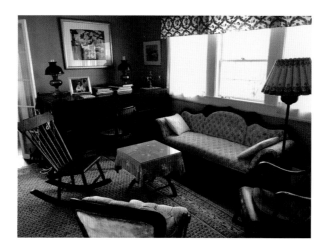

Winslow Homer Studio
Portland Museum of Art

———

Winslow Homer (1836–1910)

Winslow Homer Studio, 5 Winslow Homer Road,
Prouts Neck, Scarborough, ME 04074

Portland Museum of Art, Seven Congress Square,
Portland, ME 04101

207-775-6148 **portlandmuseum.org**

When you paint, try to put down exactly what you see. Whatever else you have to offer will come out anyway.
—WINSLOW HOMER

Winslow Homer's studio is perched on the rocky peninsula of Prouts Neck, Maine, a twelve-mile drive from the Portland Museum of Art. Visitors begin their journey to the studio at the museum and proceed out to the summer community established by Homer's family in the 1880s. The Homers first visited in 1875 and soon began spending summers in Prouts Neck. To create that elite enclave, the cosmopolitan Homer clan purchased much of the land and engaged Portland-based architect John Calvin Stevens to erect several buildings in the Shingle Style, including their impressive family home, appropriately named The Ark for its size and position near the water.

In 1883, Winslow Homer abandoned his urbane life in New York City when the family gave him The Ark's two-story carriage barn to convert into his primary residence and studio. Stevens transformed the 1,500-square-foot space and moved it to establish a more comfortable distance from the family house, while still remaining in its proximity. The renovated building had no running water or electricity, and Homer

relied primarily on the large central fireplace for heating and cooking. Surrounded by the glories of coastal Maine, he took up a simple life that allowed him to focus on his work with a new perspective and to receive guests in his studio, all while also continuing frequent travel.

A dramatic shift in Homer's art ensued. Although he had achieved success with his Civil War illustrations in *Harper's Weekly* and garnered acclaim for his oil paintings and masterful watercolors, demand for his work had decreased. As if anticipating the art world's impending shift toward abstraction, Homer moved from figurative and detailed renderings to paintings and etchings that capture the character and mood of the landscape and ocean that he observed every day. His influence grew so profound that, although its location was not widely known, the studio became a place of discreet pilgrimage after his death until it was restored and opened to the public in 2012 by the Portland Museum of Art.

The view of the studio from the road—the low and windowless extension, added in 1890, is punctuated only by an elongated chimney—lacks the drama of the building's ocean-facing facade. There, the sloping, four-sided mansard roof is obscured by the spectacular covered balcony wrapping around the second story. Within, darkly stained horizontal and vertical boards cover the walls, ceilings, and floors. The open and sparsely

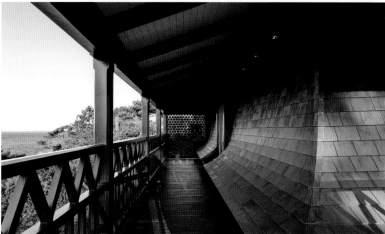

furnished central room is dominated by a fireplace accented by a built-in side bench and antlers hanging from the chimney. A multipaned window offers a framed ocean view that evokes the one depicted in *Weatherbeaten* (p. 47, bottom), an 1894 masterpiece on view at the Portland Museum of Art.

The living space features mounted fish skins from one of Homer's frequent excursions, his wicker daybed, and even scribblings on the wall, including an enigmatic quote from Emile Gaboriau's novel *The Clique of*

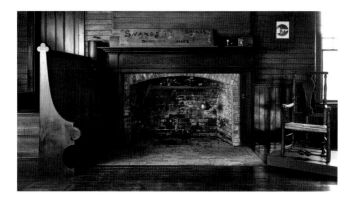

Gold: "Oh what a friend chance can be when it chooses." Everywhere are clever built-ins and ingeniously tucked-in spaces such as the library. The upstairs loft space opens onto the expansive balcony. Here the painter spent so many hours observing the surf and the changing weather patterns that his brother purportedly joked that he would wear out both the floorboards *and* the view.

Outside, follow a winding path through tall grasses to the shore and step directly into a Homer seascape, complete with all the sensory aspects he captured so adeptly, from the sublime jumbles of rocks lining the coast to the life-affirming pound of the surf and the salty spray of the Atlantic.

The Portland Museum of Art boasts a notable collection of works by Winslow Homer inspired by Prouts Neck, including ten paintings, fourteen watercolors, and hundreds of woodblock engravings of illustrations executed for *Harper's Weekly*.

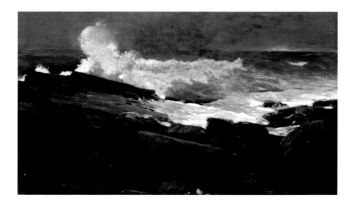

Chesterwood
National Trust for Historic Preservation

Daniel Chester French (1850–1931)

4 Williamsville Road, Stockbridge, MA 01262
413-298-3579 **chesterwood.org**

It is as beautiful as Fairy-land here now… I go about in an ecstasy of delight over the loveliness of things.
—DANIEL CHESTER FRENCH

Daniel Chester French's *tour de force* of solemnity and contemplation, the sculpture of the seated Abraham Lincoln that graces the Lincoln Memorial (1922) in Washington, DC, not only depicts one of the country's most revered leaders, but also the very essence of democratic ideals. French created it in part at Chesterwood, his summer retreat in the Berkshires of western Massachusetts. The sculptor of more than one hundred monuments nationwide, French devoted the same artistry to Chesterwood itself, a place of inspiration and retreat that fed his creative impulses and personal interests.

French was born into an established New England family and spent much of his childhood in Concord, Massachusetts, among such intellectuals as Ralph Waldo Emerson. He received his first art instruction from Concord neighbor May Alcott, sister of Louisa May Alcott, author of *Little Women*. (The character of Amy in the novel is based on May.) *Minute Man* (1875), his first important commission, commemorates the Concord militiamen who fought at the dawn of the American

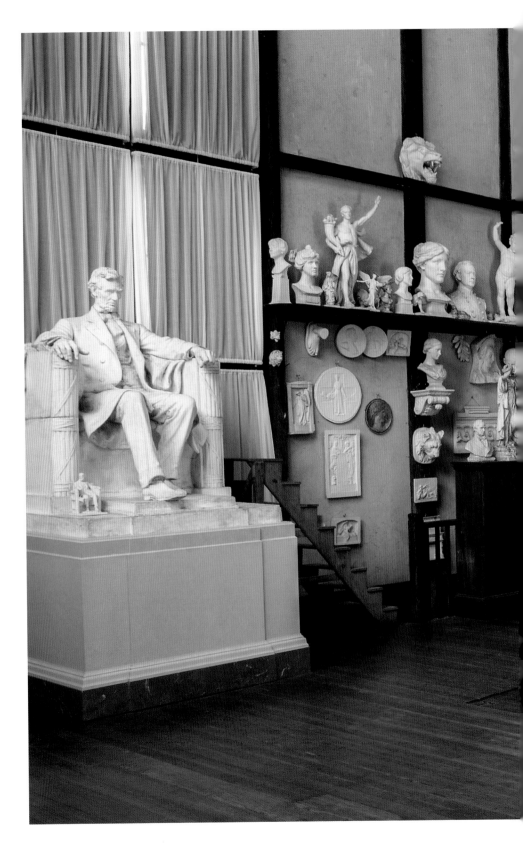

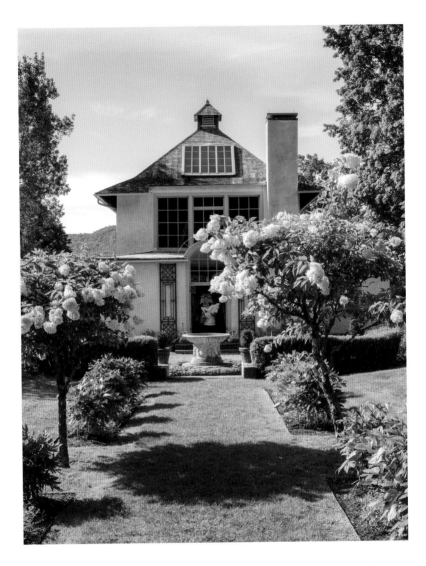

Revolution, and it launched his fifty-year career. After travel and more formal training in Europe, French and his wife, Mary, settled in New York City's Greenwich Village among a number of talented and influential artists.

Stockbridge, Massachusetts, with its easy access to both New York and Boston, provided an ideal location for a summer retreat. Over three decades, French transformed the working farm he purchased in 1896,

fusing his love of New England agricultural heritage with his preference for classical aesthetics. The family typically resided at Chesterwood from May through October, a time French referred to as "heaven."

After realizing an old barn was inadequate for use as a studio, French engaged Henry Bacon, future architect of the Lincoln Memorial, to help him design a new studio. The resulting stately structure, with its stucco facade, echoes an Italian villa. Inside, a small reception area leads to an expansive working space with a large, north-facing window and a twenty-six-foot-high ceiling, tall enough to accommodate works of monumental scale. The large final preparatory working model for the Lincoln Memorial commands the space among plaster models for other commissions. Also in the workroom is a bronze reduction of the George Washington equestrian statue (1900), which can be seen in Paris in the Place d'Iéna, two blocks from the banks of the Seine. Overhead shelves are dense with smaller figures, and on the walls dangle plaster life casts of hands the artist used as references. *Andromeda* (1931), a pristine white-marble reclining nude and French's last work, illustrates the artist's proficient modeling of the female form. The statue rests on a railroad flatcar that can be pushed on a length of railroad track through a set of double doors and into the open air. The artist ingeniously devised

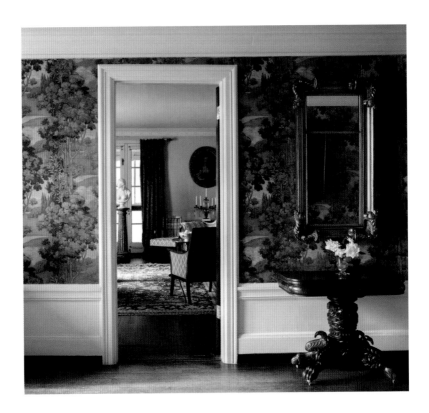

this mechanism to consider how natural light and perspective affected his works once outdoors.

One end of the studio leads to an expansive covered piazza whose elevated prospect receives the cooling afternoon breeze off the Housatonic River, even on the hottest days of summer, and affords sweeping views of Monument Mountain. At the other end is an extensive formal garden of French's design. This outdoor room, with a pergola at one edge, features delphinium, hollyhocks, boxwood, hydrangea, and peonies. The garden was a frequent setting for summertime entertainments with family and friends, including Edith Wharton, Henry James, and Isadora Duncan.

French again engaged Bacon to build the family's home when the original farmhouse proved insufficient. The stucco-clad residence incorporates Georgian, Colonial Revival, and Italianate influences. Inside, forest-patterned tapestry wallpaper echoes the Berkshire setting, and

corncob capitals supporting the upstairs landing nod to American bounty. The furnishings and decor are a combination of the sculptor's found treasures, family heirlooms, and paintings by French and his artist colleagues. The name Chesterwood derives from the town of Chester, New Hampshire, where the sculptor's grandparents had a home. Indeed, the parlor at Chesterwood was built to its namesake's exact dimensions, and even includes furnishings from that house.

French sculpted Chesterwood's 122 acres of pasture, formal gardens, sweeping lawns, and woodland walks with the same sensitivity he applied to his monuments. One of the site's more challenging hikes leads to spectacular views of Monument Mountain, and a gentler path offers vistas toward Lee, Lenox, and Stockbridge. The original barn now houses exhibition space, including a collections study gallery displaying more than 150 of French's studies, models, and finished works. Before her death, French's daughter Margaret French Cresson, a sculptor in her own right, opened up Chesterwood to the public in 1955 while she remained living in the residence, ultimately gifting the entire site and its collections to the National Trust for Historic Preservation in 1968.

Down the road from Chesterwood is the Norman Rockwell Museum. In Stockbridge, the famed Red Lion Inn is one of the nation's oldest inns, in continuous operation for more than two hundred years. Across the street at Saint Paul's Episcopal Church is a small bronze cast of French's *Spirit of Life* (1914). A trip to the Frelinghuysen Morris House & Studio in nearby Lenox [p. 56] provides a modernist counterpoint to Chesterwood.

Frelinghuysen Morris
House & Studio

George Lovett Kingsland Morris (1905–1975)
Suzy Frelinghuysen (1911–1988)

92 Hawthorne Street, Lenox, MA 01240
413-637-0166 **frelinghuysen.org**

Abstract pictures do not spring from pure invention but are often linked, however remotely, with the artist's visual surroundings.
—GEORGE L. K. MORRIS

It is possible that Modern art is simply a record of humanity trying to find its way.
—SUZY FRELINGHUYSEN

A mammoth bronze cast of a reclining nude woman titled *La Montagne* (*The Mountain*), sculpted by Gaston Lachaise in 1934, graces the entrance to the property where abstract artists George L. K. Morris and Estelle Condit "Suzy" Frelinghuysen built their modernist home. The house also makes architectural nods to traditional Southwest Pueblo design. Its rectilinear white planes and glass blocks distinguish it from the many Gilded Age mansions that occupy the Berkshires, whose rich woodlands and majestic hills have long appealed to artists and to the wealthy. Both Frelinghuysen and Morris had notable patrician backgrounds and, in fact, built their summer retreat within the Morris family's larger estate, Brookhurst.

A large studio, built a decade before the house and featuring nearly an entire wall of north-facing windows, dominates one side of the structure. Morris conceived this space for himself, modeling it after the Le Corbusier–designed studio of one of his Paris teachers, the cubist painter Amédée Ozenfant. In 1940, a few years after their marriage, Morris and Frelinghuysen designed the house to align seamlessly with the studio, assisted by local architect John Butler Swann, who also shared their interests in Southwest indigenous architecture. To build the house, Morris sold Picasso's *The Poet* (1911) to Peggy Guggenheim for $4,500.

Ample windows throughout flood the house with natural light and highlight the abundance of art that the couple both collected and created for the space. The foyer's elegant marble floor reflects the light streaming through two glass brick columns that flank the doorway, while a graceful curving staircase draws light down from above. For the stairwell, Morris created a fresco of primary colors with deep black accents, capped by curving bands of glass brick.

Both Morris and Frelinghuysen were trained muralists. Their experiments led them to incorporate contemporary materials like corrugated metal and painted glass within the works they installed in their home. A sunken living room harbors a bar ingeniously tucked under the stairs, its shelves still stocked with libations. One side of this room is lined

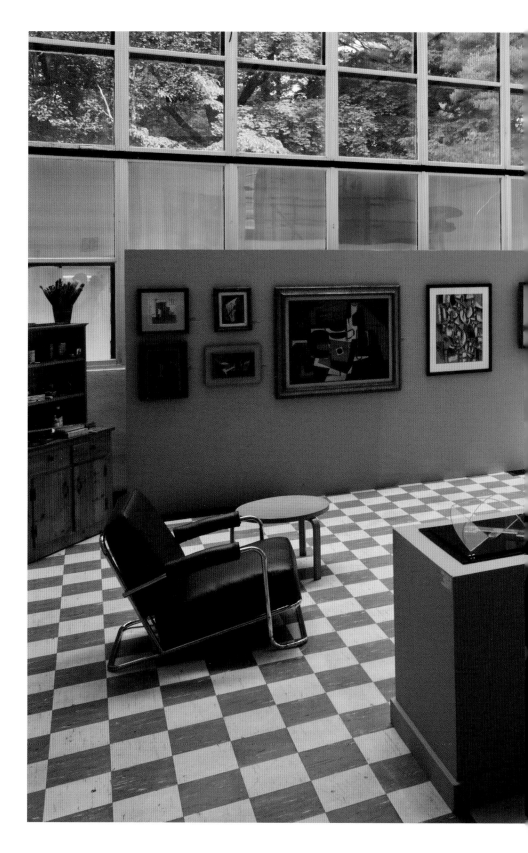

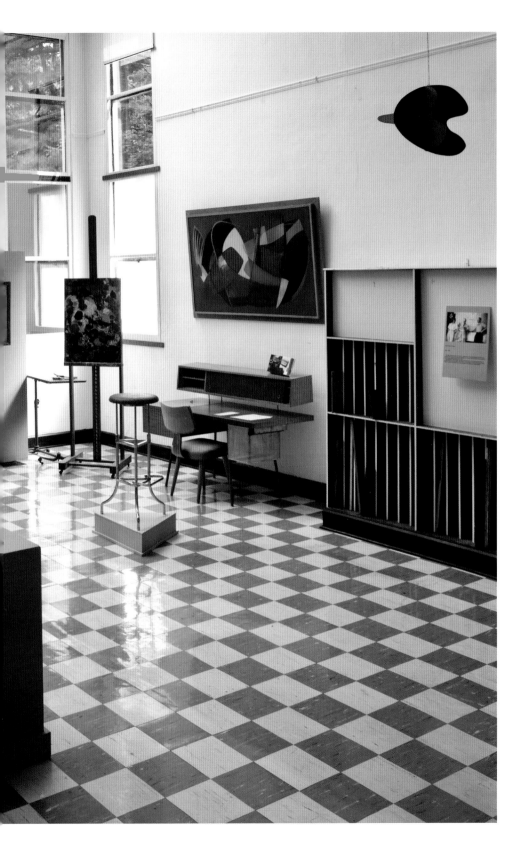

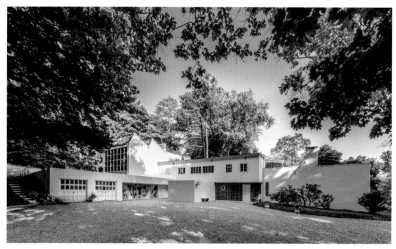

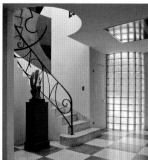
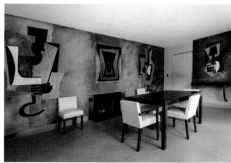

with built-in bookcases, while the other comprises dozens of windows that grant a beautiful view to the lush landscape beyond. A rich, leather-tiled floor provides the backdrop for the art deco furnishings the couple collected, including chairs covered in zebra-print upholstery, mirrored tables, and curving wood consoles. A 1905 claro walnut Knabe piano holds pride of place in a room full of impressive midcentury furniture, decorative arts objects, and design features. Frelinghuysen was an acclaimed opera singer as well as a painter, performing for the New York City Opera under the name Suzy Morris.

The walls abound with works by Frelinghuysen and Morris alongside their stunning art collection, largely acquired in Europe. The collection was originally displayed in a number of family properties: Lenox, their Manhattan apartment, their Paris townhouse, and Morris's

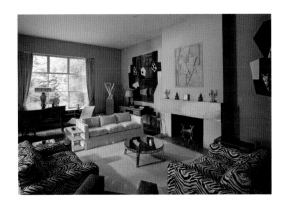

mother's townhouse. It includes works by Henri Matisse; cubist masters Juan Gris and Fernand Léger, with whom Morris studied; Georges Braque and Pablo Picasso, with whom Morris was acquainted; Alexander Calder; and Man Ray, who photographed them both. In the living room, two of Morris's large murals border his marble relief sculpture above the mantel. Frelinghuysen's deep blue and black frescoes enliven the gray walls of the dining room. She also created an illusionistic Italianate mural cycle on one of the walls in her bedroom upstairs, where she painted a window onto a spectacular imagined cityscape. The bathrooms in each bedroom are remarkable for their intact, fashionable Crane fixtures and yellow, teal, and brownish-orange tiles. Morris's own separate bedroom and his adjacent studio are both lined with art. Other accents to the studio's soaring space are its fantastic checkerboard flooring and the small loft with its glass floor.

Frelinghuysen and Morris were key figures in both American and international modern art circles. Morris was an art critic for the *Partisan Review* and was involved in building the Museum of Modern Art's collection. Both were powerful advocates for abstract modes of painting. They frequently entertained guests in the Berkshires, making use of the patios, terraced gardens, and lush landscape of the forty-six-acre property, all now open for exploration.

Visitors should also see The Mount, the Lenox estate of Morris's cousin Edith Wharton. Pass by the Morris Elementary School, adorned by an abstracted mosaic Morris created for the facade. The home and studio of sculptor Daniel Chester French [p. 48] is in nearby Stockbridge.

Saint-Gaudens National Historical Park
National Parks Service

Augustus Saint-Gaudens (1848–1907)

139 Saint Gaudens Road, Cornish, NH 03745

603-675-2175 **nps.gov/saga**

The aim of art is to represent not the outward appearance of things, but their inward significance.
—AUGUSTUS SAINT-GAUDENS

The tranquility of sculptor Augustus Saint-Gaudens's New Hampshire estate—with its view of the majestic Mount Ascutney in the distance—belies the socializing and frenetic creativity that took place here in the heart of the Cornish Art Colony, which included artists, architects, writers, and musicians. By the time Saint-Gaudens—along with his wife, Augusta, and his brother, Louis (a sculptor in his own right)—first came to Cornish in the summer of 1885, he was already an acclaimed virtuoso of civic monuments and portrait sculpture. In Cornish, he expanded his reach. His interests in architecture and gardening flourished, and the result is an estate that is itself a monument to one of America's greatest sculptors.

Saint-Gaudens, along with his French father and Irish mother, emigrated from Dublin to the United States when he was six months old. He returned to Europe in 1867 to train as an artist, first in Paris and then in Rome, where he met Augusta Fisher Homer, an American art student whom he later married. Saint-Gaudens's first major commission, a

monument to Civil War admiral David Glasgow Farragut (1880, Madison Square Park, New York), established his reputation, and he became one of the Gilded Age's most sought-after sculptors. Saint-Gaudens's technical mastery, lyrical compositions, and ability to convey the emotional and psychological characteristics of his subjects made him an ideal artist to meet the post–Civil War era's demand for commemorative monuments. Like the Beaux-Arts buildings being erected at the time, his works drew from classical and Renaissance antecedents and conveyed the aspirational values of the increasingly cosmopolitan republic.

The Saint-Gaudenses came to New Hampshire to escape the oppressive New York City summers. For a number of years they rented the property, which included the brick Federal-style house that had been built in

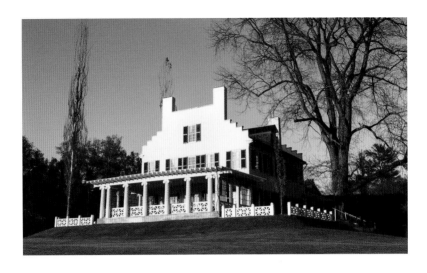

1817 (and which the artist later painted a gleaming white), and the hay barn that Saint-Gaudens used as a studio. After purchasing the estate in 1892, they began transforming it into the cohesively designed environment that it remains. With assistance from architect George Fletcher Babb, the couple added such features as the dormer windows, steps to the gabled ends of the house's roof, and the broad, Ionic-columned porch that affords striking views of the landscape. The house contains much of the couple's art collection, including the tapestries that adorn the living and dining room walls, antiquities, paintings by Augusta Saint-Gaudens, and gifts from noted friends like Stanford White, a frequent collaborator and partner in the legendary architectural firm McKim, Mead & White.

The gardens surrounding the house are the work of Saint-Gaudens, with later alterations by landscape architect Ellen Shipman. Brick walkways connect a series of distinct outdoor spaces, or rooms, that are embellished with casts of the artist's major works (the original monuments can be found throughout the nation). One of the most striking spaces is the Roman-style atrium, where classical colonnades surround a reflecting pool, all bounded by vibrant green grass. At either end of the pool, gilded bronze turtles spout water at blooming lily pads while the sculptor's renowned work *Amor Caritas* (1898) looks on.

The full-scale casts of some of Saint-Gaudens's most lauded works include the monument to Colonel Robert Gould Shaw and the 54th

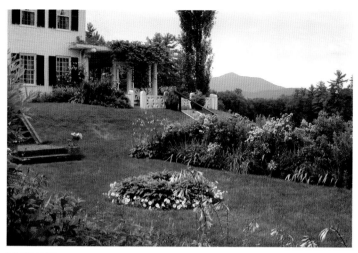

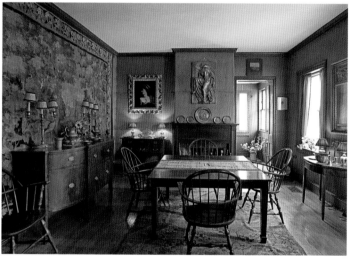

Massachusetts regiment (1897), the Union's second volunteer black regiment of the Civil War and its commanding officer. The original monument, located on Boston Common, is said to have directly inspired the screenwriter of the Oscar-nominated film *Glory*, which traces the heroic efforts of the unit.

The birch allée leads to the Little Studio, built in 1904 with classical features, including a pergola supported by Doric columns that punctuate the striking Pompeian red exterior. A replica of a section of the ancient

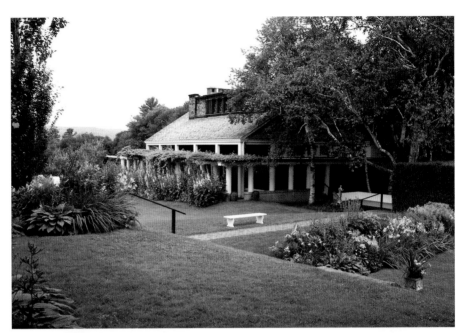

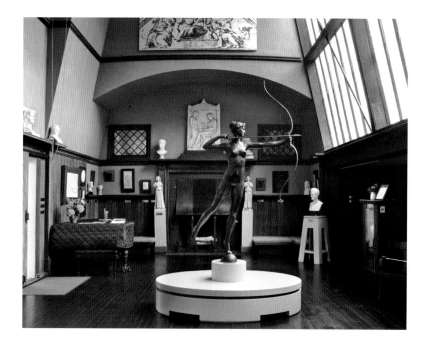

Parthenon frieze embellishes one exterior wall. Inside are examples of the sculptor's portrait reliefs. Dominating the space is a six-foot bronze cast of *Diana* (1893), bow drawn and gracefully balanced on the point of one foot; the original statue once graced the top of New York's first Madison Square Garden. Examples of the artist's early cameo work and his coinage can be viewed nearby in the New Gallery, while changing temporary exhibitions are on display in the Picture Gallery.

The 190 acres of woodlands and fields are open to visitors as well. Among the landscape's delights are a sculpture of the Greek god Pan presiding over a marble pool, a floral garden, heirloom fruit trees, and nearly two miles of hiking trails, one of which leads to the pond where the family swam and ice skated. Scattered throughout the property are mature trees that Saint-Gaudens planted.

Visitors are encouraged to cross the Connecticut River to Windsor, Vermont, via one of the longest covered bridges in the world. Art and conservation fans alike will enjoy the nearby Marsh-Billings-Rockefeller National Historic Park in Woodstock, Vermont, and the Hood Museum of Art at Dartmouth College in Hanover, New Hampshire.

John F. Peto Studio Museum

John Frederick Peto (1854–1907)

102 Cedar Avenue, Island Heights, NJ 08732
732-929-4949 **petomuseum.org**

Where winding Toms [River]
glides gently to the Bay,
On Island Heights—a cottage may be seen
There artist lived—of unassuming way,
In snug retreat did pleasures know serene.
—SAMUEL CALLAN, FRIEND OF JOHN F. PETO, EXCERPT
FROM A POEM WRITTEN IN MEMORIAM

John Peto, a still-life painter who worked in a *trompe l'oeil* (illusionistic) style, reveled in boldly saturated colors and adorned his Victorian home with them inside and out. Walking through its rooms offers an opportunity to experience the inspiration that Peto found every day in the profusion of lush yellows, blues, reds, and greens. The reproductions of his paintings on display reveal that the same colors often appear in his work. The combination of original furnishings, objects, and artwork against this vibrant backdrop offers unique insight into Peto's creative process and means of expression.

After attending the Pennsylvania Academy of the Fine Arts in his hometown of Philadelphia for a year, Peto relocated in 1889 to Island Heights, where he'd spent summers with his family as a boy. Peto studied

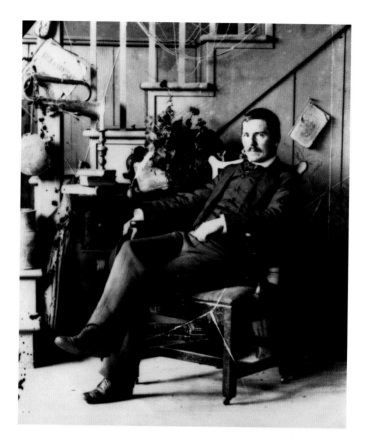

alongside his friend and mentor William Michael Harnett, who became an acclaimed *trompe l'oeil* painter. Despite continued artistic ties to Philadelphia-based artists and exhibitions at the academy, Peto increasingly painted in relative obscurity in Island Heights, where he pursued his art with intensity until his death in 1907. Over the next four decades, he all but slipped out of history; many of his unsigned works were forged with Harnett's more sought-after signature to increase their value. However, in 1949, a journalist researching Harnett discovered the truth, and today major museums nationwide include Peto's works among their collections. (Twentieth-century masters Jasper Johns and Roy Lichtenstein both paid homage to Peto in their works.)

Peto designed the stately two-and-a-half-story Shingle-Style home for his family, where they enjoyed a modest but convivial life. The year

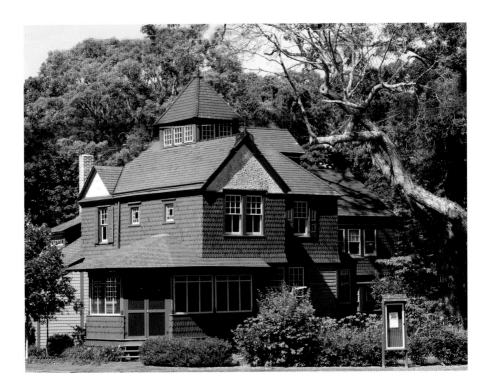

after the house was completed, the artist added a large room that doubled as his studio and the family's dining and entertaining space. The barn—a play space for his daughter, Helen—and flower gardens followed. Although Peto continued to paint and sold works largely to local clients, he often relied on other means to sustain his family, including bartering paintings for goods and services and playing the cornet at a local religious revival (Peto was an accomplished musician).

The house remained in the Peto family for 115 years until a benefactor purchased it in 2005 and it became a museum. Through extensive research and study of physical evidence (including analyzing sixty-odd layers of paint), architectural features such as wooden roof shingles, the screened-in porch, and dormer windows—and even the artist's "Peto Studio" sign—have all been re-created or returned to their former glory. The original furnishings and small objects that grace the rooms often found their way into the artist's compositions: ginger jars, candlesticks, and Peto's own beloved cornet all make appearances. The hooks in the

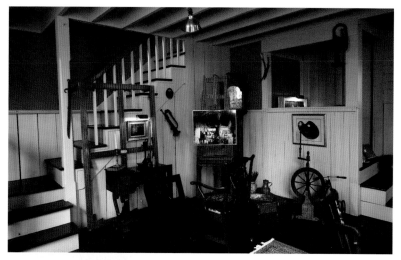

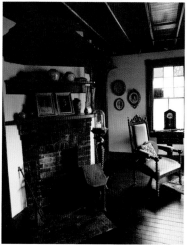

studio's rafters once supported a swing for Helen that Peto installed so he could paint with her playing by his side. Also on display are the painter's studio chair, a Chippendale that he altered by adding casters, and the impressive Colonial-era grandfather clock that Peto augmented with a *trompe l'oeil* design.

The home of John Peto embodies the life and work of an artist who chose to live on his own terms, emphasizing family, retreat, and spiritual renewal.

Alice Austen House

Alice Austen (1866–1952)

2 Hylan Boulevard, Staten Island, NY 10305

718-816-4506 **aliceausten.org**

*I am happy that what was once so much pleasure for me turns out
now to be a pleasure for other people.*
—ALICE AUSTEN

A storybook cottage rests on a slight rise on Staten Island, its gardens
and sweeping lawns leading to breathtaking views of New York Harbor
and the Narrows, a bay bisected by the impressive Verrazzano-Narrows
Bridge. Here the unconventional life of Alice Austen, one of the coun-
try's groundbreaking photographers, unfolded. Austen spent almost
her entire life at the seventeenth-century Dutch house known as Clear
Comfort, moving in with her mother's prosperous family after her father
abandoned her and her mother when she was an infant. She later shared
Clear Comfort with her partner, Gertrude Tate, a kindergarten teacher
and dance instructor from Brooklyn, despite both families' disapproval of
their five-decade relationship.

The cottage was expanded several times, most notably by Austen's
grandfather, who purchased it in 1844 and added the Victorian and
Gothic Revival touches that remain. A gracious, long porch faces the
water, and the high, shingled roof is bordered with overhanging eaves
and gingerbread trim. The interior reflects the family's refined tastes:

nineteenth-century highly decorative wallpaper, porcelain displays, fine built-in features, and family mementos. All have been re-created here, with the help of Austen's photographs, to convey both life in the period and Austen's experiences. Installations highlighting her images and those of modern-day photographers are also featured.

An uncle gave Austen her first camera when she was ten. Another uncle, a chemist, taught her the technical aspects of producing images from her glass plate negatives. Both men helped her build a tiny darkroom in an upstairs closet, which visitors can see today. In Austen's era, photography required considerable physical effort from the photographer to handle the heavy gear, and patience on the part of the sitters to keep motionless for the necessarily long exposures. Because the house had no running water, Austen washed her prints outside. Her faithfully recorded notes document dates, weather, lens type, exposures, and other technical aspects of her work.

Austen's life reflected both her privilege and her ardent nonconformism. She appeared in the elite *Social Register of New York*, traveled

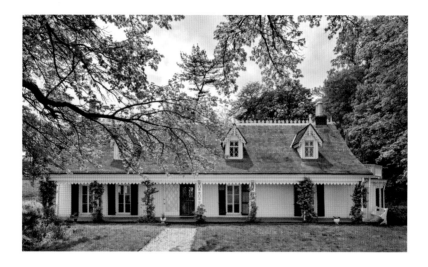

abroad, and belonged to the local bathing and tennis clubs. Her financial means also allowed her to pursue photography without the need for an income; being a "working" photographer would have been untoward for a woman of her class. Nevertheless, she approached her art with professional seriousness. An avid gardener, she designed the landscape at Clear Comfort and founded the Staten Island Garden Club, suitable pursuits for women at the time. Yet the athletic Austen, who began Staten Island's first bicycle club, cut a peculiar figure when she cycled into New York donning a corset and bustle, equipment in tow, to capture photographs of people, places, and circumstances so distinct from her own life.

She produced thousands of images, an astonishing number given photography's technical limitations. Her subject matter was vast, ranging from intimate scenes of friends and family to frank compositions of quarantined immigrants and candid depictions of the everyday lives of newspaper boys, shoeshine "bootlicks," and cart vendors in lower Manhattan (p. 75, below right). Her camera and hundreds of photographic prints made from original negatives are on view at Clear Comfort.

Austen lost everything in the 1929 stock market crash. Forced to sell her home and belongings and legally denied the right to live with her partner, Tate, by relatives, she later declared herself a pauper and moved into the local poor house. Tate remained her devoted companion and frequent visitor. Austen asked a friend from the Staten Island Historical

Society to take her glass plate negatives for safekeeping. These were redis-covered a year before her death, and Austen attended the subsequent exhibition held in her honor. Proceeds from the publication of this work allowed her to live out her final days in a private nursing home. Austen is buried in her family's plot at Staten Island's Moravian Cemetery. She and Tate wanted to be buried together, but their families denied their wish.

Clear Comfort, saved from demolition with the help of a group of friends and advocates that included photographer Berenice Abbott and architect Philip Johnson, opened as a museum in 1985. In 2017, the house was designated a National Site of LGBTQ History. Visitors to Clear Comfort can take the Staten Island Ferry, one of the last vestiges of the complex ferry system in use before the construction of the city's bridges to its outer boroughs. The ride offers superb views of the Statue of Liberty and the lower Manhattan skyline.

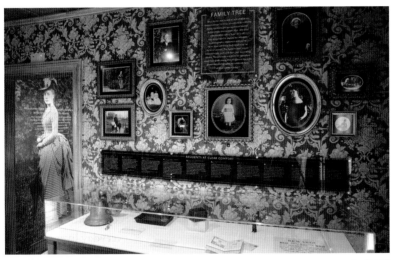

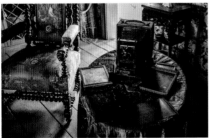

Arthur Dove / Helen Torr Cottage
Heckscher Museum of Art

———

Arthur Garfield Dove (1880–1946)
Helen Torr (1886–1967)

Arthur Dove / Helen Torr Cottage, 30 Centershore Road, Centerport, NY 11721

Heckscher Museum of Art, 2 Prime Ave, Huntington, NY 11743

631-351-3250 heckscher.org/collection_dove_torr

This site can be visited only by special appointment.
Please call in advance to arrange.

I should like to take wind and water and sand as a motif and work with them, but it has to be simplified in most cases to color and force lines and substances, just as music has done with sound.
—ARTHUR DOVE

I have the feeling I can paint now.
—HELEN TORR

Arthur Dove and Helen Torr spent many of their early years together living on a boat, sailing in Long Island Sound. The transient nature of that life, with its lack of attachment to material things and its sense of powerlessness against an unpredictable and unforgiving Mother Nature, appealed to them. But most of all, they loved the water and the light.

After a number of years spent in upstate New York, the lure of the seaside brought the two artists back to Long Island in 1938. At this time, Centerport was dotted with only a few small cottages. They settled in a one-room cottage, a former post office and general store that was only slightly larger than their boat had been, on the banks of Titus Mill Pond. The pond was created in 1774 when a portion of the harbor was dammed, and this unique ecosystem is preserved today by a set of tidal gates,

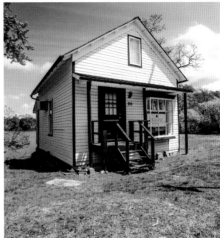

providing habitat for waterfowl and a spawning ground for fish and shell-fish. Here Dove and Torr spent the remainder of their lives, in their humble abode overlooking the water.

Torr, nicknamed "Reds" for her vibrant auburn hair, and Dove met in Connecticut in 1919. Both left their spouses to be together, eventually marrying in 1932 in a city hall ceremony purportedly featuring a ten-cent ring. They planned to accomplish a great deal in their cottage home, which they purchased for about $900. Plans changed, however, when Dove was stricken and became encumbered by a series of illnesses. Retreating from New York City and his artist colleagues including Alfred Stieglitz, Dove quietly focused on his painting while Torr set aside her own art practice to take care of him. After Dove's death in 1946, Torr remained in the house until her own death in 1967.

In 1998, the Heckscher Museum of Art acquired the Dove/Torr Cottage and began ongoing restoration work. Rustic stairs lead to the front door, and historic photographs indicate this is likely how the house looked when the couple purchased it. Additional evidence suggests that the couple built a now-lost enclosed porch, which would have allowed them to enjoy lakeside living despite the insects that inevitably come with such a location. Inside, the chair rail moulding seems unnaturally low, a result of progressively raising the floorboards in an attempt to stave off constant flooding on the first floor.

Even with the interior unfurnished, it is difficult to imagine how two artists might have lived and worked in such a small space. What little embellishment remains inside reflects the building's practical origins. Restoration revealed original wainscoting behind some of the wallboard that had been installed in opposing directions and with mismatched panels. A small bay window on the front of the building would have been the perfect nook for a display when it was a general store. A metal spiral staircase leads to the loft above, its back wall taken up by a trio of glass windows offering a picturesque framed view of the pond. Dove created some of his most important work in this unassuming space, inspired by the light effects, weather patterns, and ocean tides just beyond.

The modesty of the cottage is a reminder that among artists of great influence are those who endured the very real economic hardship that pursuing a career in art can bring, and that groundbreaking works of art can emerge from austere surroundings.

Edward Hopper House Museum & Study Center

Edward Hopper (1882–1967)

82 North Broadway, Nyack, NY 10960
845-358-0774 **edwardhopperhouse.org**

In every artist's development the germ of the later work can be found in the earlier. What he was once, he always is.
—EDWARD HOPPER

The raking light that streams through the large, double-sash windows of the boyhood home of painter Edward Hopper is the same that the artist beheld growing up and that he replicated in works again and again as an adult. This signature Hopper light, which he brought to an evolving range of subjects and settings, at once creates a crystalline atmosphere and evokes emptiness and isolation. Hopper once proclaimed, "There is a sort of elation about sunlight on the upper part of a house," and here that sentiment is unmistakably realized.

Hopper's maternal grandfather built the home uphill from the western banks of the Hudson River in the bustling town of Nyack. The site allows visitors to experience the artist's genesis, providing a prologue to the mastery that was to come and that earned Hopper the rare accolade of his own adjective, "Hopperesque," coined to denote his signature combination of atmospheric, emotional, and compositional elements that conjure precision, anonymity, and alienation.

Originally built in the Federal style in 1858, the house was expanded and ornamented loosely in the Queen Anne style popular at the turn of the century. Inside, the home retains elements of both styles: the classic simplicity of the mantelpiece, the faithfully restored plaster molding, and the wide floorboards of the original home as well as the ceiling of polished wood and a tiled fireplace from an addition built the year of Hopper's birth. Many of these architectural details appear in the artist's mature works, created long after Hopper had moved from Nyack. Today, most of the rooms are not furnished, but Hopper's art materials, the wooden bicycle he rode around town, and a rotating selection of early drawings and ephemera are on display. The downstairs rooms feature exhibitions and works of contemporary artists that reflect Edward Hopper's legacy.

Hopper's bedroom upstairs was also his first studio. The room has been re-created based on the artist's paintings and engravings of the space. Such small bedroom studios were the first working spaces for

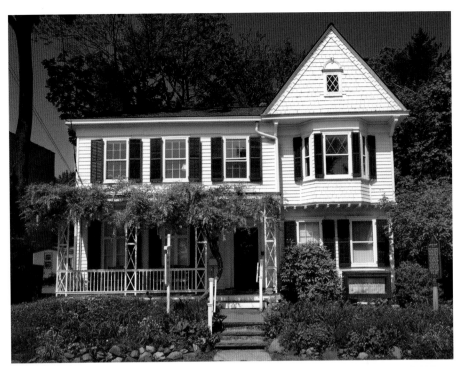

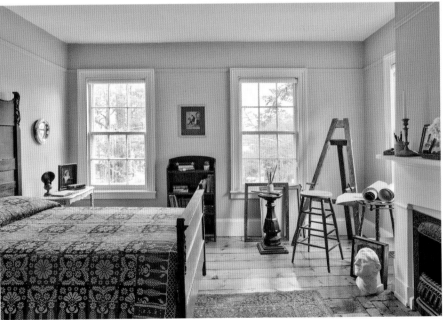

many artists, whether they went on to fame or struggled throughout their careers. The upstairs hallways display more boyhood treasures, as well as cartoon drawings passed between Hopper and his wife, Josephine Nivison, whose own artistic practice was subsumed as she managed his career. This form of nonverbal communication, which often recorded rifts in their marriage, demonstrates what Hopper meant when he said, "If you could say it in words, there would be no reason to paint."

No visit to the Edward Hopper House is complete without an excursion to take in the larger environs of Hopper's youth. He loved boats and the water, and often made his way down to the bustling waterfront, a thriving boat-building center during his boyhood, where he spent hours at the docks and shipyards. Such scenes appear throughout Hopper's work, from his early sketches of riverside scenes to the boats and seascapes of his mature work. To the north is the Palisades' Hook Mountain (now a state park), which Hopper depicted in several paintings. The village streets and storefronts afford glimpses of subjects that Hopper recycled and reinvented decades later. A walking tour of Edward Hopper's Nyack is available at the museum and on the museum's website.

Hopper lived in the house until 1910. In 1913 he moved to the apartment and studio at 3 Washington Square North that he occupied the rest of his life. The apartment has been preserved and is now part of New York University. Across the river from the Hopper House and to the north is the home and studio of industrial designer Russel Wright [p. 90].

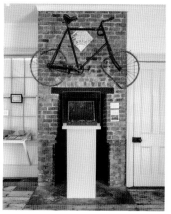

Judd Foundation

———

Donald Clarence Judd (1928–1994)

101 Spring Street, New York, NY 10012

212-219-2747 **juddfoundation.org**

*I spent a great deal of time placing the art and a great deal
designing the renovation in accordance. Everything from the first
was intended to be thoroughly considered and to be permanent.*
—DONALD JUDD

Donald Judd was an artist, furniture designer, and art critic. Among his
most important accomplishments are his efforts to revolutionize how
contemporary art is displayed. He advocated for permanent displays of
works, although because of the limiting politics and curatorial practic-
es of museums, he primarily advocated for displaying works outside of
the context of museums and commercial galleries. Without the imposed
narratives placed on them by more traditional exhibition venues, the
works would stand for themselves on the strength of their formal quali-
ties. He also pioneered a new vocabulary, still in use, for describing sculp-
tural forms, one that focuses on the formal and built attributes of an
artwork rather than more traditional associations with figure or narra-
tive. As much as he disliked and disregarded the term "minimalism" to
categorize and describe art, it is the art movement most associated with
his work, referring to art from the postwar period that features abstract
geometrical forms.

In 1968, Judd spent almost $70,000 to purchase a five-story former sewing factory in the SoHo neighborhood of Lower Manhattan to serve as living and working space. It became a laboratory (of sorts) to explore his larger ideas. He renovated the building floor by floor, transforming it into an integrated environment where he lived, worked, and on occasion taught. Integral to his overall use of the restored space is the permanent installation of his collection of artworks and objects in a manner consistent with his ideals.

By the time Judd bought 101 Spring Street, he had become an influential presence in New York's art scene, notably with the publication of his groundbreaking 1965 essay, "Specific Objects," in which he advocated for a new type of three-dimensional work that, although it might resemble painting and sculpture in some respects, was neither. The fluorescent light sculpture by Dan Flavin in Judd's bedroom (see pp. 88–89) is one example. The interior of 101 Spring Street, with its open floor plans and high ceilings, allowed Judd to experiment with permanent installations of large-scale abstract work in a nontraditional setting that facilitated the interplay of artwork and environment.

The exterior of 101 Spring Street, a soaring expanse of windows, overlooks the intersection of Spring and Mercer Streets. Delicate cast-iron columns, part of the building's industrial frame, punctuate the monumental panes of glass. Constructed in 1870, the building represents the height of aesthetic sophistication and technological advancement

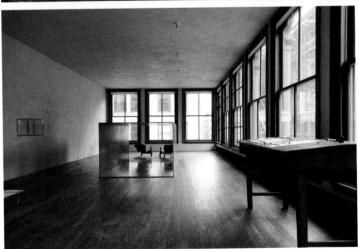

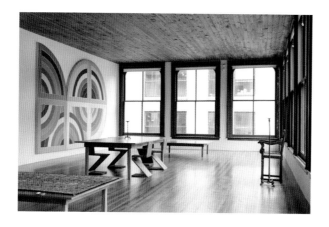

of the era. After the Civil War, large manufacturers moved to the neighborhood, and cast iron became their preferred building material. It is at once incredibly strong, lightweight, and inexpensive and is easily molded and cast into any decorative motif. When Judd moved into the neighborhood—which at the time was so undervalued that the city had planned to put an expressway through it—he was part of a group of artists who recognized the value of the historic buildings. Flooded with natural light, the spaces were ideal for studios. Today, Soho boasts the largest collection of cast-iron architecture in the world, which visitors should explore.

Visitors to Spring Street can experience the results of Judd's investigations throughout the building's five floors, which remain as Judd arranged them in his lifetime. Everywhere art, urban views, and the mundane (though aesthetically pleasing) necessities of home life—stoves, beds, sofas—create compositions against the backdrop of the distinctive historic structure. Judd's own work resides alongside his collection of iconic designs and art, including works by contemporaries like John Chamberlain, Claes Oldenburg (see pp. 88–89), and Frank Stella (above). On the second floor is furniture designed by Judd; a large table evokes the lively dinners he was known for hosting. The third-floor studio, which includes a desk, a chair, and a rug with headrest, testifies to the fact that art making is both a mental and a physical process. 101 Spring Street is an art installation writ large, set within an active living space. Judd's home and studio in Marfa, Texas, are also open to the public [p. 212].

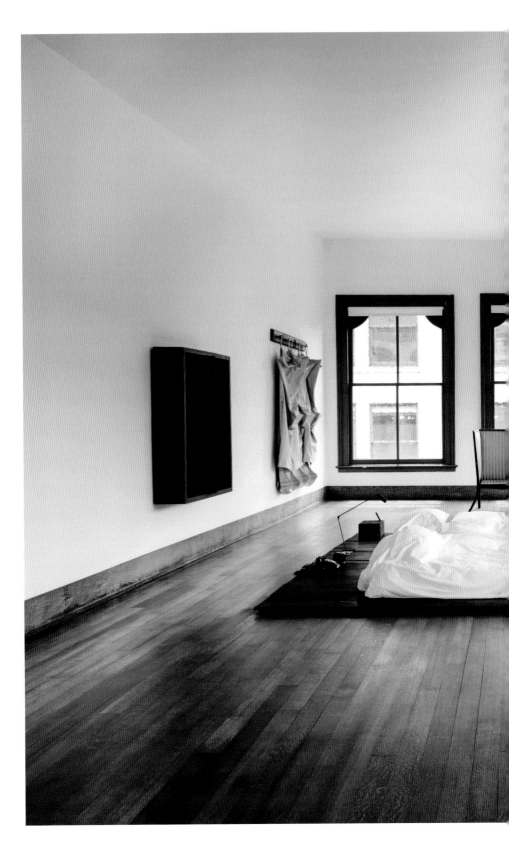

Manitoga / The Russel Wright Design Center

Russel Wright (1904–1976)

584 Route 9D, Garrison, NY 10524

845-424-3812 **visitmanitoga.org**

I hope you will take joy from my home.
—RUSSEL WRIGHT

Russel Wright, the famed industrial designer of the iconic "American Modern" tableware, transformed an abandoned quarry in Garrison, New York, into an arresting synthesis of modern architecture and nature he called Manitoga, after the Algonquin word for "place of great spirit." He and his wife and artistic collaborator, Mary Einstein Wright, originally purchased the property in 1942. In 1950 they published the best-selling *Guide to Easier Living*, a manual for maintaining an inviting and efficient home that emphasized an informal way of living for a newly suburban American public. After his wife's death in 1952, Wright increasingly retreated from New York City to this seventy-five-acre parcel located less than one hour north of Manhattan. Building on the principles set forth in *Guide to Easier Living*, Manitoga became the most personal project of Wright's life, and the one in which he took the most pride.

Wright worked with architect David L. Leavitt to create the Japanese-inspired low-slung house and studio connected by a wood-beamed pergola, all within a glorious sylvan setting. The rectilinear house, made of wood, stone, and glass, nestles like a jewel within the quarry wall.

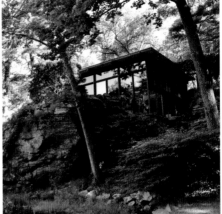
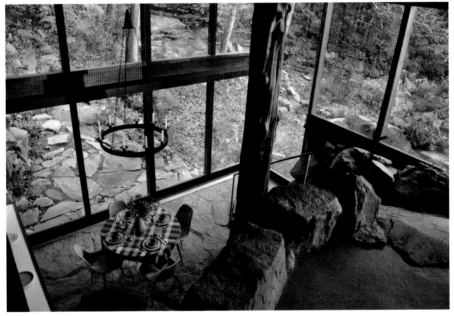

The contrast between the geometric house and its organic surroundings is at times striking, and at others harmonized by green roofs and hanging vines. The rooms are arranged at different levels to conform to the contours of the landscape, from the kitchen and dining area at the lowest level, to the open living spaces above, and finally to the bedrooms and bathrooms at the top level, where the main entrance is found.

The floor-to-ceiling windows of the open living and dining rooms provide magnificent views of the quarry and allow light to flood the space. Indeed, the interior is a testament to Wright's desire to bring the outside in: the exterior rock terraces extend into the house, a stone staircase and stacked boulders form a partial wall to mark the boundary between the living and dining rooms, and a cedar trunk that is both decorative and structural stands in the center of the open space. Throughout are examples of how Wright blended natural elements with experimental materials. He covered the living room walls with dark green plaster and embedded them with hemlock needles to produce a feathered texture, created decorative screens by combining butterfly and floral specimens with acrylic sheets, fashioned doorknobs out of rounded stones, transformed leaning branches into towel racks, and covered a door entirely in birchbark.

Wright also experimented with natural and artificial lighting to achieve the effects he sought, drawing on his early experience as a set designer. He wanted the atmosphere of the house to change with the seasons, so the furnishings and even the cabinet panels were rotated accordingly: warm, vibrant colors for autumn and winter and a serene, cooler palette for spring and summer. Both the home and studio are replete with examples of the furniture and household goods Wright designed.

The landscape was as important to Wright and as carefully devised as the architecture. He laid out two footbridges over the waterfall positioned to intensify its volume when standing above and below it. A woodland path lined with ferns and other native species borders the quarry edge and provides dramatic views of the house. The house earned the moniker Dragon Rock when Wright's daughter compared one of the outcroppings at the water's edge to a dragon lowering its head to drink. The extensive trails beyond the house and quarry lead to footbridges over streams, a wildflower meadow, a birch grove, and opened vistas with stunning views of West Point and Storm King Mountain and glimpses of the Hudson River. Those who are more adventurous can trek to the highest point, known as Lost Pond, where a remote, spring-fed pool awaits.

Visitors can extend their visit to the area by traveling across the bridge to Bear Mountain State Park or Storm King Art Center. Directly north of Manitoga is Boscobel, a Federal-style home and estate offering magnificent views of the Hudson River Valley. Farther north is Dia:Beacon, in Beacon, which houses modern and contemporary works by masters such as Andy Warhol, Agnes Martin, and Dan Flavin.

Olana State Historic Site
NYS Office of Parks,
Recreation and Historic Preservation/
The Olana Partnership

Frederic Edwin Church (1826–1900)

5720 State Route 9G, Hudson, NY 12534

518-751-0344 **olana.org**

I would rather reside on a mountain…from its eminence you take
in its beauties only.
—FREDERIC EDWIN CHURCH

Frederic Edwin Church was the premier landscape artist of the Hudson River School, the nation's first art movement. He is best known for his monumental paintings, many resulting from explorations abroad, that brought him both unprecedented critical acclaim and astonishing financial success and made him the most famous artist of his age. The name Olana, chosen for his home overlooking the Hudson River, is thought to reference an ancient Persian fortressed city above a fertile river valley. Olana conveys the same grand theatricality that marks Church's iconic canvases. Of it the painter once exclaimed, "About an hour south of Albany is the Center of the World—I own it."

In 1845, as a teenager learning his craft, Church sketched the view looking down to the Hudson River from what would become Olana's southern slope. At the time, he was studying with Thomas Cole, father of the Hudson River School, at his home in Catskill, New York [p. 114]. Cole had suggested that the pupil travel across the river to sketch from a different vantage point. Church would later return to the same hillside to

select a site for his home. Thus, the landscape that Olana inhabits is the site of Church's artistic birth.

Every aspect of Olana's design—architecture, decoration, and landscape—bears Church's imprint. Its natural splendor, evident from the moment visitors enter through the winding uphill road, suggests the majesty of an iconic Hudson River Valley landscape painting. The artist painstakingly designed the 250-acre landscape, including the five miles of historic carriage roads with views over four states, and

augmented this working farm over the course of forty years. Along the drive that meanders through the grounds, the Churches' first home appears on the right, just beyond a series of red farm buildings: a small yellow cottage likely designed by architect Richard Morris Hunt for the newlywed Isabel and Frederic Church, where the couple lived for the first decade of their marriage. Beyond the groves of trees and wildflower-flecked fields lies a breathtaking panorama of views of the Hudson River and both the Berkshire and Catskill Mountain ranges. The composition culminates in the edifice that the artist began building in 1870 upon returning from an eighteen-month sojourn to Europe and the Middle East. This home was inspired by Persia and other Middle Eastern cultures, as well as Church's imagination.

Consulting with architect Calvert Vaux, the artist intended the new house not only to contain modern conveniences such as gas light, centralized heat, and indoor plumbing, but also to represent his personal aesthetics. Every facet of the house's exterior and interior contains Persian-inspired applied decoration designed by Church, as hundreds of extant drawings attest. The imposing limestone and brick edifice climaxes in a bell tower that affords a consummate vista of the mighty Hudson River.

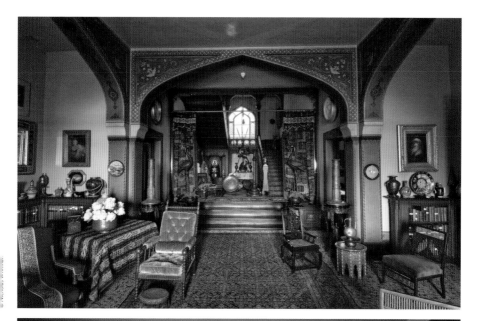

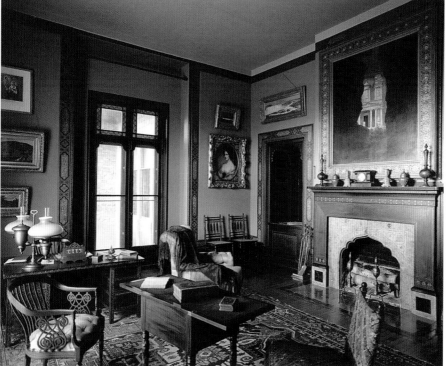

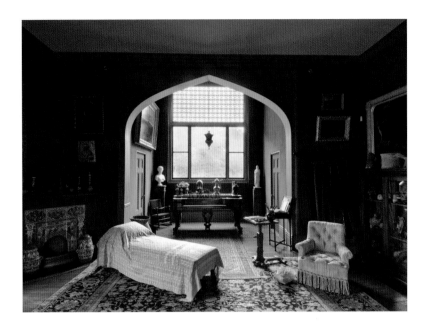

Every window is designed to be as unique as the view it offers. In the central Stair Hall is a sizeable window created entirely from intricately cut paper pressure-fit between sheets of amber and clear glass, meant to evoke the warm ambient light the painter witnessed filtering through the screen-filled homes of the Middle East, in particular those in Beirut and Damascus. Complementing this effect, the adjoining Court Hall displays the myriad objects he amassed from all over the world over many decades, displayed in what he deemed to be the most pleasing artistic arrangement. Works by Church adorn the walls, including many studies for major masterpieces that now reside in museums around the world. At one end of the house is a painting studio that he began designing in 1888 and completed in 1891. At the other is a dining room densely arranged with the artist's collection of old European masters. Visitors in Church's era described traveling through the property in carts pulled by imported Syrian donkeys to arrive for dinner surrounded by these works. The visual feast continues on the second floor, with furnished bedrooms embellished by delicately designed wallpaper, gilded picture rails, and decorative woodwork. Today several of the rooms are used as a gallery space dedicated to annual rotating exhibitions.

That Olana has survived is an achievement that began with the efforts of art historian David Huntington. On learning that the last Church family member had died in 1964 and that the property and its contents would be sold, Huntington convinced the heir to give him time to organize an effort to preserve Olana and its treasures. After a two-year nationwide fundraising drive, New York State stepped in with a legislative bill to close the financial gap and steward the property. Today, Olana is operated by The Olana Partnership in a cooperative agreement with New York State and stands as one of the most intact, and most visited, artists' residences in the world.

Pollock-Krasner House
and Study Center
Stony Brook University

Lee Krasner (1908–1984)
Jackson Pollock (1912–1956)

830 Springs-Fireplace Road, East Hampton, NY 11937
631-324-4929 **pkhouse.org**

*I don't look at the view, I watch it. The land is alive, tells you
things when you let it.*
—JACKSON POLLOCK

*One thing Jackson and I had in common was experience on
the same level—feeling the same things about the landscape,
for instance, or about the moon....I had my own way of using
that material.*
—LEE KRASNER

Dense swirls of color—some thin and frothy as spiderwebs, others thick
and solid as ropes—spin endless rhythms of black, white, red, and yel-
low across the floorboards of the Long Island studio that Abstract
Expressionist Jackson Pollock (born Paul Jackson Pollock) occupied
during the most innovative period of his career. Many of his and Lenore
"Lee" Krasner's artistic innovations were directly inspired by their home
environs. Pollock laid canvas onto the floor of the former barn and
then poured and dripped paint onto it, inevitably spilling some over
the edges. In 1953, the studio floor was covered with Masonite and was
rediscovered only when Stony Brook University became the property's

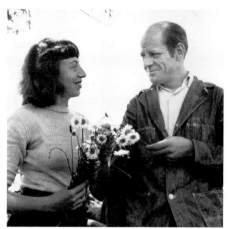 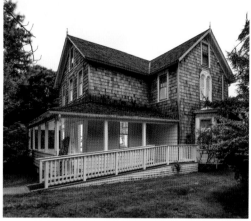

steward. Objects are embedded in the paint on the floor's surface, as are Pollock's footprints. Sharp lines define where an edge of paper or canvas once lay, and scholars have been able to link areas of the floor to specific masterpieces.

The walls bear other gestural marks that are the remnants of Lee Krasner's action paintings, in which she used arc-like movements to allow the paint to land on her working surface and beyond. Krasner occupied this studio in the decades after Pollock's death in 1956. In the anteroom are painting materials belonging to both artists, including a row of Pollock's cans of house paint and brushes and Krasner's paint-spattered boots and stool.

The property is where much of the drama that marked Pollock and Krasner's life together occurred, but it also is where they enjoyed supreme moments of creativity, entertained friends, gardened, and made the property their own. The couple initially sought the quiet hamlet of Springs, beyond the posher Hamptons, as a winter retreat from New York City and the demands of increasing fame, but at Pollock's urging, they decided to try staying year-round. A loan from patron Peggy Guggenheim allowed them to purchase the one-and-a-quarter-acre property, where they moved only eleven days after marrying in 1945.

From the door of the studio's anteroom, grassy slopes lead down to the salt marsh and Accabonac Creek beyond. Pollock went so far as to move the building to ensure that the tranquil view was unobstructed.

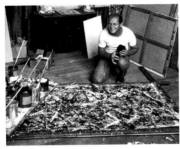
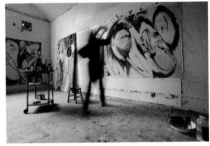

A pile of glacial boulders on the lawn marks the view toward the marshes. The smell of salt and the sound of birdlife often punctuate the air.

Closer to the road is the 1879 cedar-shingled house, which had no plumbing and only a coal stove for heat when the couple purchased it. Initially, Krasner used the back parlor as a studio and Pollock painted in an upstairs bedroom illuminated by northern light. After the barn became Pollock's studio, Krasner took over the upstairs studio. Downstairs, Pollock tore down a series of interior walls to create a combined living and dining space adjacent to the front parlor.

Pollock and Krasner, as most artists, lived with their art, so the rooms were painted white (like contemporary art galleries) to show off their artwork. Today, prints by both artists are on view, and an early painting by Pollock, *Composition with Red Arc and Horses* (ca. 1938), hangs over the kitchen cupboard.

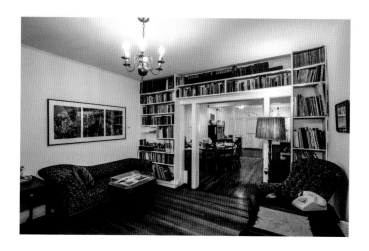

The house retains the couple's furnishings and personal items, like floor-to-ceiling bookcases brimming with books and jazz records and a hi-fi turntable and amplifier. The eclectic furniture includes pieces given to them by friends and those like the Victorian sofa that Krasner purchased secondhand. The sizable dining-room table, made by an important English furniture maker, could accommodate twelve and was the centerpiece of many gatherings that Krasner hosted after Pollock's death.

The upstairs bedrooms display many personal items, including the shells and stones that Krasner enjoyed collecting from the beach, alongside more exotic objects she acquired. All these items contribute to the sense that although the couple's relationship was fraught with tension, they also found enjoyment and love here. Friends recall that rather than feeling isolated, the property radiated a relaxed, neighborly atmosphere.

Because Krasner understood the importance of Pollock's achievements, she carefully managed his estate and tirelessly promoted his work after his death. She also ensured his legacy after her own passing by preserving their Long Island home and establishing a foundation to support future generations of artists.

The two are buried in nearby Green River Cemetery; glacial boulders such as those on their own property mark their graves. The studio of nineteenth-century painters Thomas and Mary Nimmo Moran [p. 110] in East Hampton village is an excellent counterpoint to the Pollock-Krasner experience.

The Renee & Chaim Gross Foundation

Chaim Gross (1902–1991)

526 LaGuardia Place, New York, NY 10012

212-529-4906 **rcgrossfoundation.org**

Art gives me happiness, and when I'm not working I'm miserable.
—CHAIM GROSS

The life of sculptor Chaim Gross, whose townhouse in the heart of New York's vibrant Greenwich Village was his last residence and studio, is an immigrant's tale of hard work, talent, and luck. Born in 1902 to a Jewish family in the Austro-Hungarian Empire (in what is now Ukraine), he immigrated to New York in 1921 to escape the ravages of World War I and the ensuing wave of anti-Semitism. Gross had already completed some preliminary art study in Europe, and after his arrival, he worked as a delivery boy, barely eking out a living. "I just wanted enough work to keep me alive while I made sculpture," he remarked of those early years. He studied at several New York art schools, including the Art Students League, Educational Alliance Art School (where he would later teach), and the Beaux-Arts Institute of Design. Gross also participated in the Depression-era Public Works of Art Project, teaching and creating art for public spaces. In 1928 he met Renee Nechin, a politically active Lithuanian immigrant and literature student at Brooklyn College. She not only became her husband's muse and model, but also his manager and a steadfast champion of his work. They had two children, engineer

Yehudah Gross and artist Mimi Gross. Chaim Gross credited his wife with being largely responsible for his success.

In the 1930s, Gross gained attention for his abstracted figural wood sculptures. Rather than searching out the perfect piece of wood for a predetermined form, Gross adopted an opposing approach known as direct carving: allowing the piece of wood, through its idiosyncratic features, to suggest the sculpture's form. Both the Metropolitan Museum of Art and the Whitney Museum of American Art acquired some of his works after his 1932 debut solo exhibition. Six years later, the artist was the subject of filmmaker and historian Lewis Jacobs's twenty-eight-minute film *Tree Trunk to Head*, showing Gross at work on a portrait of Renee in his Greenwich Village studio. Not released until 1951, the film provides an intimate look at the sculptor's personality and methods.

In 1962, after occupying a series of separate homes and studios around Manhattan, Gross purchased this 1873 four-story red brick building to bring his work and home lives under one roof. He worked closely with modernist architects Arthur Malsin and Don Reiman on its redesign. They retained many elements of the original facade, including ground floor details like the neoclassical attached cast-iron columns, while adding purple brick and plate-glass windows. They also added a gallery to the ground floor. However, the most striking alteration is an expansive sunken studio off the gallery at the back. An enormous skylight illuminates the space, which contains tools, raw materials, and over fifty finished works spanning Gross's seventy-year career.

The second floor was rented out as an apartment when Gross lived there, but it is now used as a temporary exhibition space, highlighting areas of the collection.

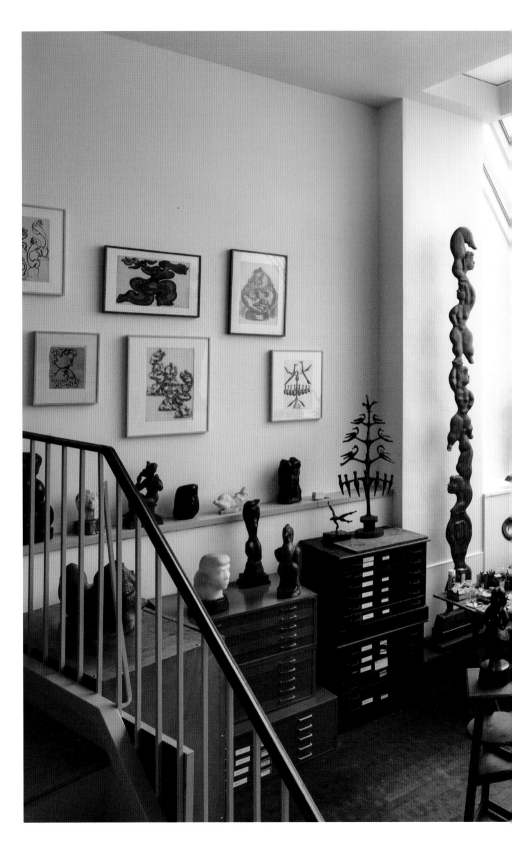

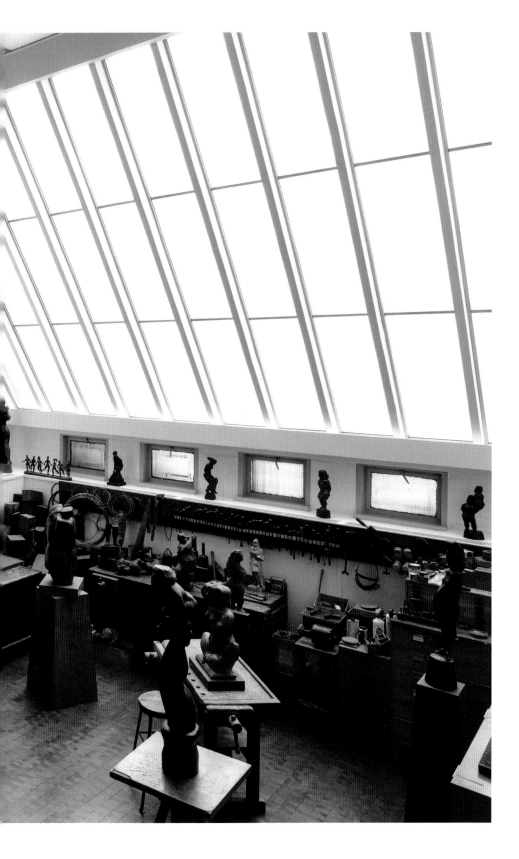

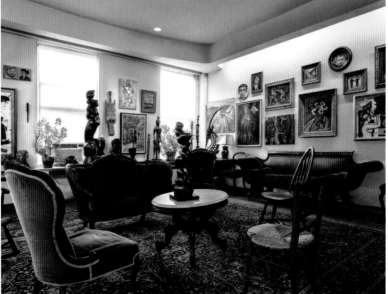

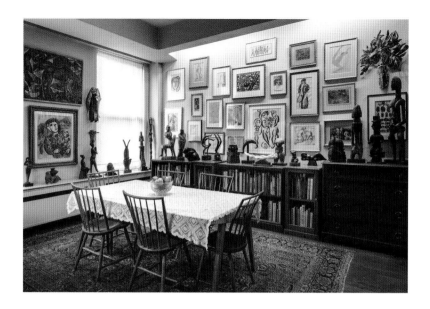

The main living quarters are on the third floor. A largely open space running the full length of the building contains the living room, dining room, and kitchen. Everywhere is art: densely hung, exploding with color, and all carefully curated by Gross. The floor introduces visitors to his collection of African, Oceanic, and ancient American artifacts, which sit alongside works he acquired—often through exchange—from his friends and contemporaries such as Milton Avery, Willem de Kooning, Stuart Davis, Louise Nevelson, Marsden Hartley, Raphael Soyer, and Red Grooms (once married to Gross's daughter), as well as works by Pablo Picasso, Henry Moore, and Auguste Rodin. The fourth floor, which originally contained the bedrooms, is now dedicated administrative space.

Renee and Chaim Gross first established the Chaim Gross Foundation in 1974, with donations from friends, later incorporating it as a nonprofit in 1989 and changing the name to honor both of them. At that time, they also decided to keep the collections onsite at LaGuardia Place to preserve the home, studio, art, and legacy of the artist.

Gross's large-scale bronze *The Family* (1979), donated to New York City in 1991, is installed at the nearby Bleecker Playground at Eleventh Street in Greenwich Village. Donald Judd's home at Spring Street is also open for visits [p. 84].

Thomas & Mary Nimmo Moran Studio
East Hampton Historical Society

———

Thomas Moran (1837–1926)
Mary Nimmo Moran (1842–1899)

229 Main Street, East Hampton, NY 11937
631-324-6850 **easthamptonhistory.org/thomas-mary-nimmo-moran-studio-ca-1884**

In working I use my memory. This I have trained from youth, so that while sketching I impress indelibly upon my memory the features of the landscape and the combinations of coloring so that when back in the studio the watercolor will recall vividly all the striking peculiarities of the scenes visited.
—THOMAS MORAN

The work of Mrs. Mary Nimmo Moran demands particular notice. I doubt whether in the work of any etcher in America or in Europe are to be found more painter-like qualities than hers exhibit.
—LESLIE W. MILLER, *THE CONTINENT*, 1883

Long before the Hamptons became a popular retreat for artists and the wealthy on the eastern end of Long Island, Thomas and Mary Nimmo Moran, influential New York City–based artists, built the first permanent artist's studio in East Hampton in 1884. Thomas Moran was already renowned for his watercolors portraying the landscapes of the 1871 United States Geological Survey expedition that influenced the preservation of Yellowstone and its designation as the country's first national park. His subsequent 1873 journey to the Grand Canyon with geologist

and explorer John Wesley Powell resulted in some of the most striking images of the region ever made. Meanwhile, Mary Nimmo Moran was at the forefront of the etching revival, and in 1881 became the first woman elected to both the New York Etching Club and the Royal Society of Painter-Etchers and Engravers in London, her work garnering the praise of the great Victorian art critic John Ruskin. The Morans had been summering and painting in the Hamptons since 1878, and in 1882 purchased a piece of property on a quaint village street. Together, they designed their ideal summer home and studio, all housed under one roof.

The result is an eclectic structure that, although largely in the Queen Anne style—with shingle siding, a pedimented front porch, and a polygonal turret—is also infused with neoclassical, Arts and Crafts, and Aesthetic Movement detailing, all of which contributes to the house's handmade character. The house, among the first in the area to include both running water and electricity, is a unique survivor of a bygone era when many Victorian buildings graced the village. A beautiful flower garden enhances the property. Initially designed by Mary, both she and Thomas depicted the garden in several paintings, one of which is on display inside. The site also includes the portable bathhouse the Morans brought to the beach, a prefabricated guest cottage (likely used by Mary as her printing studio), and an open-air boathouse constructed from recycled debris to house the Morans' gondola, which they purchased in Venice from the poet Robert Browning. Even Thomas's wind-powered water pump remains.

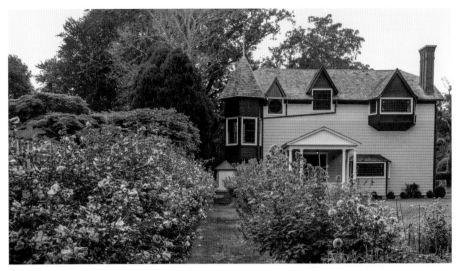

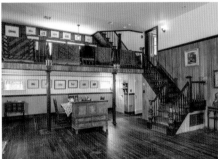
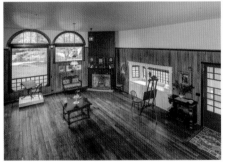

The Morans brought the same ingenuity and artistry to the interior. At the time of the house's construction, many of New York City's older buildings were being demolished to make way for brownstones. Thomas salvaged architectural features from the destruction and installed them in East Hampton, often transporting them east on the Long Island Railroad. For instance, the front doors were originally from a candy store on lower Broadway. The studio's substantial north-facing window was once a store-front, now installed upside-down with its transom at the bottom. And a hodgepodge of heavy balusters support the railing along the upstairs gallery that the Morans designed for the display of small artworks.

The large, central room was a multifunctional space that included the studio as well as dining and living areas, although one reporter of

the era teased that the Morans had built a "studio with a cottage annex," suggesting the primacy of the workspace. Even so, the artists enjoyed an active social life hosting salons, performances, and dance parties in this house. Its intricately carved Aesthetic Movement corner fireplace features a mantel embellished with delicate miniature portraits of the family whimsically added by the couple. Underneath the projected bay window is a deep built-in cabinet ornamented with Corinthian columns and pilasters that complement the gallery's supporting columns—all repurposed from Greek Revival buildings. The aestheticized carved sunflower on the staircase railing is among the sophisticated details that are easy to overlook and that contrast with the simple vertical beadboard paneling that lines the studio and gallery. Another staircase leads from the gallery to the family's bedroom quarters. Upstairs, each bedroom and the historic bathroom is appointed with period furnishings. One room's whimsical circular window and the others' deep bay windows containing ornamental leaded glass usher in the light and create an airy and unified series of spaces. The simple, handcrafted bracketed shelves and built-in bookcases provide storage and allow art and decorative objects to be displayed. The couple resided in the home until Mary Nimmo Moran's untimely death in 1899, after which Thomas Moran lived on and off here during summers for the rest of his life.

The East Hampton Historical Society and Thomas Moran Trust spent a decade scrupulously restoring the house, which opened to the public in 2018. Visitors to East Hampton can also visit the Historical Society's other sites, as well as the Jackson Pollock and Lee Krasner home and studio, also in East Hampton [p. 100].

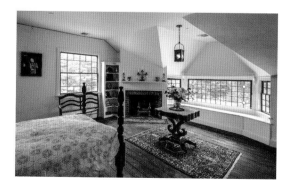

Thomas Cole
National Historic Site

—

Thomas Cole (1801–1848)

218 Spring Street, Catskill, NY 12414

518-943-7465 **thomascole.org**

*American scenes are not destitute of historical and legendary
association; the great struggle for freedom has sanctified many
a spot, and many a mountain stream and rock has its legend,
worthy of poet's pen or painter's pencil.*
—THOMAS COLE, FROM "ESSAY ON AMERICAN
SCENERY," 1836

Here, on the western side of the Hudson River Valley, where the majestic
Catskill Mountains and surrounding villages meet the mighty Hudson,
is the birthplace of the Hudson River School, the nation's first art move-
ment, and the home of the man credited as its founder. Its gracious front
porch looks out to the Catskills sweeping across the western horizon.
Inspired by such views and scenes witnessed during sketching excur-
sions in the region, Thomas Cole, now considered a foundational envi-
ronmentalist, created landscape images that placed the nation's untamed
wilderness at the very heart of America's identity. Cole and other such art-
ists who both aggrandized and romanticized nature dominated the art
scene in the early to mid-nineteenth century. Their potent images of the
nation's diverse natural splendor still resonate with contemporary view-
ers. Cole inspired it all, and the area around his home is where he began.

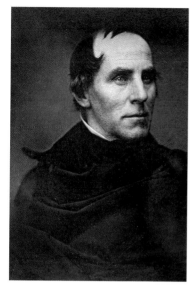

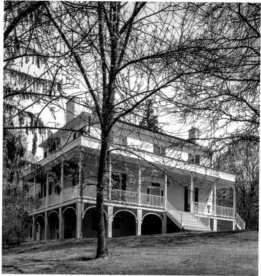

Cole emigrated to the United States from England as a teenager, settling first in Ohio and eventually making his way east as a largely self-taught traveling portrait painter and engraver. In the summer of 1825, he took a life-altering sketching trip up the Hudson River from New York City. These sketches became the basis for paintings he later executed in his studio. He exhibited three of these groundbreaking works in a Manhattan bookstore's window. Their immediate sale launched his career.

The artist continued his summer sketching expeditions in the Hudson Valley and beyond, often boarding at Cedar Grove, a 110-acre farm in the village of Catskill. He married Maria Bartow, the niece of its proprietor, in 1836, and the couple moved into Cedar Grove's ample 1815 Federal-style house. Today, the house is nestled among the tree-lined streets of the village on approximately six acres of lawns and gardens.

The impressive porch wraps around two sides of the rectangular brick house, a favored spot for visitors to linger. Within, the painstakingly restored interior is accompanied by immersive technological storytelling. The entrance hall sports periwinkle-blue walls and a brightly patterned floorcloth. The parlors on either side, filled with original furnishings, bear the friezes that Cole painted onto the plaster walls soon after his arrival. In the vivid green-colored parlor on the right, visitors are greeted by a

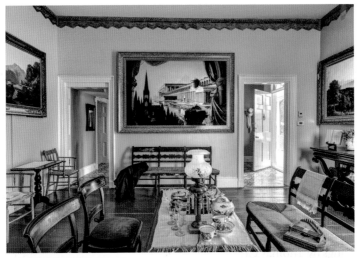

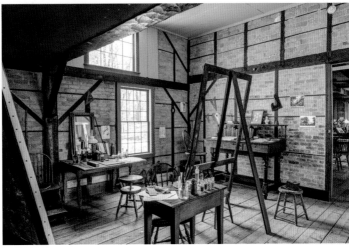

cinematic experience: stunning images of Cole's masterpieces are projected onto the walls as his story is told through his own words, taken from his essays on American art as well as his poems, journals, and letters, voiced by the actor Jamie Bell. Cole was a prolific author whose best-known work today is the 1836 "Essay on American Scenery."

Across the hall, the west parlor features a series of reproductions of some of Cole's most important paintings coupled with motion-activated projections, which make letters seem to appear magically on

desk surfaces. The installations tell the surprising stories behind the art-works and guide visitors through Cole's sometimes heated dealings with his patrons. These compelling narratives also illuminate the commission-centered art business of this period. The second floor features original paintings by Thomas Cole as well as his sister Sarah and daughter Emily. An installation in a large second-floor gallery explores Cole's artistic methods and includes the artist's original brushes, palettes, sketches, and both finished and unfinished paintings.

The historic campus includes the reconstructed 1846 New Studio building that Cole designed. The artist used the Italianate building as his workspace before his untimely death in 1848, and the building was torn down in 1973 before the site became a museum. However, it has been skillfully and accurately rebuilt and today houses annual exhibitions on Cole and the Hudson River School. Elsewhere on the grounds are Cole's 1839 Old Studio (an outbuilding adapted by the painter), now outfitted with the artist's easels and tools, the gardens and the cedars that likely gave the property its name, and even the original privy.

No trip to the Thomas Cole National Historic Site is complete without venturing into his beloved Catskill Mountains. (The fourth highest peak in the Catskills is named Thomas Cole Mountain in honor of the artist.) The area contains numerous sites that were depicted in nineteenth-century Hudson River School paintings, and maps of the Hudson River School Art Trail are available in the Thomas Cole visitor center. The Art Trail includes Olana [p. 94], the home of Cole's protégé Frederic Church, directly across the Hudson. The two historic sites are now linked by the Hudson River Skywalk, a new walkway across the Hudson River via the Rip Van Winkle Bridge.

Andrew Wyeth Studio
Brandywine Conservancy &
Museum of Art

Andrew Newell Wyeth (1917–2009)

1 Hoffman's Mill Road, Chadds Ford, PA 19317
610-388-2700 brandywine.org/museum/
studios/andrew-wyeth-studio

One's art goes as far and as deep as one's love goes.
—ANDREW WYETH

Painter Andrew Wyeth's 1948 work *Christina's World* (Museum of Modern Art, New York) remains one of the most haunting images in American art. It depicts a woman from the back sitting in a field and seeming to lean toward the weather-beaten house in the distance. Wyeth and his wife spent part of every year in Maine, where *Christina's World* and many other works are set, yet the center of Wyeth's world was Chadds Ford, Pennsylvania, where he was born and raised, matured into one of the most recognizable artists of the late twentieth century, and drew inspiration over his entire life. Although the painter belonged to a three-generation artistic dynasty—son of illustrator N. C. Wyeth and father of painter Jamie Wyeth—he maintained his own distinctive approach. Painting subjects he knew as intimately as his own hand, he captured at once the prevailing character of a place and its infinite details, as only someone with true *knowing* of a thing can.

Wyeth moved into this converted 1875 schoolhouse (previously occupied by his sister Henriette and her husband Peter Hurd, both artists), just down the road from his childhood home, shortly after his

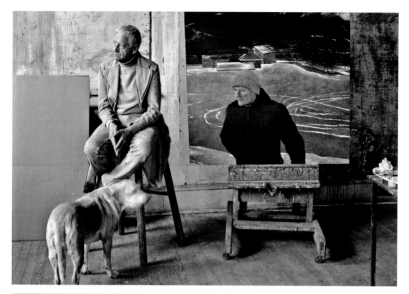

marriage to Betsy James in 1940. Even after the couple bought another home nearby, the painter maintained his studio here until his death in 2009. The austerity and elegance of the space makes it an intriguing counterpoint to the more haphazard neighboring studio that his father worked in. The natural beauty and texture of the interior walls are punctuated by thoughtful presentations, such as the World War I German soldier's overcoat that hangs on an eighteenth-century Pennsylvania Dutch cabinet, with a selection of military helmets displayed on top. A built-in cabinet in the living room displays his impressive collection of military

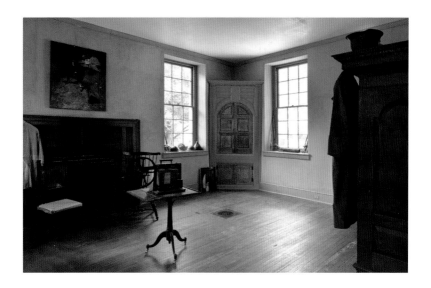

miniatures that he began acquiring as a boy. Modern fencing foils, a fencing mask, and a helmet rest on a deep windowsill, a carefully arranged reference to the artist's favorite sport. Throughout, expansive windows allow exquisite natural light to infuse the space. Together, the light and groupings of objects recall the compositions in his paintings. The museum's installation also replicates a period in the 1960s when Wyeth's son Jamie used a corner of the main room as a studio. Here, the young artist painted such iconic works as *Draft Age* and a posthumous portrait of John F. Kennedy.

A small room beyond the living room houses Wyeth's extensive art library, including books on old masters like Albrecht Dürer, iconic American painters such as Thomas Eakins and Winslow Homer, and even contemporary filmmaking. The canisters of film reels recall his love of movies, which he often projected on the walls of the living room for family and friends. A closet brims with costumes that his subjects wore and are easily recognizable to Wyeth aficionados. Many of the reproduction paintings on display are by Howard Pyle, one of N. C. Wyeth's teachers. The landscape that presses in through the windows is one that Wyeth pursued throughout his life. He chose not to travel extensively so that he could embrace his immediate environs and gather an intimate knowledge of them for his work. As he explained, "I paint my life."

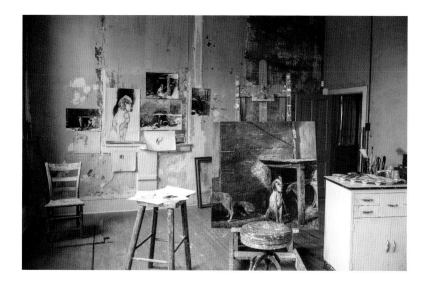

Jamie Wyeth once remarked, "To understand my father's world, one need only visit his studio." The reproduction sketches now displayed on its walls reference the original pieces that served as the basis for final works, and which the painter was known to put on display for family and friends in the nearby kitchen. He used the studio's large mirror to view his work from differing angles. Lined up in jelly jars are rows of pigment powders, jewel-like tones of blue and red. An egg carton references the tempera medium he favored.

The nearby Kuerner Farm, a lifelong inspiration that Wyeth discovered on a childhood walk, is open to the public. The farm and Andrew Wyeth's studio, as well as his boyhood home and N. C. Wyeth's studio [see p. 130] are all part of the Brandywine Conservancy & Museum of Art complex, which houses an important collection of regional American art.

Demuth Museum

Charles Henry Buckius Demuth (1883–1935)

120 East King Street, Lancaster, PA 17602
717-299-9940 **demuth.org**

I am back in the Province in the garden of my own Chateau.
—CHARLES DEMUTH

Precisionist painter Charles Demuth returned again and again to his birthplace in Lancaster, Pennsylvania, between periods spent in New York, Paris, and Provincetown, Massachusetts. Demuth suffered from diabetes, which rendered him bedridden for extended periods, and he was one of the first Americans to receive insulin treatment. As he adapted to his illness—and persevered despite it—his family home remained a constant.

Adjacent to the home is the family business, a tobacco shop established in 1770 by one of the artist's ancestors and operated by the family until 1986; the shop remained open until 2010, making it the longest continually running tobacco shop in the United States. The financial success of the business allowed Demuth to study art at Drexel Institute of Art, Science and Industry (now Drexel University) and the Pennsylvania Academy of the Fine Arts in Philadelphia. Both of his parents also encouraged his artistic nature. His father, an amateur photographer, brought young Charles along on photography trips to capture local architecture, the countryside, and the circus. His mother hired area artists to

give her son art lessons. Her garden was highly regarded in the community and has been restored to appear as she designed it. Its chevron patterns appear in the painter's early sketchbooks and inspired many of his later works.

During winters in New York City, where he maintained a studio on Washington Square South, Demuth developed a close friendship with Alfred Stieglitz and Georgia O'Keeffe, whom he sometimes hosted in Lancaster. In Paris, he studied at several highly regarded art schools, including the Académie Julian, and associated with avant-garde figures such as Gertrude Stein. Summers in Provincetown, beginning in 1914, saw him helping to establish the Provincetown Players with acclaimed playwright Eugene O'Neill. Demuth was homosexual at a time when he could rarely reveal his identity safely and only among his closest friends. Despite struggling with diabetes since childhood, he produced more than a thousand works of art, mostly in his Lancaster studio, which he called his "Chateau." The Metropolitan Museum of Art acquired one of his works in 1923, and a monograph on him—written by modernist artist, critic, and powerbroker Albert Eugene Gallatin—was published in 1927.

The architecture surrounding the Demuth home and store remains relatively unchanged. The tobacco shop boasts a prominent red brick and glass storefront. (The shop is owned by the museum and open during select special events.) The white brick exterior of the house appears as it was during Demuth's childhood. Inside, the unfurnished first floor is now a gallery space dedicated to displaying the work of Demuth and his associates, along with exhibitions on related topics. The museum boasts the

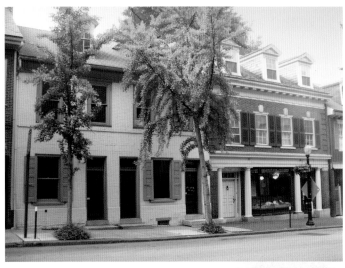

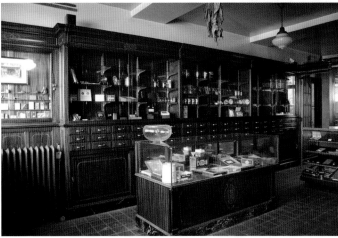

largest collection of Demuth works in the world, including many painted in his upstairs studio. This space now features his easel, brushes, and oil paints. A few of Demuth's artworks are on display in his studio, including a self-portrait and a portrait of his mother. The Demuth Museum's collection includes exquisite floral compositions inspired by his mother's garden that convey the painter's mastery not only of oil and watercolor painting, but other techniques as well. For instance, in lieu of applying white paint to paper, he sometimes left the paper blank to convey light

and dimension. Despite his physical limitations, the artist continually found inspiration at his Lancaster home, painting garden scenes or views of the city that stimulated and sustained him (p. 123, right).

Walking around the neighborhood, visitors may recognize many of the buildings depicted in Demuth's art. The nearby Lancaster Central Market, established in 1730, is the oldest continually operating farmers' market in the country.

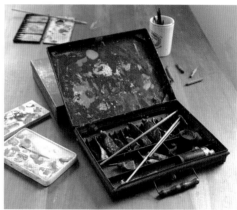

Mercer Museum & Fonthill Castle
Bucks County Historical Society

Henry Chapman Mercer (1856–1930)

Fonthill Castle, 525 East Court Street, Doylestown, PA 18901

215-348-9461

Mercer Museum, 84 South Pine Street, Doylestown, PA 18901

215-345-0210 **mercermuseum.org**

Except the Lord build the house, they labor in vain that build it.
—HENRY CHAPMAN MERCER

Tile maker and archaeologist Henry Chapman Mercer's rambling concrete castle, Fonthill, is a marvel of experimentation, contemporary materials, and Mercer's own design. Its construction pushed the boundaries of what materials could do, making it a quintessentially modern endeavor. Yet from an architectural standpoint, and considering the historical collections that Mercer housed there, Fonthill is an homage to the past.

During its construction from 1908 to 1912, the local paper provided frequent and colorful updates, including descriptions of the rooster who stood guard over the site and photographs of Lucy, the horse whose job was to haul seemingly endless loads of hand-mixed concrete. (Lucy is immortalized by the weathervane atop the castle.) The narrative in the paper is by turns awestruck and bewildered by the eccentric artist and scholar's undertaking. Mercer himself recognized the possibility of failure, but took comfort in knowing the risk was entirely his own.

The completed house assumed castle-like proportions, with forty-four rooms, including a library, a grand salon (which Mercer called "The Saloon"), several bathrooms, five bedrooms, and eighteen fireplaces.

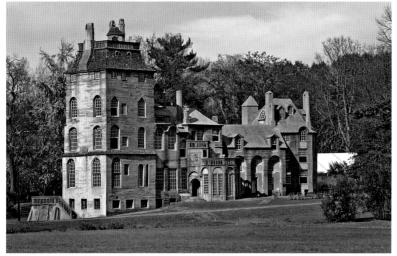

Many details were inspired by European architecture that Mercer visited while on a grand tour as a young man. These are traceable to specific buildings because Mercer transcribed so many features faithfully from their sources, which included the Byzantine, Gothic, and Romanesque.

The interior can rightly be described with one word: tilemania! Original Persian, Spanish, Chinese, and Dutch tiles and even clay Babylonian texts grace the walls and ceiling of every room, mingling with Mercer's own tiles produced at the thriving Moravian Pottery and Tile Works he founded on his estate. Ceiling tiles were set into the wet concrete during construction and Mercer's beloved dog Rollo's paws are also memorialized on one of Fonthill's myriad staircases. Even more tiles and

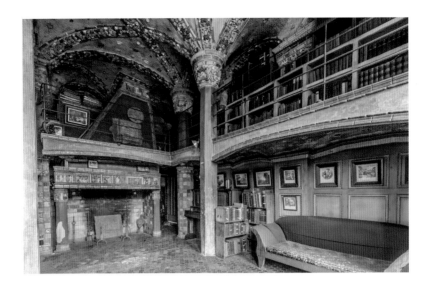

numerous Latin inscriptions were later added to the walls and floors, and tile setting continued throughout the house nearly up to the time of Mercer's death in 1930.

Displays of his extensive ceramics collection abound, and books line the walls of almost every room. Many of the more than six thousand volumes are annotated in his own hand. The castle features historical references and objects alongside singular handmade details, but Mercer also incorporated all the modern conveniences of his era, including ten bathrooms and a powder room, dumbwaiters, an Otis elevator, and intercom and telephone systems throughout.

Mercer gave many of the rooms themes and then fashioned tiles to embody them. For example, the brilliant pink and blue tiles in the ceiling of the Columbus Room depict scenes of the explorer's voyages, but also of indigenous peoples and cities in the New World (p. 127, top right). The prevailing gray concrete beautifully offsets the color schemes throughout. The walls have a luminous patina created when Mercer burned tar paper and let the oily residue react with the concrete surface. Against the heaviness of the walls, more than two hundred sizable windows allow light to flood the interior of Fonthill. Although the light has faded many of the pigments, visitors still experience the overall brilliance and profusion of color reflecting Mercer's vision.

With the choice of concrete and tile, Mercer wished to use a method that would allow for "the greatest latitude for an expression of individuality." He kept detailed records and sketches of his design and created model rooms that he then arranged in unusual configurations, resulting in Fonthill's irregular roofline and the idiosyncratic passageways that connect the rooms. Once erected, the house was Mercer's creative center: he not only designed tiles, but he also drew, painted, illustrated, and wrote fiction in his "Castle for the New World."

Steps away from Fonthill, the Moravian Pottery and Tile Works continues to create tiles using the artist's original molds, slips, and glazes. A mile away in central Doylestown is the Mercer Museum, another concrete edifice created by Mercer that houses his collection of some forty thousand everyday objects from eighteenth- and nineteenth-century America.

Mercer created tiles for the Boston home (now museum) of Isabella Stewart Gardener. His tiles cover the floor of the Pennsylvania State Capitol building in Harrisburg, and his 1929 *Ancient Carpenters' Tools*, still in print, remains a fundamental text of the trade.

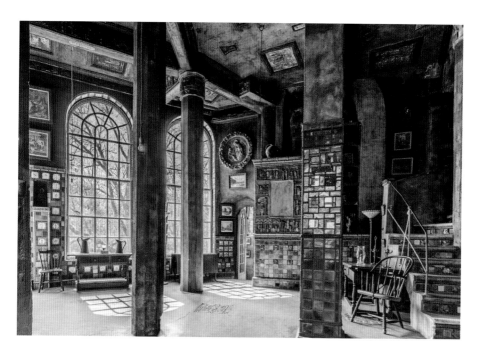

N. C. Wyeth House & Studio
Brandywine Conservancy & Museum of Art

Newell Convers Wyeth (1882–1945)

1 Hoffman's Mill Road, Chadds Ford, PA 19317
610-388-2700 **brandywine.org/museum/studios/**
nc-wyeth-house-studio

This is the little corner of the world wherein I shall work out my destiny.
—N. C. WYETH

Painter, muralist, and illustrator N. C. Wyeth's outsized personality matched those of the epic figures he depicted in more than one hundred books, including the likes of Robin Hood, *The Last of the Mohicans*'s Hawkeye (p. 132, bottom), and *Treasure Island*'s Long John Silver. The latter commission in 1911 allowed him to purchase eighteen hillside acres, which he called "the most glorious sight," in the town of Chadds Ford, Pennsylvania, in the heart of the Brandywine River Valley. Wyeth had become enamored of the area while studying there with illustrator Howard Pyle. He designed a home and studio that would foster three generations of Wyeth artists, including his son Andrew Wyeth and his grandson Jamie Wyeth.

The impressive studio's interior brims with objects representing a cross between the contents of a massive toy chest and a forgotten attic treasure trove. Wyeth used these props and costumes to model his many illustrations. For instance, a canoe worthy of any James Fenimore Cooper novel rests along one wall, a tricorne colonial hat adorns a bust of George

Washington, a spinning wheel rests in a corner, and a rack of antique fire-arms hangs on the wall in the entry way. One of the easels displays *George Washington the Farmer*, a preparatory painting he executed for an illustration done in 1945. The massive, arched Palladian window casts light on shelves and shelves of books, and as the light changes, new wonders come into view. Wyeth's five children liked to dress up in the costumes to play make-believe in the rolling pastures just beyond the studio doors. Other, more serious work props include a lantern slide projector used to enlarge initial drawings for transfer to canvas.

The studio originally had no electricity, and the artist controlled light coming in from the enormous window through a series of large, draped curtains. Later, he installed a state-of-the-art artificial lighting system of twelve theatrical-style footlights that he mounted on the ceiling.

A set of imposing doors open onto the 1923 addition Wyeth used for mural paintings, with its greenhouse window soaring to the ceiling, a double-decker ladder, and a mural depicting William Penn resting upon

two stools. The setup has an air of unfinished business that is underscored by a palette in the original studio inscribed with a date and the directive "Do Not Use." The date—October 18, 1945—is the day before Wyeth died suddenly in a tragic car accident alongside one of his young grandsons. The note is in the handwriting of daughter and artist Carolyn, who trained with her father and then painted in both the house and the studio for the rest of her career. Carolyn was also an art teacher, and her nephew, painter Jamie Wyeth, was among her students at Chadds Ford.

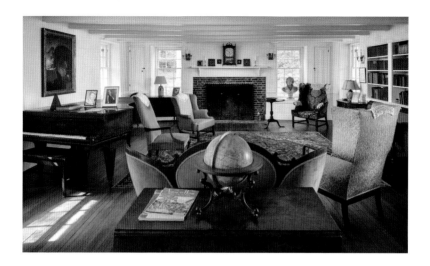

Wyeth's stately brick home, set in a grove of trees near the studio, attests to the relaxed family life he and his wife created. Inside, the house reflects both modesty and simplicity. In the warmly paneled dining room, benches, rather than chairs, line the long sides of the table. The living room's grand piano demonstrates the importance of music to the family. Upstairs, the canopied four-poster beds are adorned with inviting coverlets, and chest-on-chests signal the family's taste for furnishings based on the Colonial Revival. Wyeth remains a great and sweeping persona, but his home and studio convey how important family life was to him.

A delight of visiting the property is that the studio of his son Andrew Wyeth [p. 118] and Kuerner Farm, which inspired many of Andrew's works, are nearby. All three are managed by the Brandywine Conservancy & Museum of Art, whose collection boasts works by the three generations of Wyeths and other key regional American artists. The fifteen-acre museum site was once a gristmill and includes a river trail that visitors can meander along.

For those who wish to venture a bit further, one of the country's premier horticultural sites, Longwood Gardens, is in nearby Kennett Square. Also, just across the Delaware border is the renowned Winterthur Museum, the former estate of Henry Francis du Pont that houses one of the most important collections of American decorative arts in the country.

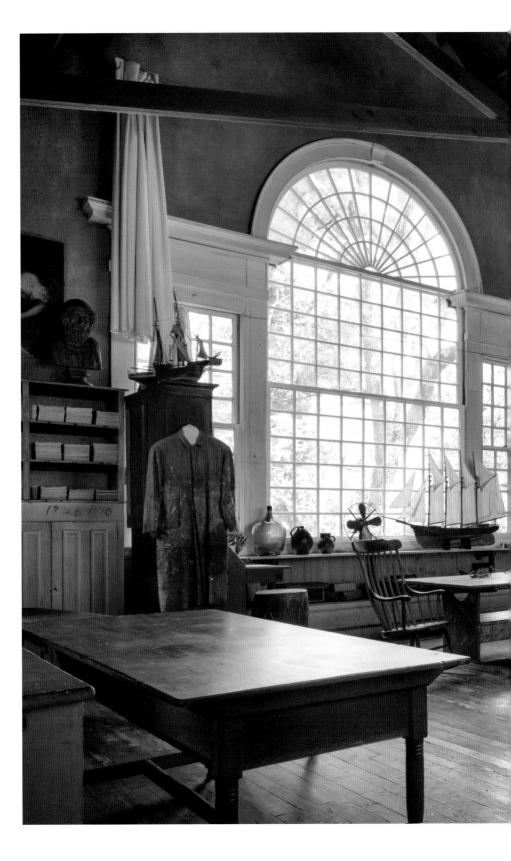

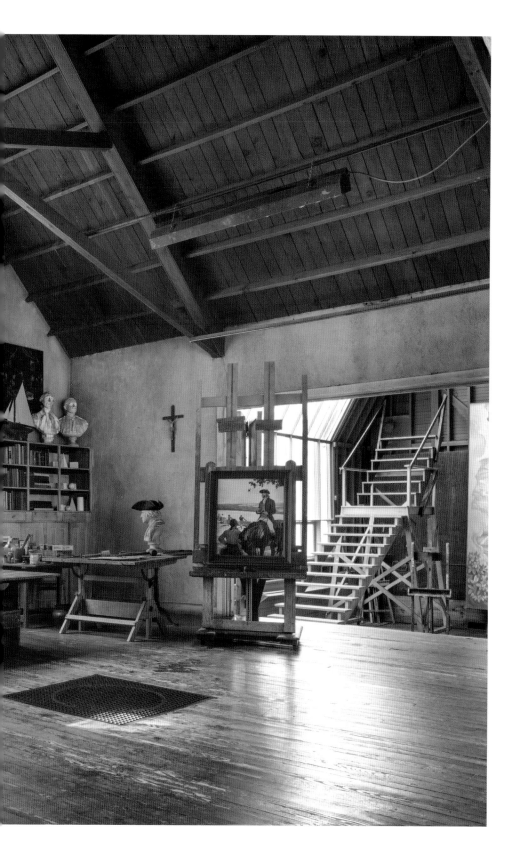

Wharton Esherick Museum

Wharton Harris Esherick (1887–1970)

1520 Horseshoe Trail, Malvern, PA 19355
610-644-5822 **whartonesherickmuseum.org**

If it's not fun, it's not worth doing.
—WHARTON ESHERICK

Artist and celebrated woodworker Wharton Esherick crafted his home and studio entirely by hand, from the carved coat pegs to the lampshades, the kitchen cutting boards, and the triumphant spiral staircase. His technical mastery is evident in the doors and cabinet drawers that move with impossible ease and in unexpected directions. Esherick began work on the studio in 1926 and devoted the next four decades to its development. Today, the site offers an opportunity to see his sculptural work and furniture together, and visitors are encouraged to touch the many wood surfaces throughout.

Esherick first studied drawing and painting at the Pennsylvania Museum and School of Industrial Art (now the University of the Arts) and later at the Pennsylvania Academy of the Fine Arts. With only six weeks until graduation, he dropped out, determined to forge his own path. He began carving wood for pragmatic reasons: he needed frames for his paintings. The artist then began carving woodblocks, illustrating several books in the 1920s, before moving on to sculpting in wood. Furniture making soon followed. Esherick derived his forms from the

specific features of his materials rather than imposing a design on them, making his approach to furniture unique. This cemented his legacy as a leader of the Studio Furniture Movement, which emerged in the 1940s and was defined by its rejection of traditional design and mass-produced furnishings in favor of singular, functional works of art. His designs were also influenced to some degree by the theories of Austrian philosopher Rudolf Steiner.

Esherick built his wood, stone, and concrete home and studio atop Valley Forge Mountain on twelve wooded acres. The site includes a 1928 log garage that now houses a visitor center, as well as a 1956 workshop of striking blue hues designed with famed architect Louis Kahn (currently a private residence, with plans to open in the future). The buildings represent the artist's experimentation, inspiration, and evolution and reflect a variety of styles.

The progressively constructed spaces that make up the studio resemble an interconnected, organic sculptural form where one is hard-pressed to find a straight line and every glance falls on the warm honey glow of

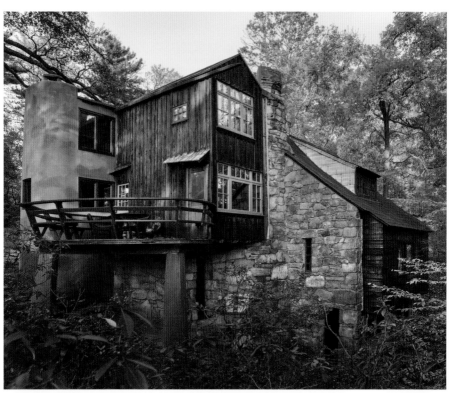

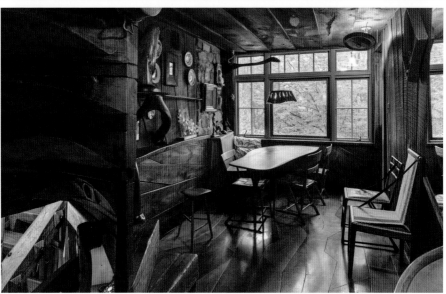

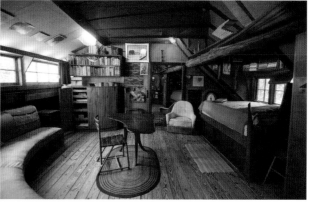

wood. The artist's talents in canvas, metal, stone, and other media are also on display. He possessed a strong conservation ethos, apparent in the interesting ways he made use of endless scraps of material, including angled paneling, latches, and other features. The ceiling beams were salvaged from old barns.

Esherick filled every last space in the house with his creations, and several of his early paintings adorn the walls. The desk built into the nook under the stairs perfectly conveys this approach. He also eschewed buying anything that he could make, like the paper dispenser that rests beside his rotary phone. The upstairs loft became Esherick's bedroom, where he elevated his bed so it was level with the loft windows, giving him a southern view of his property and the surrounding woods and offering the illusion that he looked out from a treehouse. He later added the adjoining wooden tower, which includes a dining room and another bedroom. The last addition, built in 1966, is the concrete silo coated in a fresco of brilliant hues of ochre, purple, brown, and green.

Virtually every component of the studio, from the spoons to the staircase, is an example of Esherick's artistic work, allowing visitors to see the evolution of his creative process and its infinite variety. Alongside these works live his personal belongings, from a small collection of Mexican glassware and his personal library to his clothing in the dresser drawers. A true virtuoso, Esherick coaxed art out of each individual piece of wood in a dazzling array of forms and surrounded himself with the beauty that resulted in this total work of art, his home.

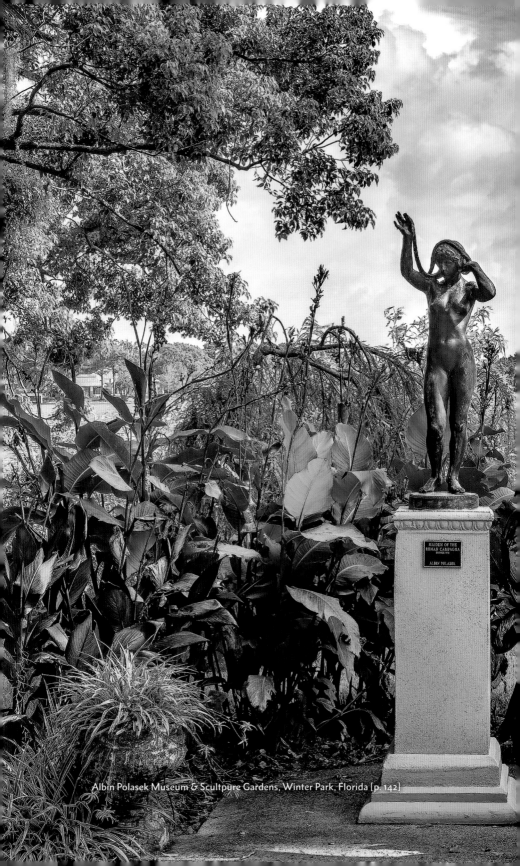

Albin Polasek Museum & Scultpure Gardens, Winter Park, Florida [p. 142]

Southern Region

Albin Polasek Museum & Sculpture Gardens

Albin Polasek (1879–1965)

633 Osceola Avenue, Winter Park, FL 32789

407-647-6294 **polasek.org**

Art is a path to the superior.
—ALBIN POLASEK

The tranquility that characterizes the three-and-a-half-acre lakeside home of Czech-born figurative sculptor Albin Polasek is the culmination of the artist's personal journey, marked by his pursuit of creative expression in the face of physical adversity. Several of the sculptural works that punctuate the lush, subtropical gardens were executed after Polasek suffered a debilitating stroke that paralyzed his entire left side. He completed them, wheelchair bound, using only his right hand—a testament to his tenacity, faith, and talent.

Polasek had come to Winter Park, Florida, to retire from a successful three-decade career as both the sculptor of numerous public and private commissions and the head of the sculpture department at the Art Institute of Chicago. He secured the position after formal study in Philadelphia and Rome, funding his education with money saved from carving ecclesiastical works for churches throughout the Midwest. He had learned this skill as a young apprentice to a woodcarver in Vienna, having left the Moravian village of his birth, in what is now the Czech Republic, to seek a better life. In 1901, when he was twenty-two, the artist

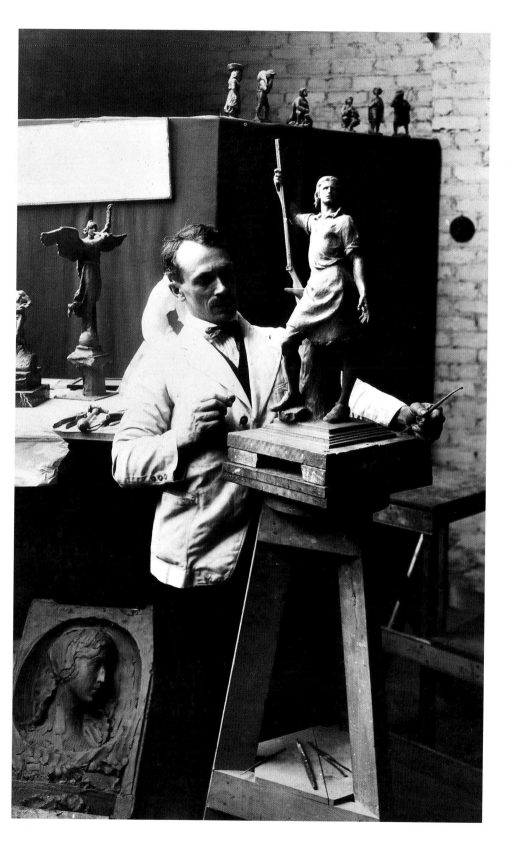

emigrated to the United States. He would succeed and become a professional artist, teacher, and the internationally renowned sculptor of the *President Wilson Memorial*, located in the Czechoslovakian capital, Prague. (The president had been instrumental in championing Czech independence after World War I.) Polasek received the commission a decade after the formation of the new nation, creating the first monument to Wilson in any country.

Many years later, Polasek carefully designed the Winter Park studio himself, with functionality at the forefront of his mind. Even as he retired from active teaching, he wished to work on sculpture daily. In 1961, he established the Polasek Foundation, intending the house and studio to be open to the public after his death to share his love of classical sculpture. Accordingly, the site's architecture, gardens, and sculpture present an autobiographical glimpse into his playful character, his artistic genius, and his heritage. The concrete cinder-block home and studio incorporate Slavic and Moravian influences from his childhood, such as exposed beams, vaulted ceilings, and deep-set windows. They are situated around a courtyard set with a mosaic of brilliantly colored tiles that express both

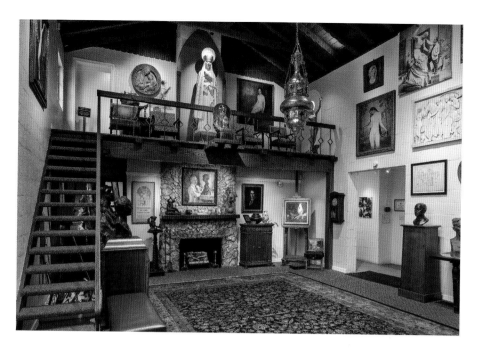

the strong hues typical of Moravia and the tropical tones of Florida that delighted him. At the center of the courtyard is the *Emily Fountain,* a sculpture of a young woman playing a harp, in which the water element is ingeniously engineered to comprise its strings. This was unveiled in 1961 as a romantic wedding present to his second wife, Emily Muska Kubat Polasek, who served as its model and inspiration.

Throughout the house and studio are the objects Polasek acquired during his lifetime, including those from his travels abroad and within the United States, as well as gifts from family and friends. All are still carefully arranged according to his design. The studio reflects the graciousness of a European-style salon combined with a practical working space with all the sculptor's original tools. His folk-painted bedroom furnishings and decor, like the shepherd's axes and embellished heart, reflect his Moravian roots.

To walk through the gardens is to be immersed in the stories that inspired Polasek: allegorical, mythological, classical, and Christian narratives as well as the fables of Polasek's youth. The figures convey a vivid range of human emotion, including sorrow, jubilance, and weariness.

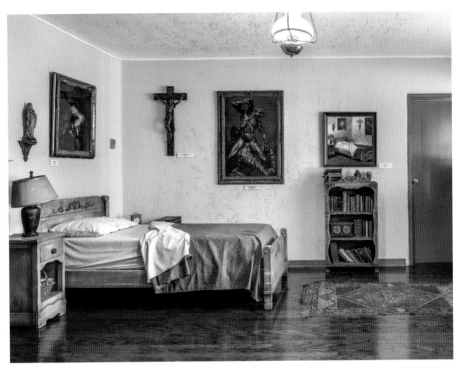

The sculptor laid out this landscape, setting his works against vistas of the nearby lake, magnificent white camellia, bald cypress, oak trees, and native plants such as agave, century plant, and aloe.

The gardens also feature Polasek's bronze casts and stone carvings of works created earlier in his career. The original sculptures grace churches, public spaces, and museums throughout the world. These include the iconic *Sower* (1915, Chicago Botanic Garden and above), an archetypal male figure sowing the seeds of his future, as well as *Man Carving His Own Destiny* (originally conceived in 1907, opposite bottom), an early work that has come to embody Polasek's life and career. The artist completed more than fifty versions of it in his lifetime. This figure, who is carving himself from a block of stone, captures Polasek's belief in diligence, American opportunity, and self-determination. Reflecting on his legacy, the artist commented: "I have made sculptures for the future… if now and then some wanderer comes along who understands their message, I shall rest content." Fellow sculptor Ann Norton's home and studio is several hours south in West Palm Beach [p. 148].

Ann Norton Sculpture Gardens

Ann Weaver Norton (1905–1982)

253 Barcelona Road, West Palm Beach, FL 33401
561-832-5328 **ansg.org**

Art should be beautiful and made to last.
—ANN WEAVER NORTON

A walk through the lush gardens that sculptor Ann Weaver Norton designed in collaboration with her friend, and world-renowned botanist Sir Peter Smithers, reveals her wish to create a sanctuary both for people and for abundant flora and fauna. Established only a few years before her death, the gardens are a testament to Norton's deep commitment to environmentalist principles and provide a permanent home for the monumental works of her late career.

This multisensory experience integrates art and nature. Recognized as one of the largest public collections in Florida, the gardens include walkways that meander through lush vegetation that includes more than 250 species of rare palms and numerous other tropical plants. A rich, loamy fragrance envelops the vegetation's interesting, often sculptural shapes, and the gardens provide habitat for birds and other wildlife, who offer their auditory accompaniment in this contemplative place.

Set among all this splendid verdure are examples of the artist's work. Monolithic sculptures of handmade brick are highlighted in pools or provide deep contrast to the unmanicured garden, while smaller works

tucked into foliage await discovery. Many reflect Norton's lifelong exploration of abstract form, although figurative pieces also appear, one inspired by a rock formation in Bryce Canyon, Utah. Both the artworks and garden design show Norton's interest in Eastern philosophy and reflect her travels to the American West and India.

The gardens terminate at the property's impressive home, designed by famed architect Maurice Fatio and built in 1925. Norton's husband, Chicago steel magnate and art collector Ralph Hubbard Norton, and his first wife, Elizabeth, hired architect Marion Sims Wyeth to redesign the building in 1935. The couple also hired Wyeth to design the nearby Norton Gallery and School of Art (now the Norton Museum of Art) to share their art collection with the public.

Ann Weaver came to Florida to teach sculpture at the newly formed school. The Alabama-born artist had been educated at some of New York

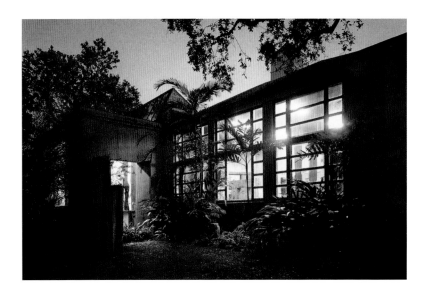

City's finest art schools, received two Carnegie Traveling Fellowships, and earned distinction for her rigorous approach to teaching. She quickly established close friendships with the Nortons and the gallery's first director and his wife. A year after Elizabeth Norton's death in 1947, Weaver and Ralph Norton married. Wyeth was hired again, this time to design Ann's new studio, with her input, to complement the house. This building features twenty-two-foot high vaulted ceilings and wide, angled clerestory windows providing ample room and light for working on large-scale sculpture. When Ann became a widow only five years later, she turned her attention wholly to her art. In her husband's memory, she soon created a monumental work in granite that she installed in the gardens.

Norton's studio offers visitors insight into her sculpting methods. Small studies for larger works, wire armatures that provide internal support, and two-dimensional drawings that inspired three-dimensional pieces—executed in plaster, clay, stone, and bronze—abound. These are dominated by the substantial pieces of wood from which sculptural forms still wait to emerge. Norton preferred to work with northern red or "giant" cedar, a material favored by indigenous peoples of the Pacific Northwest for their monolithic totemic works. She said of her method, "I use everything—the cracks in the wood, the knots, and the gnarls. I like my work to flow together with nature."

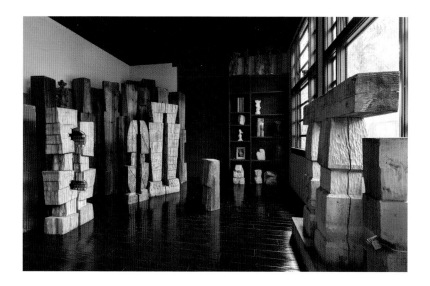

Together, the house, studio, and garden reflect Norton's continual evolution. She once compared herself to "the tip of an iceberg" and believed that the creative spirit provided fuel and comfort to her, even in the face of mortality. Norton conceived the gardens as she battled terminal leukemia.

Visitors to the site also should visit the nearby Norton Museum of Art. The more modernist examples within the collection can be credited to Ann Norton's influence on her husband's later collecting tastes.

Melrose Plantation

Clementine Hunter (c. 1887–1988)

3533 Highway 119, Natchitoches, LA 71452
318-379-0055 **melroseplantation.org**

*God puts these pictures in my head and I just puts them on canvas
like he wants me to.*
—CLEMENTINE HUNTER

Nestled among the swaying trees that line a quiet country road near
Natchitoches, Louisiana, lies Melrose Plantation, an antebellum estate on
the Cane River. Its story culminates with the career of artist Clementine
Hunter, a self-taught African American folk artist whose masterpiece is
an epic mural cycle that adorns the walls of one of the oldest buildings on
the property. Today, visitors can view these paintings and tour the build-
ings and grounds that remain.

Melrose Plantation was founded in 1796 by a former slave whose
French merchant father had secured his emancipation. Over the course
of the nineteenth century, the plantation was home to both black and
white owners who expanded the main house and added outbuildings,
all of which survived the Civil War intact. In 1899, John and Carmelite
("Cammie") Henry bought the property. Cammie Henry was a preser-
vationist who acquired historic log cabins from around the parish and
installed them on the plantation grounds. She also collected objects such
as weavings, Cane River art, and photography, as well as Louisiana lore, all

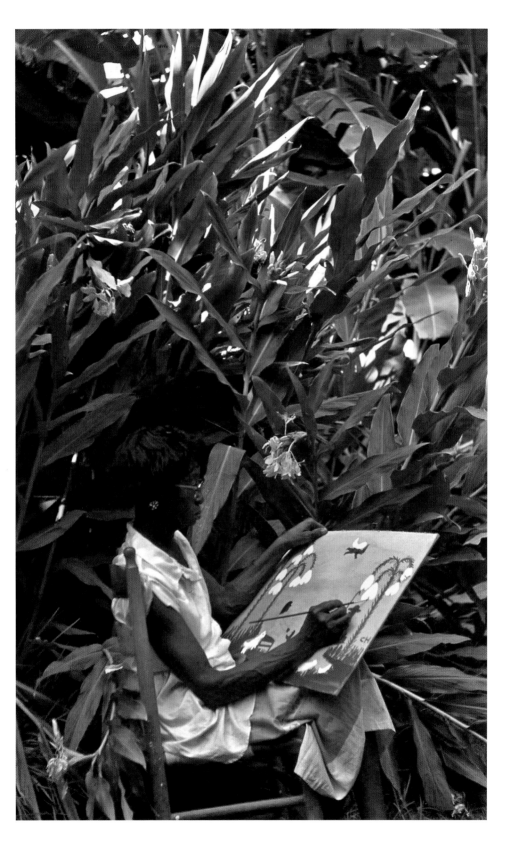

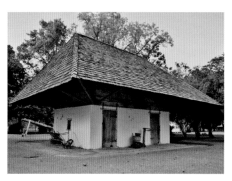
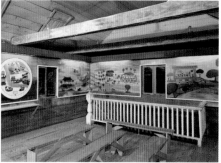

of which were in danger of being lost. After her husband's sudden death in 1918, she not only maintained what had become an agricultural empire, she also created a haven for artists, craftspeople, and authors at Melrose, making it a center for what became known as the Southern Renaissance.

Clementine Hunter was born on a nearby plantation in 1887 and came to Melrose with her family to work for the Henrys when she was twelve. She had always possessed an artistic nature, which first emerged through the domestic objects she crafted. But it was not until she was in her fifties and a grandmother that her true artistry burst forth. She began to paint using materials that had been left behind by one of the visiting artists, and once she started, she couldn't stop, using every object she could find as a surface for her art. After a full day of manual labor—she worked as a cook, among other things—she spent evenings painting by the light of a kerosene lamp. (Hunter also wrote a cookbook using her firsthand experiences at Melrose Plantation. It drew the attention of

Alice B. Toklas, who singled out one of her recipes and registered it with the French Academy in Paris.) Supplies were expensive, and her prolific habits led her to thin her paint with turpentine and to charge twenty-five-cents' admission to the exhibitions she held in her cabin. Through her tenacity, Hunter became well known and her work was featured in local exhibitions, even meriting a mention in *Look* magazine.

When she was sixty-eight, Hunter began the nine-panel mural cycle that depicts a story she was uniquely placed to tell: that of everyday life on the plantation. The scenes include a funeral procession, an evening at the local honky-tonk, a washing day, and even a self-portrait. Hunter placed the sweep of buildings constituting Melrose Plantation prominently among the images. African House, where the murals are installed, is a rectangular edifice with a steep low-hanging roof that lends it a mushroom-like appearance. Built and used by slaves, its architecture recalls both French barns and West Indian and subtropical African vernacular structures.

The small cabin where Hunter lived and painted for many years now sits behind the main house. A sign reading "Clementine Hunter, Artist" makes it unmistakable among the nine other surviving buildings. Here visitors can see more examples of her work as well as personal items such as her worktable, her artistic tools, and the photograph of John F. Kennedy that she hung over her nightstand.

Other buildings on the site include Yucca House (its first residence, a French Creole cottage built by slaves), the weaving cabin, the bindery, and the Big House, with its sweeping, two-story porch. Melrose Plantation remains a singular place that documents the artistic flowering of one of the country's most famous African American folk artists.

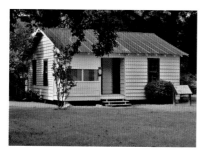 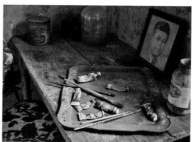

Edward V. Valentine Sculpture Studio
The Valentine

Edward Virginius Valentine (1838–1930)

1015 East Clay Street, Richmond, VA 23219
804-649-0711 thevalentine.org/exhibition/
edward-v-valentine-sculpture-studio/

*Some of the saddest and yet sweetest moments of my life have been
spent there, and I love the old place.*
—EDWARD V. VALENTINE

Sculptor Edward V. Valentine enjoyed a five-decade career creating portrait busts, idealized figures, and monumental public sculpture. He is best known for several commissions memorializing fellow Virginians, including Thomas Jefferson and Robert E. Lee. As his middle name, Virginius, suggests, he was a Virginian through and through and was especially devoted to his native city of Richmond. Valentine trained throughout Europe with some of the most highly regarded artists of the day and remained there throughout the Civil War. Once he returned to Virginia, he spent the rest of his life there, establishing himself as one of the most successful sculptors working in the South during his lifetime.

In 1871, Valentine purchased land at 809 East Leigh Street that included an 1830s carriage house. He renovated the space as his living quarters and working studio, adding a large north-facing window. Later, Valentine constructed a large annex to accommodate the monumental scale of his work, but retained the earlier studio for modeling, social, and business purposes. The smaller studio was moved to its present location

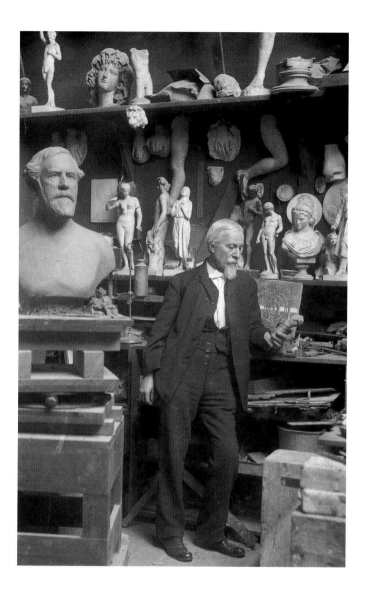

in the 1930s after the sculptor's death and is now part of The Valentine, a museum focused on the history of the Richmond region.

For nearly four decades of Valentine's life, his studio was a popular tourist destination, where he hosted such luminaries as writer Oscar Wilde and actors Joseph Jefferson and Edwin Booth (both of whom sat for a bust). The affable and knowledgeable sculptor gave talks in his studio

about not only his art, but also the history of Richmond, a subject that became his primary focus in later years. It was here that he executed his most famous works, including the standing *Thomas Jefferson* that resides at Richmond's Jefferson Hotel and the reclining marble figure of Robert E. Lee that marks Lee's burial place at Washington and Lee University in Lexington, Virginia. Among the abundance of sculptural objects and artist's tools on display are the full-size plaster models for these works. The modest space also boasts a profusion of smaller works in a variety of media, including plaster, bronze, and marble. These objects and the interpretive displays educate the visitor about the complex creative processes of sculpture making, in particular those required for creating portrait works.

Edward and his brother Mann shared a fascination with history. Mann ran the family health tonic business, and with the fortune he accumulated, he amassed a collection of art, artifacts, and curiosities. He purchased the 1812 Wickham House, now part of The Valentine, to house the collection. When Mann died, he left the collection, including the house, as a bequest to establish the museum. Edward became its first president and dedicated the rest of his life to running it. In his last decades, Valentine abandoned sculpture altogether and devoted himself to researching Richmond's history.

The fruits of his efforts are on display at The Valentine today, which continues to document the city's complex past. Richmond, the state's capital, was also the capital of the Confederacy during the Civil War. Its picturesque Monument Avenue is punctuated by imposing monuments, erected during the Jim Crow era, aggrandizing Confederate leaders like Robert E. Lee, Thomas "Stonewall" Jackson, and Jefferson Davis, this last sculpted by Valentine and unveiled in 1907. Although the artist produced numerous works not associated with the Confederacy, many of his works can be linked to an era of monuments dedicated to the "Lost Cause," an ideology that downplays or omits the role of slavery in the Civil War, painting it instead as a heroic struggle by an outnumbered army to preserve the Southern way of life. Today The Valentine is at the forefront of the current dialogue involving the relevance of this type of statuary in the present-day United States and examines these issues in the context of Valentine's sculpture, Richmond's history, and its diverse contemporary community. Artist Gari Melchers's home and studio is about an hour north in Falmouth, Virginia [p. 162].

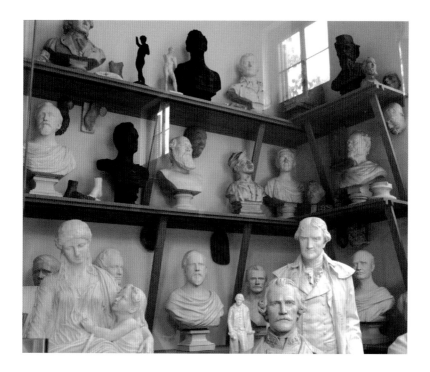

Gari Melchers Home & Studio
University of Mary Washington

Julius Garibaldi Melchers (1860–1932)

224 Washington Street, Falmouth, VA 22405
540-654-1015 **garimelchers.org**

On my return…I walked through the house and opening the
back door, looked down the hill across the fields and the river.
The beauty of Virginia made me wonder how I could ever
have left it even for a winter.
—GARI MELCHERS

Julius Garibaldi Melchers, known as Gari, was an American Impressionist,
portraitist, and muralist. Born in Detroit and trained in Europe,
Melchers was widely successful and influential in his own lifetime. He
was deeply involved in establishing what are now the Smithsonian
American Art Museum and the Virginia Museum of Fine Art. After his
death, he descended into relative obscurity, but has been rediscovered
over the last twenty-five years by the art market and the general public.
Belmont, his Virginia estate, represents the sixteen-year effort he and his
wife, Corinne, invested in creating both a convivial retreat to nurture
artistic production and a carefully designed environment that embodies
Southern hospitality and a bucolic lifestyle. This intersection of
cosmopolitanism, Southern gentility, and agricultural enterprise makes
Belmont singular and inviting. Melchers continually found respite here,
as well as inspiration for his artwork.

By the time Melchers met Corinne Mackall, a southerner and a budding artist, on a transatlantic crossing in 1902, he had studied at many of the most prestigious art schools in Europe and had achieved an international reputation. After their marriage the following year, the couple enjoyed a fashionable life in Europe, dividing their time among Germany, France, and the Netherlands. Corinne abandoned her own artistic ambitions to support her husband, critiquing his work, modeling for him, securing other models, sewing costumes, and even stretching canvases. The outbreak of World War I brought them back to the United States, where Melchers established a studio in New York City. The hectic pace of the city led them to seek a rural retreat to serve as their home and a repository for the impressive collection of fine and decorative arts they had amassed while abroad. Corinne's southern roots led them to Falmouth, Virginia, close to the birthplaces of both George Washington and George Mason, and the twenty-two-acre Belmont estate, which was in need of loving attention.

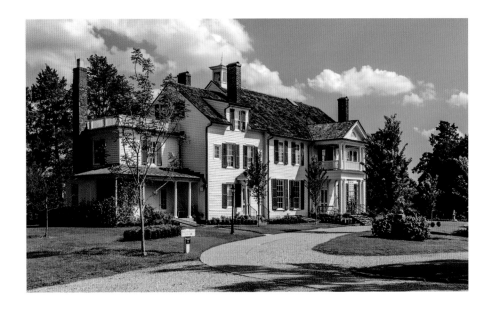

The couple devoted themselves to the rigorous task of improving their storied home and surrounding landscape and overseeing construction of a studio and its display galleries. The east elevation of the Georgian house features a winding double staircase adorned with an exquisite ironwork railing. The home affords beautiful and varied views of the formal gardens they designed and of the picturesque farmyard where the historic smokehouse, springhouse, and horse stable still stand. Because it sits on a ridge, the property also offers vistas of nearby Fredericksburg, Falmouth, and the Rappahannock River, which lends its cooling breezes to the estate. A walk around the spectacular grounds is a must for visitors today. The winding path laid out by the couple in the 1930s runs from the summerhouse toward the ice pond, connecting to the 1.5-mile Belmont-Ferry Farm hiking trails that wend through the woods and presenting a view of the Rappahannock River falls. The estate and adjoining trails provide excellent sites for birding and fishing, too.

Elegant and spacious, the house contains virtually all the couple's personal possessions. Among the decorative objects, furniture, and paintings from all over the world are especially fine examples of Dutch decorative and fine arts. In the parlor hangs a painting by Gari Melchers, reproducing the adjoining hexagonal sunporch added in 1916,

demonstrating that the interior remains virtually as it was. Not to be missed are several works by Corinne Melchers, a deft artist in her own right, including *The Model* (ca. 1929), which portrays her husband at his easel and the model he is painting, reflected in a mirror at the rear of the room.

The showcase of the estate is Gari Melchers's massive granite and sandstone studio, which he designed in the 1920s. Today it houses the largest collection of his paintings and drawings anywhere—some 1,600 items—and features rotating exhibitions spanning his career. The studio workroom includes his original artist materials, a cabinet likely owned by his sculptor father, Julius, plaster casts, and floor-to-ceiling paintings.

Gari continued to divide his time between New York and Belmont, in the ensuing years, while Corinne spent most of her time in Virginia, managing the gardens and the working farm, where chickens and turkeys roamed and cows provided fresh milk and cream. Belmont attests not only to the painter's critical and financial success, but also to the love and devotion of husband and wife to each other and to their southern sanctuary.

At her death in 1955, Corinne Melchers left the property to the Commonwealth of Virginia as a memorial to her husband's legacy.

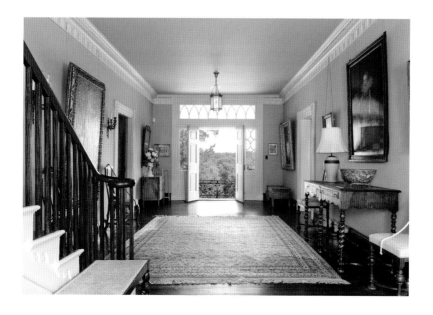

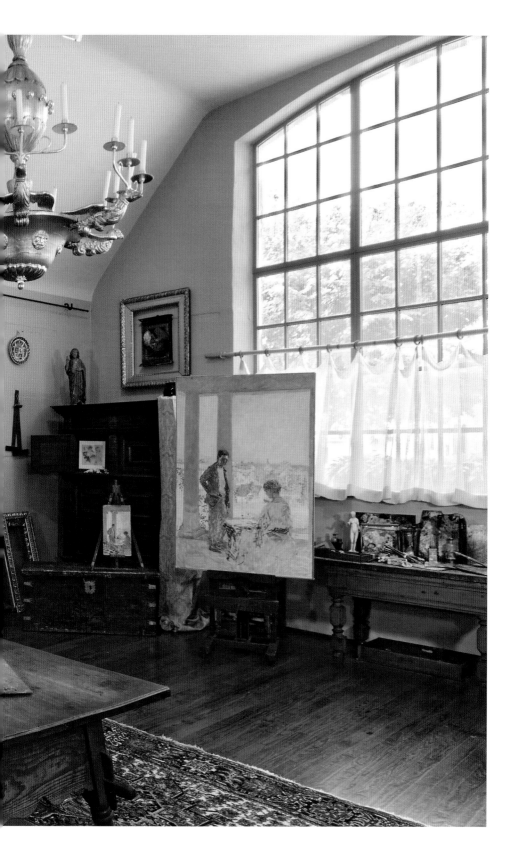

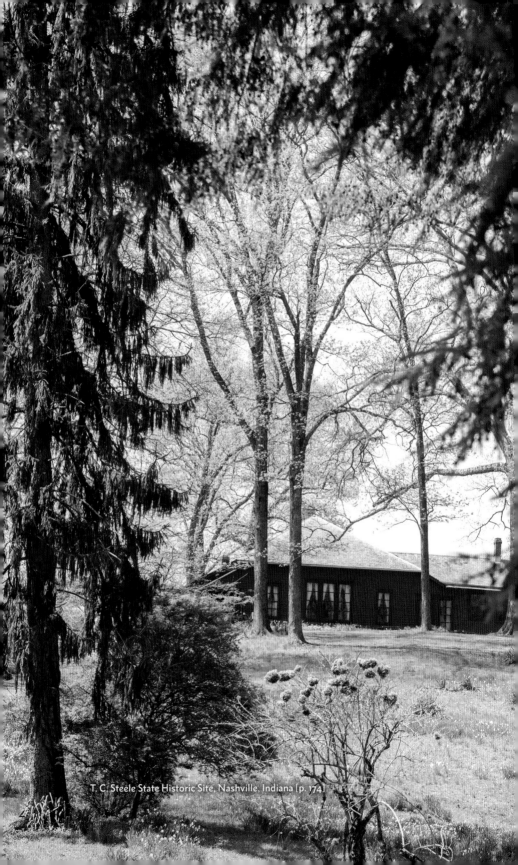

T. C. Steele State Historic Site, Nashville, Indiana [p. 174]

Midwest Region

Roger Brown Study Collection
School of the Art Institute of Chicago

Roger Brown (1941–1997)

1926 North Halsted Street, Chicago, IL 60614

773-929-2452 **saic.edu/rogerbrown**

[I am] always interested in making art that a lot of people could respond to on different levels.

—ROGER BROWN

Roger Brown was one of the leading Chicago Imagists, a circle of artists associated with the School of the Art Institute of Chicago (SAIC) that emerged in the late 1960s whose work was both representational (i.e., it depicted recognizable forms) and irreverent. They ignored the art establishment and its emphasis on minimalism and abstraction, and instead embraced nonconformity. Brown's home and studio, a former storefront building he bought in 1974 for $17,500, teems with a vast and eclectic array of densely displayed objects. He called it a "museum of inspiration."

The Alabama-born Brown arrived in Chicago in 1962 as a scholarship student, eventually earning both a BFA and an MFA from SAIC. A few of his professors encouraged their students to frequent the Maxwell Street Market, a weekly open-air flea market, for inspiration, a suggestion Brown eagerly followed. He had already begun collecting during his youth, and in adulthood he became an astute judge of art and objects, relying on his own discernment to build his collection, which reflects a remarkable breadth of interests.

Brown and his partner, architect George Veronda, converted the four apartments of the building into a single dwelling, with Brown's studio downstairs. Brown conceived of the space as an integrated home, studio, garden, and collection environment. The first floor now serves as an orientation/project space for SAIC, but its bookcases brim with publications of all subjects, sizes, and spine colors, ranging from Rand McNally's *Campground and Trailer Park Guide* to the intriguing *Elvis World* book set (Brown was distantly related to Presley) to volumes on Chicago politics and the Nazi regime, alongside perhaps more expected titles on the sculptor Alberto Giacometti and painter Henri Matisse. The LPs displayed on another shelf are a small selection of more than three hundred the artist owned. Visitors can choose from among these to create the soundtrack for their visit; staff play digitized versions of the selected albums over the site's speaker system.

The stairs lead to a wide-ranging display of art and objects that covers nearly every surface. The long, open living room and dining room hold rustic wood-hewn painted signs, tribal masks, and pop-culture items ranging from advertisements to plastic dolls to Christian devotional works alongside artwork by Brown and the numerous self-taught artists he discovered and championed. The theatricality of the display recalls the artist's earlier experiences as a set and costume designer for the opera and

theater. The medley of glorious texture and color also includes local items mixed among those from his travels abroad. For instance, Malaysian spears hang beneath an image of a bald eagle. Even the furniture is covered in things. A pair of fuzzy Ronald and Nancy Reagan bedroom slippers rests on a sofa nestled between two iconic Marcel Breuer "Wassily" chairs, all surrounding a Mies van der Rohe "Barcelona" table. Guests visiting the artist were encouraged to push everything aside to make room to sit down, and yet he arranged every last item meticulously. Indeed, he claimed that the objects seemed to suggest an affinity for one other, and he was merely their conduit of expression.

Brown was interested in how objects were made and believed that what he deemed "good design" was the most important criterion, whether the object was handcrafted or mass-produced, fine art or commercial. The collection was integral to the evolution of his own work. He wanted to surround himself with things that he found interesting. And although he purposely didn't explain exactly how the collection influenced his work, he did once remark, "Half the time I'm painting, I'm laughing."

Brown's 22-by-54-foot glass mosaic *Arts and Sciences of the Ancient World: The Flight of Daedalus and Icarus* adorns the front of 120 North LaSalle Street, across from City Hall. Visitors should be sure to stop there on the way to the Art Institute of Chicago, where they can see works by Brown and many other artists in the Historic Artists' Homes and Studios network.

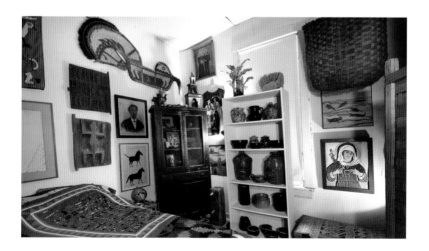

T. C. Steele State Historic Site
Indiana State Museum and Historic Sites

Theodore Clement Steele (1847–1926)

4220 T. C. Steele Road, Nashville, IN 47448
812-988-2785 **indianastatemusem.org/tcsteele**

It has seemed to me that the greatest of all arts is the art of living.
—T. C. STEELE

T. C. Steele, American Impressionist painter and leading member of the Hoosier Group, was already a successful artist with an international reputation when he purchased land in rural Brown County, Indiana, in the 1890s. He selected the initial 171 acres, he wrote, "because it was in the midst of innumerable beautiful subjects. They are spread out around in every direction." In the ensuing decades, Steele and his wife, Selma, transformed the former farm into an extensive, highly landscaped retreat that inspired Steele's painting. They also established a gathering place for the burgeoning local art community. Today, the site offers visitors an experience akin to stepping directly into one of the artist's landscape paintings.

Steele designed a barn-red, craftsman-style house on a hilltop six hundred feet above the surrounding countryside; several outbuildings of the same color contrast with their pastoral surroundings and echo the characteristic farm buildings of the region. The residence draws on the era's artisanal craft aesthetics, including a pyramidal roof to provide high ceilings, screened porches, and beautiful hand-carved wood details. On the living room's central fireplace, friend and artist Gustave Baumann

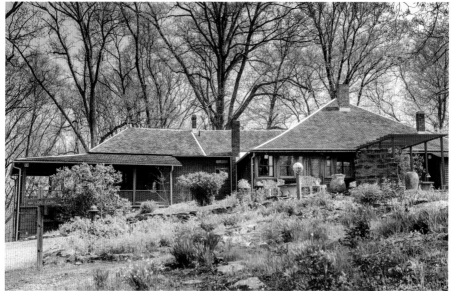

engraved the words of Scottish writer Fiona MacLeod, "Every morning I take off my hat to the beauty of the world," one of many inspirational quotes found throughout the site. Bookcases containing Steele's extensive library flank the fireplace, and numerous Steele paintings hang high on the vivid green walls. The Steeles named their home House of the Singing Winds after the melodic sounds they heard as breezes flowed through the eastern porch, where they dined in warmer weather.

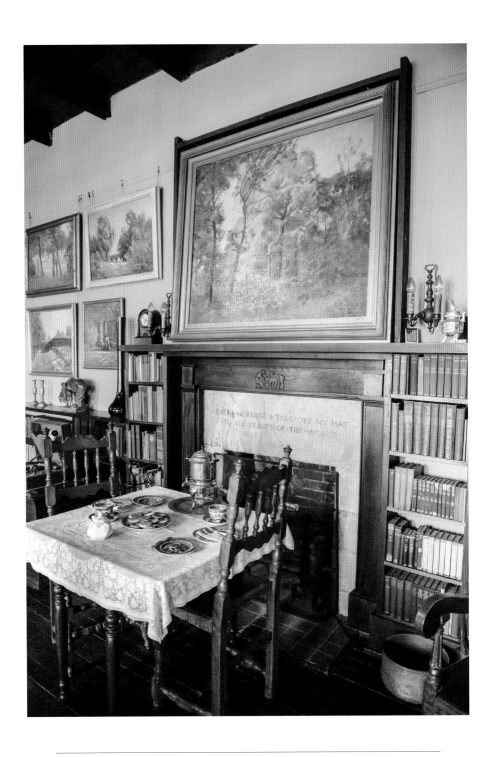

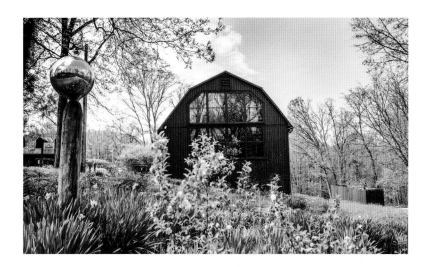

Steele's first studio was the present-day living room, but the west wing was added later to serve this function. Eventually, the painter built a sizable barn-like building with an enormous classical-style window to capture the northern light. Inside, situated among many of his paintings, are his easel and other working materials. This formal studio served primarily as an exhibition space for those who came to view and purchase his art.

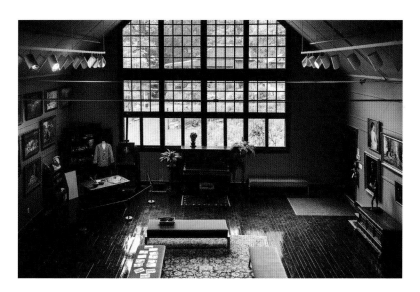

Because Steele prioritized painting *en plein air*, he built two rustic structures on the property that allowed him to paint in the fields even in inclement weather. Earlier, he had designed an ingenious horse-drawn wagon studio—described by his daughter Daisy as resembling a "Gypsy Wagon"—to travel throughout the Indiana countryside. A recreation of the original, which was destroyed in a fire, stands near the site's classroom.

Nature was a crucial inspiration for Steele, captured in his credo, "Seasons come and go, Eternal Change, but always with their gifts of beauty." The property boasts a varied landscape, from formal floral gardens to forests, hidden arbors, and even a stone bridge. A series of beautifully laid stone walkways mark the designed landscape and lead to five hiking trails through the property, which includes a cemetery where the Steeles are buried. Another trail leads to the historic Dewar log cabin, where displays document the area's natural history. The adventurous

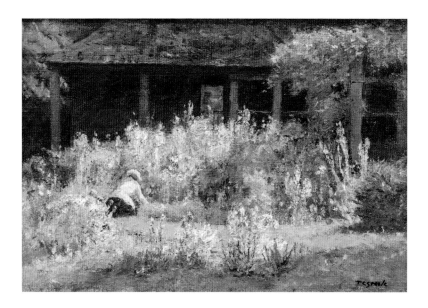

visitor can take one of the trails to connect with the forty-two-mile Tecumseh Trail.

The stunning and expansive gardens designed by Selma Steele are another highlight. They include great swaths of daffodils and wildflowers on the hillside, water lily ponds, opulent formal perennial beds protected by rose arbors, and an extensive series of plantings defined by rock terraces, walls, and borders. When her husband began painting the gardens, she described this as the "highest peak" of the joy she found in her work.

Among those drawn to the region by Steele's example were a younger generation of painters who would become known as the Brown County Art Colony, most notably Adolph Shulz and his wife, Ada Walter Shulz, Will Vawter, and Gustave Baumann.

Despite its remote location, Brown County received many visitors who traveled there to see the landscape these artists made famous in their paintings. The Steeles' life at House of the Singing Winds embodied what they believed not only artists, but all people, required: "To a people these sanctuaries of the spirit are necessary for sanity and growth and I use the word sanctuary advisedly for they are places not only for recreation and enjoyment but inspiration."

Grant Wood Studio
Cedar Rapids Museum of Art

Grant DeVolson Wood (1891–1942)

810 Second Avenue SE, Cedar Rapids, IA 52403

319-366-7503 **crma.org**

All the really good ideas I ever had came to me while I was milking a cow.

—GRANT WOOD

American Gothic (1930, Art Institute of Chicago, p. 183, bottom right), one of the most iconic and reproduced images in all of American art, was painted in the compact space that served as Grant Wood's home and studio for just over a decade. Wood transformed the second floor of a late nineteenth-century brick carriage barn, which had been recently converted into a six-car garage, into a marvel of flexible space for working and living.

Wood was born in Anamosa, Iowa, and moved to Cedar Rapids with his mother and sister after his father died in 1901. Apart from short stints in Minneapolis (at the Handcraft Guild) and Chicago (at the School of the Art Institute of Chicago), traveling several times to Europe (including one year of study at Paris' Académie Julian), and serving briefly in the military, he spent his life in Iowa, where he taught art and pursued a painting career. Known for wearing starched white shirts, dress shoes, and denim bib overalls while working (the last a nod to the farmer and factory cultures of the midwest), Wood is remembered to have said,

"I needed to go to France to appreciate Iowa."

In 1924, Wood's long-term patron David Turner hired him to redecorate the interior of a stately nineteenth-century home he intended to use for a funeral business, and he offered Wood the upper floor of the carriage barn, where he, his mother, and sometimes his sister lived. The artist's ingenuity transformed the nearly one-thousand-square-foot space into a functional interior that reflected his interest in—and talent for—architecture and design. The central cupola and sharply sloping roof lines are complemented by exposed beams, roughly textured white walls, and simple wood floors, all evoking the modest lodgings he would have seen in Europe and reflecting the popularity of handcrafted design in the United States at this time.

Wood added a series of windows to bring more light into the studio. Built-in niches and innovative storage areas maximized the space with artistic flair and creativity. He carved out a bedroom, a minute kitchen, and a bathroom that included a sunken tub built into the former hay

shoot. Most of the space was dedicated to living, dining, painting, and entertaining. Storage cupboards held rollaway beds, and his own paintings were stored behind a wall on movable racks that could be wheeled out as needed. A beautiful floral-motif metalwork screen hides the radiator, and a metal bushel basket was adapted for use as the fireplace hood. Indeed, Wood's handcrafted metalwork, which also includes lanterns and light poles, appears throughout. The studio stands as an exemplar of loft living and D I Y ingenuity.

Living rent free allowed Wood to quit his teaching job at McKinley Junior High School and devote himself to painting. His home and studio also became a social hub for the community. The artist even hosted early theatrical performances by what eventually became Theatre Cedar Rapids.

Wood's wit is on display at the front door, which is a repurposed coffin lid. Its painted glass insert features a dial and pointer to indicate the artist's whereabouts, including "Taking a Bath" and "Having a Party," along with the more expected indicators like what time he might return (p. 183, bottom left). The artist vacated the studio in 1935 when he accepted a full-time teaching position at the University of Iowa and moved to Iowa City.

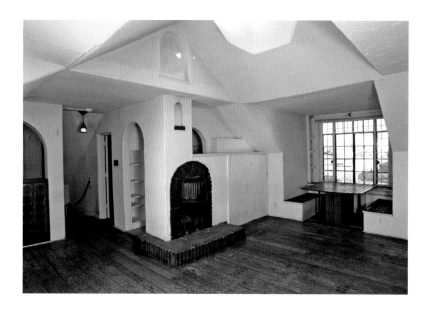

Only a few blocks away is the Cedar Rapids Museum of Art, which houses the largest collection of the artist's works (as well as owning and operating the studio). The nearby Brucemore estate features a relief mural that Wood created in one of its sleeping porches, and the city's Veterans Memorial Building boasts a stained-glass window of his design. The Grant Wood Scenic Byway stretches eighty miles from Stone City to the Mississippi River and offers the feeling of stepping into one of Wood's landscape paintings. A little further away in Eldon, Iowa, one can visit the *American Gothic* house, which served as the backdrop for the artist's most famous painting.

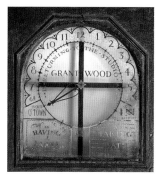 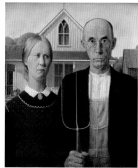

Thomas Hart Benton Home and Studio State Historic Site Missouri State Parks

Thomas Hart Benton (1889–1975)

3616 Belleview Avenue, Kansas City, MO 64111

816-931-5722 **mostateparks.com/park/thomas-hart-benton-home-and-studio-state-historic-site**

The only way an artist can personally fail is to quit work.
—THOMAS HART BENTON

The stately property in the Roanoke neighborhood of Kansas City that painter, muralist, author, and arts educator Thomas Hart Benton called home perfectly encapsulates his complexities. Born into a political family in Missouri, Benton defied his father to become an artist. He nevertheless embraced the necessity of wielding influence to win large commissions, including one for Harry Truman's presidential library. Sophisticated and well read, Benton championed rural America and its inhabitants in his art and forcefully expressed his populist political views. His groundbreaking murals depicting multiple narratives are at once irreverent and lyrical, and often courted controversy.

The Paris-educated Benton became an influential art instructor in New York, most famously introducing a young Jackson Pollock to his antiestablishment philosophy. After two decades there, the artist accepted a teaching position at the Kansas City Art Institute. His wife, Rita, who managed every aspect of Benton's career and their home life, purchased the house for $6,000 while the artist was traveling. Built in 1903 by architect George Mathews, a proponent of the City Beautiful

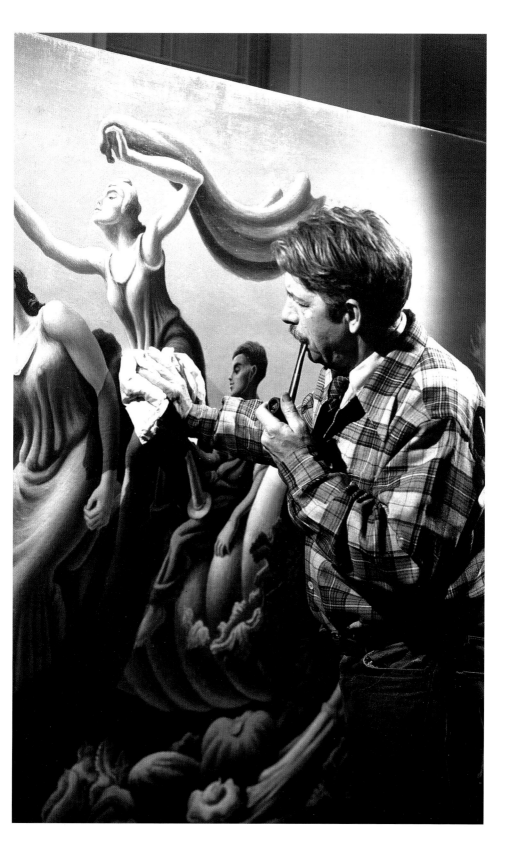

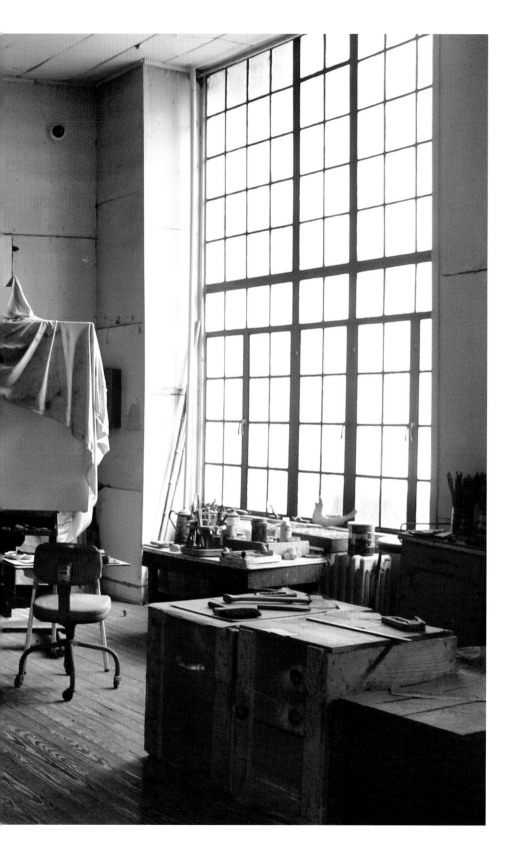

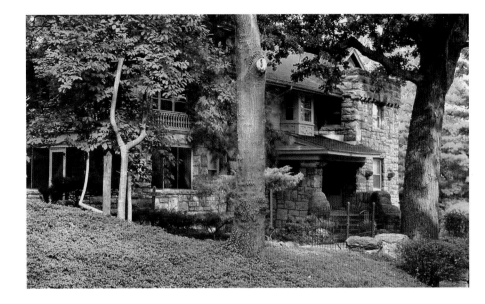

Movement, the 7,800-square-foot limestone edifice, with its mature trees and paved walkways, demonstrates Benton's financial success. The neighborhood boasts several other homes by Mathews as well as numerous Prairie-style homes. Frank Lloyd Wright designed the house adjacent to Benton's in 1940.

In accordance with Rita Benton's wishes, the interior of the 24-room, 3.5-story home remains much as it was when she died only eleven weeks after her husband in 1975. The elegant architectural features include a free-standing central fireplace and the wide staircase that winds around it. Everywhere is evidence of the Bentons' vibrant lifestyle, beginning with the baby grand piano near the entrance; everyone in the ardently musical family played an instrument, several members recorded an album together, and their son became a flutist with the Boston Symphony Orchestra. Well-worn slipcovered furniture surrounds a television topped by a rabbit-ear antenna, clothes still hang in the closet, the ironing board is out, and a table full of liquor bottles waits in the dining room. As a child, their daughter was allowed to paint while sitting on the floor of Benton's studio as he worked, and she also painted several windows in the house with figures that emulated those found in traditional stained glass. The Bentons were avid entertainers, hosting dinners,

musicales, and discussions, always surrounded by paintings that Rita displayed prominently in hopes of enticing guests to purchase them.

The carriage barn behind the house became Benton's studio. After spending most of his day here, literally whistling while he worked, he often returned in the evenings after dining with his family. The studio, with its generous proportions, lent itself to his large-scale mural projects. He had the lofty northern window added to supply the ideal light. The focal point is his prominent easel, which is surrounded by materials scattered in ordered disarray: row upon row of small jars of pigment, wood putty, varnishes, tubes of acrylic paints, coffee cans filled to bursting with brushes of every shape and size, rolled raw canvases, empty frames. A careful look reveals a large jawbone perched on a windowsill, a straw hat hung on the wall, and even Benton's beloved harmonica. He used the small modeled figures (known as maquettes) on display to create three-dimensional compositions for his murals. It is here that the artist died unexpectedly one evening, having returned to sign what would be his last work, but collapsing before he could do so.

One of Benton's most famous murals, *A Social History of the State of Missouri*, is installed in the state capitol building in Jefferson City. This ode to his home state also conveys many hallmarks of the artist's work: social history, political commentary, and the belief that history is alive, made through the actions of human beings.

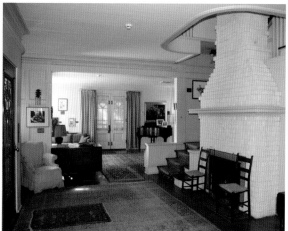

Burchfield Homestead Society

Charles Ephraim Burchfield (1893–1967)

867 East 4th Street, Salem, OH 44460

330-717-0092 **burchfieldhomestead.com**

The Elysian fields are not at the ends of the earth—they are here at my feet.

—CHARLES BURCHFIELD

Long after Charles Burchfield left his childhood home in Salem, Ohio, he returned time and again in his imagination to the fields, forests, and buildings that lay just beyond the walls of his house, and that had captivated him in his youth. Depicting his immediate surroundings in this small community in northeastern Ohio became a lifelong pursuit and resulted in works noted for their evocative depictions of nature and neighborhood buildings. This unassuming nine-room house retains all the elements familiar to any devotee of Burchfield and his art: porch, garden, grape arbor, and small alleyway. Across the street sits another equally modest house. There, a neighbor threw salt onto the sidewalk in frigid winter weather, a scene the artist immortalized in his paintings (p. 192).

In 1993, to mark the centennial of Burchfield's birth, the Burchfield Homestead Society, with the assistance of the Charles Burchfield Foundation, bought and lovingly restored the house where the artist lived from the ages of five to twenty-eight. In 2017, the society celebrated the hundredth anniversary of what Burchfield proclaimed was his "golden

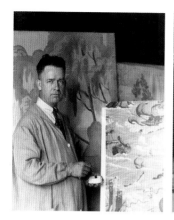
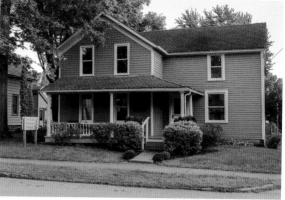

year," when the twenty-four-year-old produced more than two hundred works, many featuring views from the windows of the house as well as compositions highlighting neighboring houses and downtown commercial buildings. The rural environment surrounding the town was another important source of inspiration for Burchfield; woods and pastures were only a brief walk from his home. To visit the house and its restored garden or walk the streets of Salem today is to see Burchfield's works come to life in a virtuostic synthesis of transcription and imagination.

Charles Burchfield was born in 1893 in Ashtabula Harbor, Ohio, but became a resident of Salem in 1898, when his mother moved back to her hometown with her six children. Intending to become an illustrator, the teenage Burchfield began working at W. H. Mullins, a local metalwork manufacturer, to save money for art school. In 1912, the family expanded the home to its current nine-room configuration. The windows added at this time offer many views that are identifiable in numerous Burchfield paintings. After he graduated from the Cleveland School (now Institute) of Art in 1916, the artist's former teachers organized his first solo exhibition. Later that fall, he received a scholarship from the National Academy of Design in New York. He left the Academy after a single day, but remained in the city for another six weeks before returning to Salem.

While employed again at W. H. Mullins, Burchfield produced many artworks and frequently exhibited in Cleveland. In the fall of 1921, in anticipation of his marriage to Bertha Kenreich (also from Salem), and

to pursue an art-related career, he moved to Buffalo, New York, to design wallpaper for M. H. Birge & Sons. In 1929, in the midst of the Depression and with a family to support, he resigned from Birge to make a living as a watercolorist with the ardent support of Bertha. Burchfield acknowledged, "I would not have been able to do it if it hadn't been for the faith and courage of my wife."

Just seven years later, a 1936 *Life* magazine article named him one of America's ten greatest painters. In the 1940s, he returned to a series of drawings and sketchbooks from his youth, reworking the small compositions, including views of Salem and the house, into larger collages incorporating strips of paper pasted around the edges.

Although the Salem homestead is no longer furnished, reproductions of the artworks that highlight specific views from the windows are displayed throughout. These are enhanced by quotes from Burchfield's journals—kept his entire life—that reflect the influence of the house and neighborhood on his art making. When he was eighteen, he wrote in his diary:

> A house is often more moody than nature. What a rare thing it is. They are built by men as dwellings; windows are put in to let in light—and this strange creature results. In the daytime they have an astonished look, at dusk they are evil and seem to brood over some crime committed or begun. Each one is an individual.

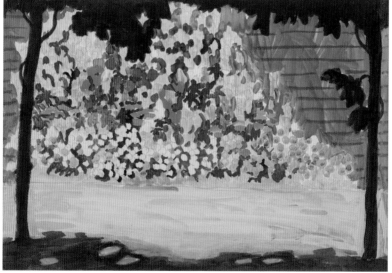

Burchfield's second-floor bedroom was his first studio, illuminated by
the skylight his mother had installed to afford her son views of the sky,
a prominent aspect of works from that period. Surrounding the house are
the replanted gardens that also figure into work from his early years.

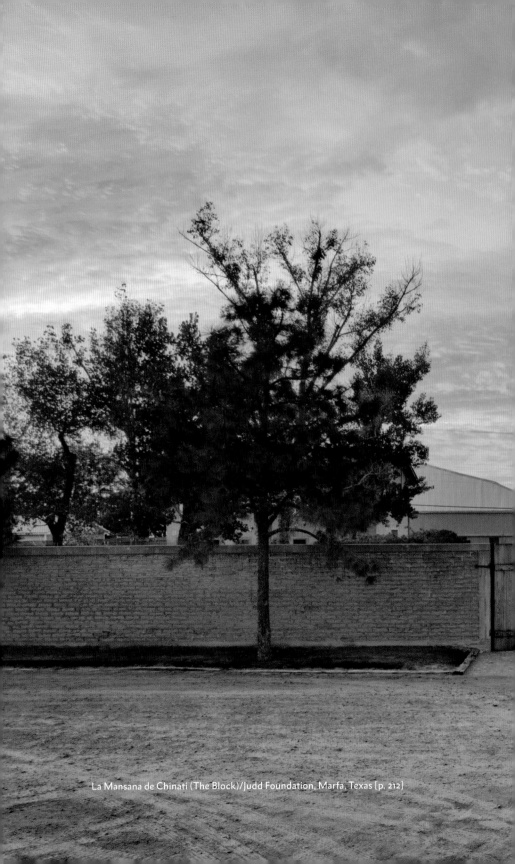

La Mansana de Chinati (The Block)/Judd Foundation, Marfa, Texas [p. 212]

Southwest Region

Abiquiú Home and Studio
Georgia O'Keeffe Museum

Georgia Totto O'Keeffe (1887–1986)

Abiquiú Home and Studio, 21120 Highway 84, Abiquiú, NM 87510
Georgia O'Keeffe Museum, 217 Johnson Street, Santa Fe, NM 87501
505-685-4539 **okeeffemuseum.org/store/products/
abiquiu/abiquiu-home-studio-tour/**

Take time to look.
—GEORGIA O'KEEFFE

Georgia O'Keeffe's residence in Abiquiú, New Mexico, was not her first southwestern home and studio, but it was the most hard-won. She began traveling regularly to the state in 1929, and first spotted the eighteenth-century Spanish Colonial adobe compound in the mid-1930s. The artist became captivated by its magnificent eastern views toward the mountains and the White Place (Plaza Blanca), awash in the brilliant desert light and set against the expansive sky. She immediately tried to buy it—and failed—from its owner, the Catholic Church. Then in the early 1940s, she tried again, and the Church still refused. O'Keeffe persisted, but by the time she finally acquired it in 1945, it was run down and in poor condition. So she and her friend Maria Chabot, with the help of local workers, began restoring and customizing the five-thousand-square-foot structure. "Inch by inch it is becoming—my house—something that feels like my shell to live in," O'Keeffe remarked, and she finally moved in four years later.

While O'Keeffe was restoring her home, the United States was entering the Atomic Age. Her progress was sometimes halted when the

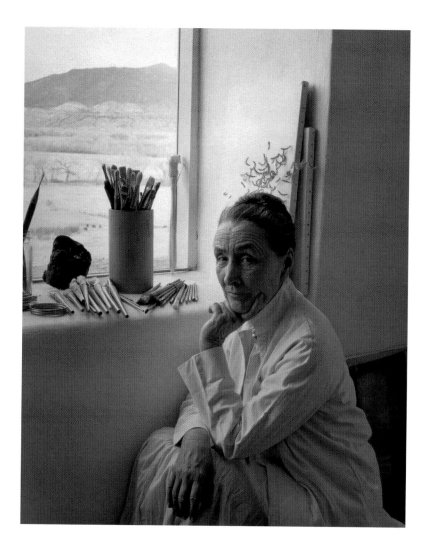

nearby Los Alamos Laboratory, which was working on the Manhattan Project, commandeered scarce building materials. In the 1960s, O'Keeffe also built a bomb shelter on her property.

The years-long renovation resulted in a space that honored both the artist's needs and the structure's Spanish Colonial style. She retained the single-story structure, with wings that are one room deep and arranged around a central courtyard, along with traditional elements like adobe fireplaces and the exposed-beam ceilings. The infamous black door,

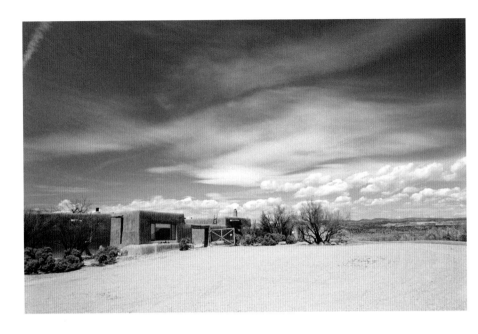

which O'Keeffe depicted in more than twenty works, is within the central courtyard. The large windows and skylights that she added illuminate what would have been dark interiors and provide expansive views of the verdant Chama River Valley and copses of cottonwood trees. In winter, O'Keeffe painted these from her corner bedroom window.

The spare interiors of both the house and the studio, a separate building within the compound that includes a large 1950s picture window and attached private bedroom and bathroom, echo the desert landscape that the artist reveled in every day. She spent hours exploring the outdoors. During her excursions, she collected objects like weathered bones, rocks, and fossils, often incorporating them into her abstract depictions of the landscape.

Inside the house, O'Keeffe painstakingly arranged her space, once remarking, "My house in Abiquiú is pretty empty; only what I need is in it. I like walls empty." The neutral walls and modernist furnishings have few companion objects beyond the specimens she collected from the desert and artfully arranged. Only a few paintings and sculptures by the artist and even fewer works by other artists and designers—such as a "Tulip Table" by Eero Saarinen and a "Bird Chair" by Henry

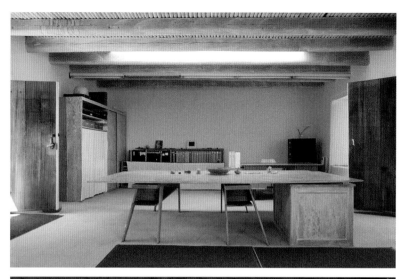

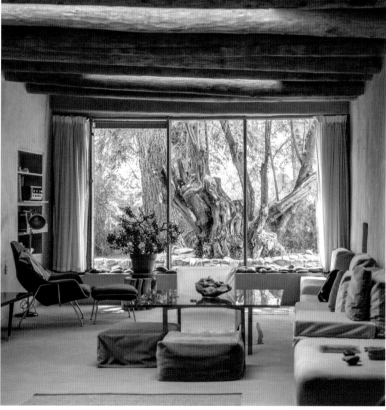

Bertoia—punctuate these spaces. The white Japanese paper lantern lighting fixture that hangs over the O'Keeffe-designed dining table is by Isamu Noguchi. As in her paintings, this thoughtful composing illustrates the artist's assertion that "what I do is fill space in a beautiful way."

An exception to the prevailing austerity is the fully equipped pantry behind the kitchen. O'Keeffe was an avid cook—she relied on what she cultivated in her beloved fruit and vegetable garden—and her pantry still contains jars of hand-dried herbs with labels written by some of her house staff. The densely packed shelves display a plethora of pots, pans, stone crocks, and other equipment that she used to prepare her own recipes— anything from borscht to homemade yogurt. Outside, visitors can enjoy the restored garden.

The Georgia O'Keeffe Museum in Santa Fe, an hour to the south, operates tours to the home and studio out of the O'Keeffe Welcome Center in Abiquiú. The museum owns the world's largest collection of O'Keeffe works—including more than three thousand pieces of personal property and artist materials. O'Keeffe spent winters in Abiquiú and summers in her more remote property, Ghost Ranch, fifteen minutes farther north. While the museum does not own the Ghost Ranch

Education and Retreat Center, the center provides driving tours of sites where O'Keeffe painted, including hikes to such spots. Within an hour's drive are sites dedicated to artists associated with the Taos Art Colony, including the homes and studios of Eanger Irving Couse and Joseph Henry Sharp [p. 202], Ernest L. Blumenschein, and Nicolai Fechin.

Couse-Sharp Historic Site

Joseph Henry Sharp (1859–1953)
Eanger Irving Couse (1866–1936)

146 Kit Carson Road, Taos, NM 87571
575-751-0369 **couse-sharp.org**

[Taos is my] first love and stomping ground...I would rather eat boiled dog in Taos than roast lamb and asparagus in Pasadena.
—JOSEPH HENRY SHARP

My interest has always been the domestic side of the Indian rather than the usual conception of the Indian always on the warpath and I have tried to depict their picturesque life from the standpoint of one who enjoys their dances, ceremonies and daily life.
—EANGER IRVING COUSE

Eanger Irving Couse and Joseph Henry Sharp (opposite, above right and left, respectively), together with four of their artist colleagues, founded the Taos Society of Artists in 1915. Through the members' art, which depicts the landscape and Native people of the region, the organization sought to enhance perceptions of the American West through nationwide traveling exhibitions. Close friends Couse and Sharp were also neighbors, their adjacent properties occupying a long slope overlooking the mountains. Today, the two-plus-acre site includes original adobe structures

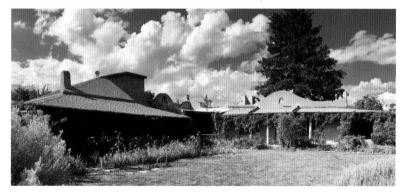

that the artists adapted for their own uses—like the Luna Chapel, the 1830s Spanish family chapel that was Sharp's first studio—along with the sprawling Couse home and studio. Virginia Couse's splendid garden, which she created on the hillside out of a high-desert landscape, provides an inviting respite for visitors and an inspiration for *plein air* painters.

Ohio-born Henry Sharp, who became deaf after a childhood accident, was fascinated with Native American life and first visited the western United States in 1883. After artistic training in Europe, he settled in Cincinnati, where he taught at the Cincinnati Art Academy. He was one of the first European-American artists to visit Taos; he first came in 1893

and began to spend summers there a few years later. Sharp had already established himself as a painter of portraits of Native people (living for a time among the Crow people), although his varied interests included landscapes and floral still lifes.

The home that Sharp and his wife, Addie Byram, purchased in 1908 exists only in remnants, but the Luna Chapel remains. Sharp built a larger studio nearby in 1915 that today houses a permanent rotating exhibition of his paintings, Native art objects he collected, and personal artifacts; a bison skull adorns the front door as it did during the many years Sharp painted there. Nearby is a replica Crow-style teepee similar to one the artist erected seasonally on the grounds.

Eanger Irving Couse's interest in Native American cultures began during his rural Michigan childhood, and he soon determined he would become a painter of Native life. While studying in Paris, he met and married Virginia Walker, a fellow American art student. The Couses began spending summers in Taos in 1902, and seven years later they purchased the house adjacent to the Sharps. It was originally a one-room Spanish Colonial house that had been built shortly after the Luna Chapel; subsequent owners added an additional six rooms. The Couses made their own additions, including a spacious studio with high, north-facing windows for him and later a machine shop and laboratory for their inventor son, Kibbey.

The families' proximity, as well as their mutual artistic interests, facilitated a lifelong bond. Both artists engaged people from Taos Pueblo as models, some of whom became close friends of their families. Couse's favorite model, Ben Lujan (who met the painter when he was a boy and regarded Couse as a second father), helped Virginia design and maintain the gardens, the first such ornamental displays in Taos. Couse's Pueblo friends called him "Green Mountain," both as an honor that recalled their sacred Taos Mountain and in warm reference to his rotund body when swathed in his favorite green sweater. The Sharps, who had no children, arranged for Kibbey Couse to take over their property after their deaths.

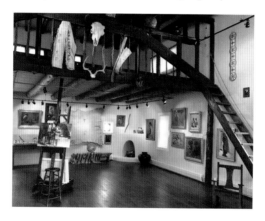

Today, the Couses' home remains intact, with their original New Mexican and East Coast furniture, their collection of nineteenth-century New Mexican religious art, local textiles, and other Native and Hispano objects. Eanger Irving's studio retains his brushes and palette alongside the Native pottery, regalia, beadwork, and other objects that appear in his artwork. The house is the most complete remaining example of life in the early Taos art colony. Outside, Virginia's garden cascades along the grounds overlooking a meadow and the towering, distant Truchas Peaks.

The Couse and Sharp families impacted both local and American history through their collecting and preservation efforts and their depictions of Native peoples, who were an intimate part of their daily lives. The site maintains ties with many of the models' descendants and continues to promote Native arts, staying true to the families' original commitment and ethos.

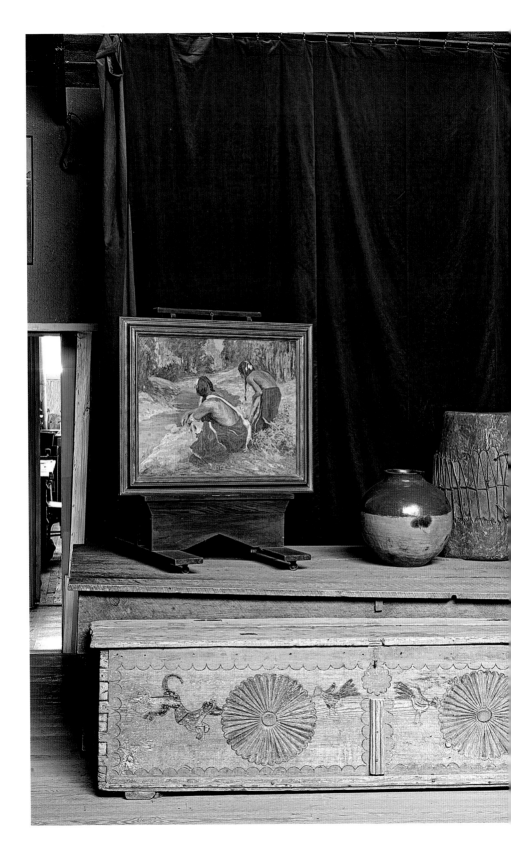

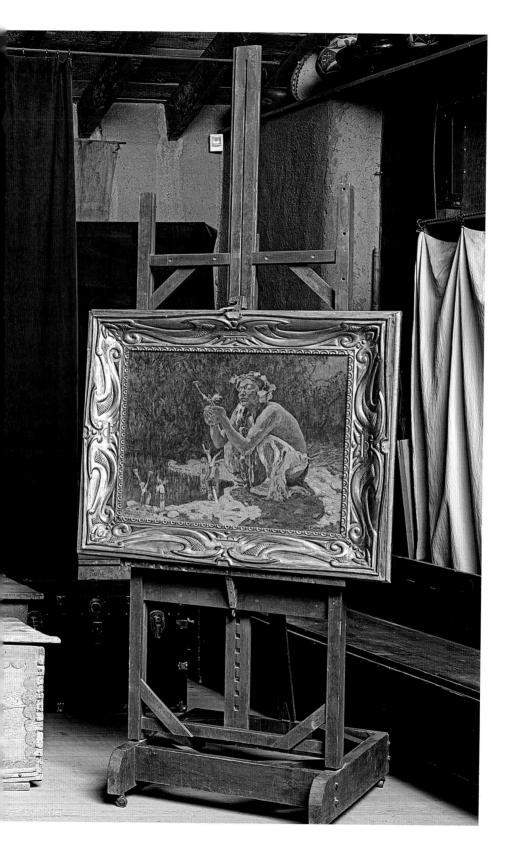

Elisabet Ney Museum
Austin Parks and Recreation

Elisabet Ney (1833–1907)

304 East 44th Street, Austin, TX 78751

512-974-1625 **elisabetneymuseum.org**

Texas has a charm for me, a charm of a particular kind, in nearing it, that no other part of the wide world has.

—ELISABET NEY

The formidable and seemingly out-of-place limestone castle that houses sculptor Elisabet Ney's studio in Austin, Texas, suggests a complex woman who defied convention. By the time Ney designed and built this studio in 1892, she had already lived several chapters of an extraordinary life that inspired three novels and four one-woman plays. Before arriving in America, she had achieved acclaim and success unprecedented for her gender. Born Franzisca Bernadina Wilhelmina Elisabet Ney in Germany, she was the first woman sculptor to study at the Munich Academy. In Germany, she counted King Ludwig II among her patrons and friends and created likenesses of such notable figures as naturalist Alexander von Humboldt, philosopher Arthur Schopenhauer, Italian war hero Giuseppe Garibaldi, German chancellor Otto von Bismarck, and King George V of Hanover.

Despite such achievements, including occupying a studio at the royal court, Ney's fierce independence proved problematic. She refused to take the name of her husband, Scottish physician and philosopher

Edmund Montgomery, and her reference to him as her "best friend" led many to believe they were not legally married. Both to escape the political upheaval that would lead to the demise of the monarchy and to seek medical treatment for Montgomery, the couple immigrated to America in 1871. By 1873, they were living at Liendo Plantation, an old cotton plantation in Texas. Ney abandoned sculpting for two decades to run the plantation and raise her family, both of which she was devoted to. She was also an early leader of the Texas women's movement. Suspicion met her on the Texas frontier because of her short haircut, exotic and unconventional clothing, and unbridled feminist, socialist, and civil rights advocacy. Familiar gossip and questions about her marriage reappeared. None of this intimidated her.

In her fifties, with her surviving child grown, Ney decided to return to her career. One of her first commissions was for likenesses of notable Texans for the 1893 World's Columbian Exposition in Chicago. This provided her with the money to buy property and build her studio in the more welcoming Austin. She named the building Formosa, Portuguese for "beautiful," likely a reference to the time she and Montgomery spent on Madeira. Ney was among the first professional artists in Texas, and hers remains the first known artist's studio in the state. The cornerstone

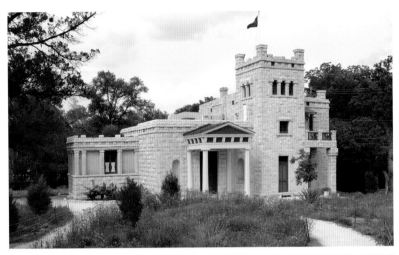

Latin inscription, *Sursum*—meaning "Arise!"—is both her creed and the name of a marble sculpture of two idealized figures on view inside.

In Austin, Ney again established a flourishing studio practice and cultivated an artistic, political, and intellectual social circle emulating the one she had in Germany. She traveled back and forth from the plantation (where Montgomery often remained) either on horseback or by buggy. Along the way, Ney was known to wear a turban, sleep in a hammock outdoors, and, purportedly, bring her bathtub. Such eccentricities

turned her into something of a local legend. Increasing commissions and a growing reputation allowed her to perfect her workspace. She enlarged the studio in 1902, and this bigger space enabled her to have many of her German works shipped to Texas to be placed on view. At this time, Ney also erected the tower study for Montgomery's use, which visitors today can ascend.

The objects on display in her studio document Ney's sculptural process and include tools, works in her preferred media of marble and plaster, and preparatory casts of hands and feet, a human skull, and even detailed musculature. The museum boasts the largest collection of Ney's works in the world, spanning her entire career and including drafts of her ultimate masterpiece, *Lady Macbeth* (1905, below), the final marble of which is at the Smithsonian American Art Museum, Washington, DC. Also on display are original furnishings and personal effects.

The Elisabet Ney Museum also features exhibitions of contemporary art by Texas women both indoors and outdoors, where sculptures are situated in the recently restored native prairie landscape. A disciple of philospher Jean-Jacques Rousseau, Ney steadfastly rejected convention in her landscaping, leaving the property in its fully natural state, to which it has been carefully returned.

Ney was a trailblazer even after her death in 1907. Immediately afterward, some 120 friends and admirers ensured the site's preservation, making it Texas's first art museum in 1911. Devotees can make the two-hour drive to Liendo Plantation, also a historic site, where Ney is buried.

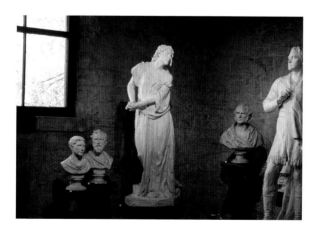

La Mansana de Chinati (The Block) / Judd Foundation, Marfa

Donald Clarence Judd (1928–1994)

La Mansana de Chinati (The Block), 400 West El Paso Street
Judd Foundation, Marfa, 104 South Highland Avenue, Marfa, TX 79843
432-729-4406 **juddfoundation.org**

*Aside from Ft. Russell…the Mansana de Chinati, the block,
a city block in town, is the largest and most complete place
that I've planned.*
—DONALD JUDD

The endlessly expansive sky and resolutely arid, horizontal landscape of
Marfa, Texas, contrast sharply with the setting of artist Donald Judd's first
home and studio: the bustling streets and soaring buildings of New York
City [see p. 84]. Yet in the context of his artistic evolution, Judd's decades-
long work at Marfa is a continuation of his ideas about the relationship
among art, architecture, and permanent installation that he began explor-
ing in Manhattan.

Marfa includes numerous buildings purchased and altered by the
artist to display artwork, from grocery stores to old hotels to a decom-
missioned military base, an effort he began in 1973. The entire town, now
a thriving contemporary artistic community, still reflects Judd's influ-
ence and is a pilgrimage site for creatives from around the globe. Viewed
in their entirety, these structures manifest his desire to create permanent
installation spaces not only for his own work, but also for that of his con-
temporaries. The artist actively sought to extend this legacy beyond his

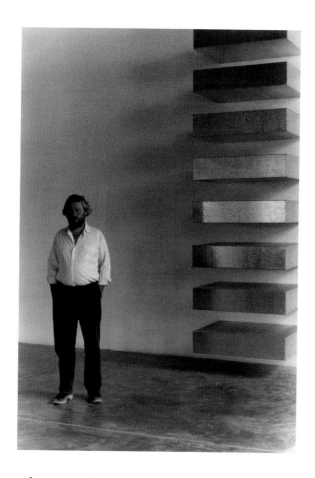

lifetime, so fervent was his belief that understanding an artwork is possible only when it is considered within its intended environment. "The art and architecture of the past that we know is that which remains. The best is that which remains where it was painted, placed or built," Judd explained. Here, he also executed his earliest large-scale architectural projects and continued a furniture design practice begun in New York.

The most personal of these spaces is La Mansana de Chinati, where Judd lived and worked. Known informally as The Block, the compound, which is bounded by an adobe wall with a wide double-door of wood slats, indeed occupies an entire town block. Situated within a downtown neighborhood and across the street from an old feed mill, the site is set against a notably low horizon line and the silhouette of the arresting

Davis Mountains. The Chihuahuan high desert radiates in all directions from Marfa, whose single blinking red traffic light beckons visitors to experience this thriving artistic oasis. In the evening, the night sky—sitting atop it all—offers otherworldly splendors.

Judd began purchasing buildings of the property only a few years after acquiring the cast iron former warehouse on Spring Street in Manhattan. As with New York, here he wished to strike a balance between his ideas for architecture and design and respect for the historical structures. For instance, the artist added the outer wall using an original adobe brick-building technique, but he also added new structures inside. The Block includes two original airplane hangars and the erstwhile Army administrative building that became Judd's home, all of which he modified significantly. The artist also added a bathhouse, pergola, greenhouse, and a pool, as well as an artwork made with adobe bricks. The grounds include a cactus-laden garden featuring distinctive furniture, both of which Judd designed. These efforts have resulted in The Block's fully integrated, holistic environment.

The hangars house the artist's personal collection of art, furniture, decorative arts, and artifacts. These include the elegant stacked wall works (see p. 213) that have become synonymous with him. Judd was also an influential art critic, and his library of more than 13,000 volumes is on display. His two-story residence includes the kitchen—replete with appliances, tableware, and three metalwork armor figures hanging from the rafters—and the bedrooms he designed for his two children. Also on view are his vinyl and cassette collections, as well as traditional regional ceramics and textiles.

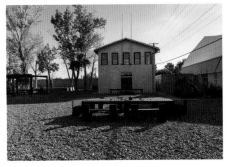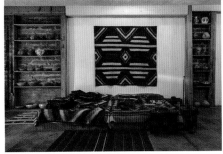

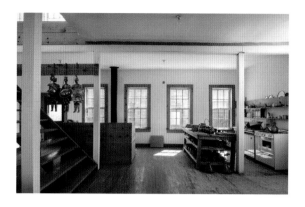

Guided visits are also available of the former commercial buildings in Marfa that Judd adapted as studios for his varied art practices including architecture and print making, and for his ranch office. These spaces contain Judd-designed furniture, his early paintings from the 1950s and 1960s, an extensive collection of modernist and period furniture, and works by other prominent twentieth-century artists and designers. Marfa also boasts large outdoor installations of the artist's work at the Chinati Foundation. The city's flourishing artistic community sponsors a year-round program of activities ranging from exhibitions to concerts to festivals.

Judd devotees also should visit his first studio and residence in New York City [p. 84]. Together, these two properties are the only intact examples of sites spanning multiple locations in the United States that are associated with the same artist and have been preserved and opened to the public.

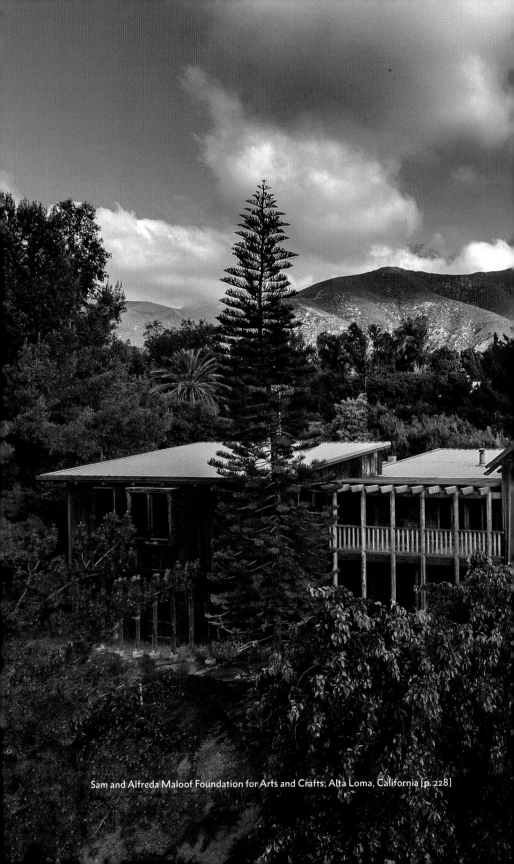

Sam and Alfreda Maloof Foundation for Arts and Crafts, Alta Loma, California [p. 228]

Mountain-Plains/
Western Region

500 Capp Street /
The David Ireland House

David Kenneth Ireland (1930–2009)

500 Capp Street, San Francisco, CA 94110

415-872-9240 **500cappstreet.org**

*And if you spend some time with the house it will glow for you in
the warmth of the afternoon sun.*

—DAVID IRELAND

Conceptual artist David Ireland's home at the corner of Twentieth and
Capp Streets in San Francisco's Mission District is his magnum opus.
Ireland spent thirty years living within the 1886 gray Victorian house that
functioned simultaneously as his home, a repository for his art, a source
of physical materials for his work, and a sculptural work of art in itself.
Fundamental to the experience of the house is understanding the artist's
belief in the beauty of even the most mundane things and the respons-
es they can evoke. Ireland explained, "Art lets us make observations of
things that were always there."

The artist's journey to 500 Capp Street was by no means direct. The
six-foot-four Ireland arrived in San Francisco from Washington state
to study at the California College of the Arts and Crafts. After earn-
ing a bachelor's degree in applied art in 1953, he served in the military;
moved to South Africa, where he worked as an architectural draftsman
and traveled throughout southern Africa; and eventually settled back in
Washington to marry, start a family, and work for his father's insurance

company. His love of Africa brought him back to San Francisco to establish Hunter Africa, a storefront that organized safaris and imported African artifacts. In 1972, two decades after completing his undergraduate degree, Ireland returned to art school, earning a master of fine arts degree from the San Francisco Art Institute. After spending a year living in New York and then traveling around the world, he returned to the Bay Area and became a prominent figure in its conceptual art movement.

Ireland bought 500 Capp Street from accordion maker and salesman Paul John Greub in 1975 for $50,000. When Greub moved out, he left behind collections of brooms, jars, buttons, rubber bands, newspapers, and the gold-leaf "P. Greub Accordions" sign affixed to the front window. What many would see as a profound nuisance, Ireland eventually saw as an opportunity. His initial cleaning efforts led to thirty months of "maintenance actions." These included stripping wallpaper, carpets, and paint along with removing baseboards and door and window trims to peel back the layers of the building's history and to expose its original raw

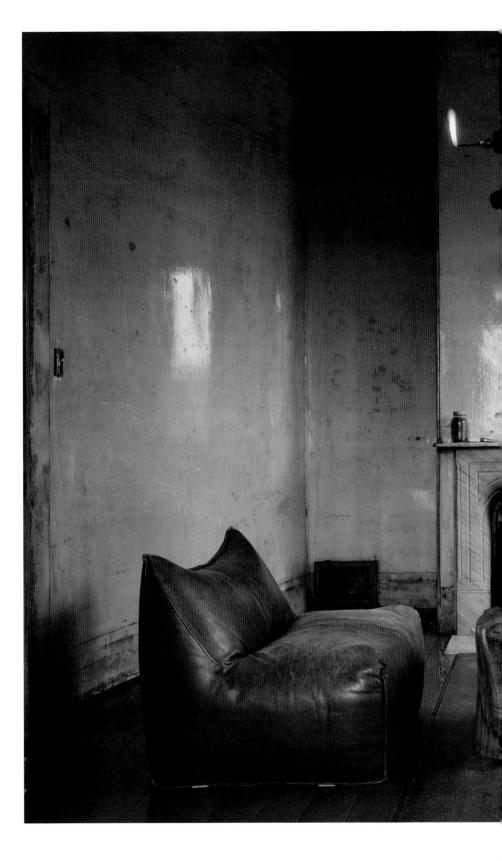

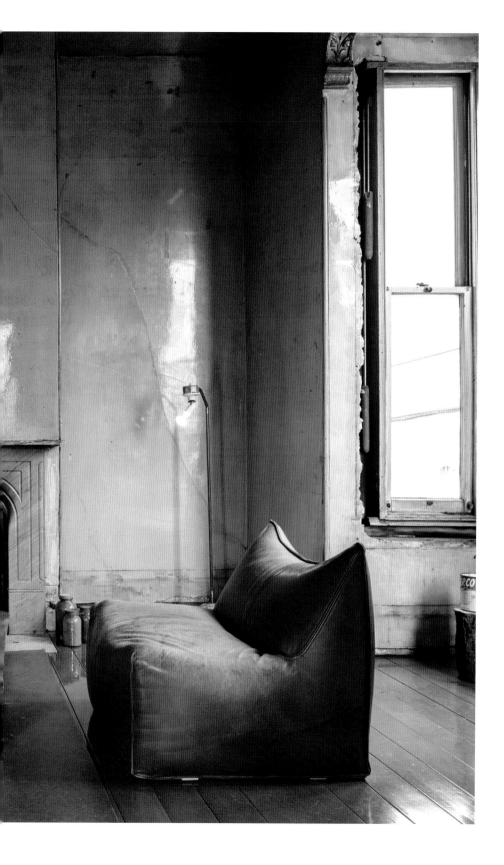

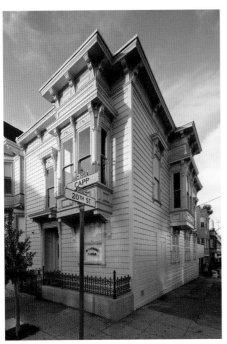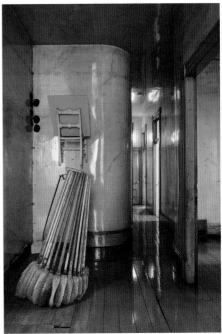

architectural elements and working mechanisms. Ireland carried out all of the work himself, but had the actions filmed, thereby turning mundane chores into performance. He also gathered everything that Greub had left behind, reimagining materials as art objects. A collection of brooms and broken chairs became sculptures (above right). He famously cautioned that "you can't make art by making art," emphasizing the importance of serendipity, but also the idea that any action can be seen as or result in art.

One of the most striking changes Ireland made to the house was coating most of the newly stripped surfaces with multiple layers of polyurethane varnish. This resulted in high-gloss amber rooms whose golden surfaces positively gleam in the light. On closer inspection, the initial impression of radiance gives way to reality. Ireland retained the wall's many cracks, dents, and imperfections, testifying to the building's history. He added to the narrative by affixing brass plaques to record the path that an enormous safe took when it tumbled down the stairs and where a punch press was dragged out the front door, leaving deep gashes in the central hall and floorboards.

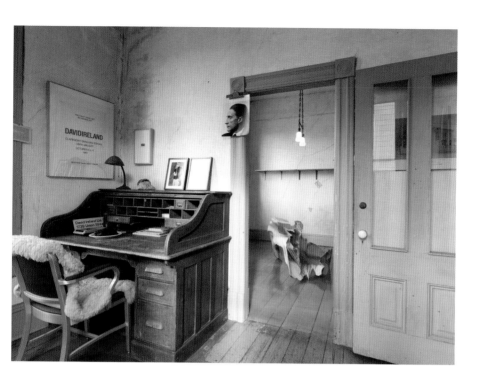

Everywhere are assemblages of objects such as *Dumbballs*, which Ireland made by tossing concrete between his gloved hands until he achieved a perfect sphere (p. 219), sculptures made of paint rollers or old jars, and even a chandelier made from a pair of propane tanks suspended in the back parlor. Also scattered among the artist's works are the many objects he collected during his travels. Ireland chose not to varnish the guest bedroom and office at the back of the building. Against the dull white plaster walls an Alfred Stieglitz portrait of Marcel Duchamp hangs on a clipboard, emphasizing Ireland's respect for the father of Conceptual art.

Ireland's work is also on permanent display in two other Bay Area locations. In Sausalito, he and Mark Thompson rehabilitated two large rooms of a decommissioned military fort at what is now the Headlands Center for the Arts. Also, Ireland designed, along with architect Mark Mack, circular furniture to be used in those rooms at Headlands. In front of the IKEA in Emeryville, his oversized metal chair sculpture welcomes shoppers. The home and studio of painter Grace Hudson is located several hours north in Ukiah, California [p. 224].

Grace Hudson Museum & Sun House

Grace Carpenter Hudson (1865–1937)

431 South Main Street, Ukiah, CA 95482
707-467-2836 **gracehudsonmuseum.org**

A picture is such a personal thing—the companion of years....
It may not show the labor, in fact after the labor is done we labor
to conceal the labor—but it is all there.
—GRACE CARPENTER HUDSON

The Sun House is the craftsman-style bungalow of artist Grace Carpenter Hudson and her ethnographer husband John Hudson. Its modest proportions and simple yet exquisitely handcrafted features reflect the couple's unpretentious rural lifestyle, their respect for good design and quality craftsmanship, their love of the natural world, and their interest in Native American cultures.

In 1912, when the Hudsons moved into the just-constructed Sun House, both were already admired in their respective professions. Grace's artwork was commercially successful and she had earned a national reputation for her numbered series of sensitive oil portraits of Pomo Indians, the indigenous peoples of the Ukiah Valley region (see p. 227).

Grace Carpenter was born in Potter Valley, some twenty miles north of Ukiah, where her parents had traveled from Kansas to homestead. There, the family befriended their Pomo neighbors. Later in life, she recalled witnessing firsthand the struggles of a people facing disease,

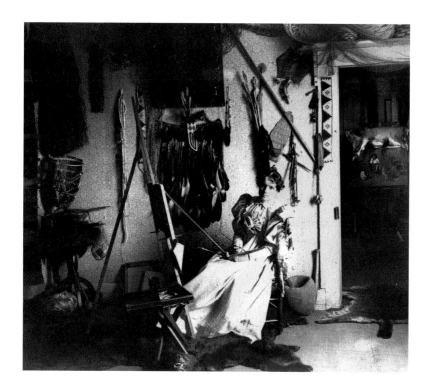

starvation, violence, and dispossession. She said that she chose to paint the Pomo people "so the world could know them as I do, and before they vanish."

As a child, the artist learned to hunt and fish, and her frontier experience inspired a lifelong love of nature. When their family grew, the Carpenters moved to Ukiah, the seat of Mendocino County, to take advantage of the greater commercial opportunities it offered. There, her parents established a photography studio located only a block and half from the future site of the Sun House.

At an early age, Grace demonstrated a talent and aptitude for drawing and painting. When she was thirteen, her parents supported her enrollment in the San Francisco School of Design (now the San Francisco Art Institute), where she excelled at portraiture. At the conclusion of her art studies she returned to Ukiah, where, in 1890, the budding artist married John Hudson, newly arrived from Nashville. This relationship changed the professional course of both of their lives.

John was fascinated with Native American cultures, and with his encouragement, Grace began to focus her work solely on painting Pomo subjects, particularly children. Her canvases quickly became popular. Drawing on his wife and her family's long-standing connections with the local Native peoples, John began to research Pomo culture. His growing expertise on their superlative basketry led, in 1901, to an appointment with the Field Columbian Museum of Chicago (now the Field Museum of Natural History) to study California Indian tribes and amass collections of their handicraft.

Concurrently, Grace—the couple's primary breadwinner up until then—was suffering from overwork and stress. She traveled to the Hawaiian Islands, where she recovered both her health and her zest for painting. Grace's canvases from this year-long period—primarily of Native Hawaiians—include some of her finest work. Eventually, John resigned from the Field and the couple returned permanently to Ukiah.

In Ukiah, the Hudsons worked closely with regional architect George Wilcox to build a home on a four-acre parcel. The resulting gable-roofed, board-and-batten redwood bungalow features large, open rooms, exposed timbers, a sleeping porch, and numerous built-in features such as window seats and cabinetry. The trellised front entry is the setting for a twenty-nine-foot totem pole acquired from Seattle's Ye Olde Curiosity

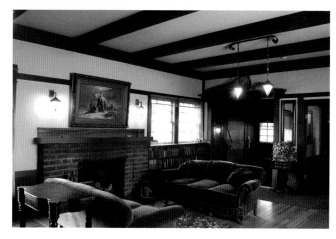

Shop during one of the couple's many excursions. Hand-wrought metal letters above the oak front door proclaim the name they gave their home—The Sun House—and alongside it is a metal Hopi sun katsina emblem. Both are believed to be crafted by John Hudson.

Much of the couple's personal aesthetic informs the interior of the house. Inside the entryway, a foyer showcases a wooden coat rack designed by John. The painted burlap walls of their bedroom feature stenciled pink tulips of Grace's making. Throughout the house, distinctive pyramidal hanging light fixtures—inspired by the shape of acorns, which are a food staple of Pomo culture—unite the indoor space. Wooden shelves over doorways display the couple's extensive collection of Pomo baskets, while a lovely carved sideboard made by the architect and given as a housewarming present remains in the dining room. In Grace's studio, photos are available that show the now-removed original raking windows and pully-operated rooftop reflective panels that controlled light flow. This system emulated one found in her parents' studio.

In addition to the Sun House, the campus features a modern museum, with galleries devoted to Grace's artwork, Pomo basketry, Carpenter-Hudson family history, and changing exhibitions. The grounds include the Wild Gardens, an outdoor educational environment focusing on native Northern California plants and habitats. These gardens provide opportunities to learn about the cultural traditions and sustainable land management practices of the Pomo Indians.

Sam and Alfreda Maloof Foundation for Arts and Crafts

Alfreda Ward Maloof (1911–1998)
Samuel Solomon Maloof (1916–2009)

5131 Carnelian Street, Alta Loma, CA 91701
909-980-0412 **malooffoundation.org**

My environment is a beautiful one, but again, it is something that was created by hand. The making of it is even more satisfying than sitting back and enjoying the finished product.
—SAM MALOOF

Woodworker Sam Maloof's handmade California home seems to embrace the surrounding landscape, which includes the majestic San Gabriel Mountains. One reason is that the edifice has no designated front door; Maloof believed that a house should be visually appealing from every angle. The expansive form took shape over many years, as Maloof slowly added to it without advance planning or even any drawings. Today, the house stands as a monumental sculpture that attests to this self-taught artist's creative vision.

The process began in 1953, when California-born Maloof and his wife, Alfreda, bought the original property, which contained a lemon grove. (The house was moved three miles to its present six-acre location in 2000 to make way for a freeway.) Sam had begun making furniture from salvaged materials for the couple's first home in 1948. Using the income from the lemon grove, Maloof began work on the house while he and Alfreda lived in a ramshackle building on the property. His increasing

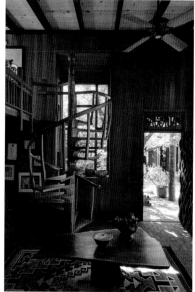

success as a woodworker provided the funds for him to continue the series of expansions that mark the impressive edifice today. The Maloofs viewed their home as a total environment, reflecting their love of nature and a life lived beyond the urban and industrial world.

Over his career, Maloof produced more than five thousand hand-made pieces of furniture. Despite lucrative offers, he declined to license his designs for mass production. One of the most famous is for an elegantly fluid rocking chair, an example of which was received into the White House collection by President Ronald Reagan. Maloof believed in connecting with every commission's client and felt that his work needed to fulfill both functional and aesthetic purposes. Alfreda Maloof, who co-founded the workshop and business, also managed it for half a century, until her death in 1998.

The redwood gate and bell tower that grace the entrance to the site's courtyard mark a transition away from everyday life. Inside is a unique combination of midcentury modern design, southwestern color schemes, and the world's largest collection of Maloof works, including Sam's first and last rocking chairs. The house also displays an eclectic mix of the Maloofs' personal collection, including ceramics, pre-Columbian

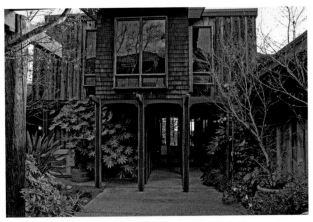

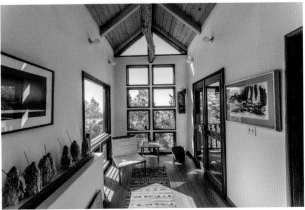

artifacts, examples of twentieth-century Native American fine art, ceramics and textiles, and contemporary artworks—many by California artists—they acquired over many years. Alfreda had been director of arts and craft at the Santa Fe Indian School in New Mexico before marrying Sam, and her knowledge of Native art and artists was instrumental in building the Maloofs' collection. Some of these pieces were given as gifts to Alfreda in gratitude for her significant role in the Native artists' community.

Through second-floor windows, visitors enjoy views of the mountains above and the valley below. The first-floor master bedroom, illuminated by industrial-sized light fixtures, is outfitted with a handcrafted case displaying examples of the Maloofs' decorative arts collection.

Throughout are other carefully handcrafted wood elements including wooden counters, cabinetry, sculpted doors, and door hinges. Many one-of-a-kind carved and crafted door latches provide examples of how Sam Maloof transformed even the most basic elements into works of art.

The artist often recycled or repurposed found materials. For instance, the lively curving staircase in the studio addition is made of laminated wood reclaimed from the packing cases used to transport boats cross-country (p. 229, right). Elsewhere are salvaged logs, reused as both posts and beams (one of which was fashioned from a fallen branch of an avocado tree grown at the original site). Brick floors throughout the home unify the spaces.

On the occasion of Sam's 2001 exhibition at the Smithsonian, President Jimmy Carter, a fellow woodworker and close friend, wrote of him, "Your passion for life, and for your craft, is obvious in every piece of your exquisite furniture." This zeal remains in full evidence in his home and studio today.

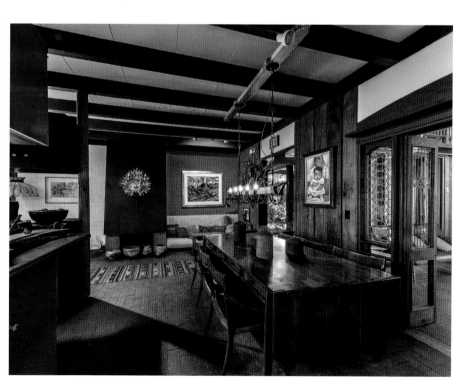

Kirkland Museum of Fine & Decorative Art

Vance Hall Kirkland (1904–1981)

1201 Bannock Street, Denver, CO 80204

303-832-8576 **kirklandmuseum.org**

It has been absolutely necessary for me to change directions in order to avoid repetition. Whenever a cycle of ideas seemed satisfactory, I knew I had done that and needed to move on and develop a greater challenge. Then the paintings remained fresh and were, I hoped, improved, and I avoided boredom.

—VANCE KIRKLAND

In both his life and art, painter and educator Vance Kirkland never stopped changing. He once said that he felt an "obligation to show some-thing new" continuously. Over the course of his career, he produced some 1,200 paintings spanning five distinctive periods and styles, many pro-duced in his small studio building in central Denver.

Originally from Ohio, Kirkland came to Colorado in 1929 to teach at the University of Denver's School of Art, becoming its director at age twenty-five. But he left only three years later to protest the univer-sity's failure to accredit its art classes, an early indicator of his indepen-dence and determination. Undaunted, he founded the Kirkland School of Art the following year, first renting and later purchasing a small brick building on Pearl Street in central Denver. Here, Kirkland taught more than one hundred students, with classes accredited by the University of

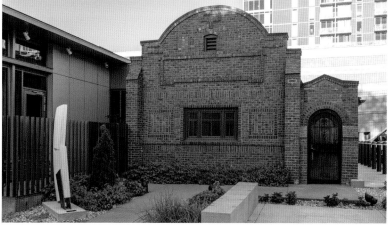

Colorado Denver, for more than a decade until he was enticed back to the University of Denver. Thereafter, the Pearl Street building functioned exclusively as his studio until his death in 1981.

English artist Henry Read had previously commissioned architects Maurice B. Biscoe and Henry H. Hewitt to design the Arts and Crafts–style brick edifice for his own art school in 1910–1911. Containing three rooms, each with north-facing windows, with the workroom at the back (eventually Kirkland's working space), it was the first commercial art building in Denver. Initially without running water and with only minimal electricity, the building was heated by coal- and wood-burning stoves and lit by gaslight augmented with candlesticks and oil lamps. A dozen of the original ribbed chicken-wire and glass windows have been preserved.

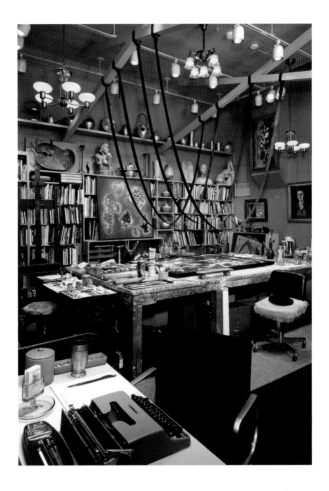

Underneath Kirkland's conventional appearance—horn-rimmed glasses, carefully cropped hair, and a penchant for suits—teemed the imagination, innovation, and frenetic energy he relied on to push the boundaries of his art. He developed an expansive self-perception, seeing himself in relation to the cosmos, which is reflected in the composition of some of his works, such as those that evoke celestial and interstellar bodies or cosmic events (see p. 233, above right). Despite the accolades he earned in New York for his early surrealist and abstract compositions, and representation by the famed Knoedler Gallery, he eschewed the city's commercial and critical world for his life and career in Denver. His studio reflects these impulses.

A sizable table—still splattered with paint and covered in Kirkland's tools—dominates the workroom, a hub around which all else seems to revolve. Above hangs a harness that Kirkland devised to suspend himself facedown over his canvases as he applied paint with dowels from overhead. Built-in bookcases abound, their careful arrangements a counterpoint to the vigor represented by the table. Alongside Kirkland's books sit plaster casts of classical sculptures and shelf upon shelf of decorative arts objects. Numerous radios populate the space, referencing the integral role that music played in his life and art. Kirkland possessed a rare way of experiencing the world known as synesthesia, in which the senses overlap. In Kirkland's case, he could sense color in music, especially modern classical compositions. Color schemes for his paintings suggested themselves as he listened. Later, he used his imagination to augment what he sensed in the music, because painting and listening simultaneously proved overwhelming. As in the workroom, Kirkland's paintings hang in the adjoining rooms among furniture and objects, some of which he acquired during his travels.

The historic studio, which was moved to its present location on Bannock Street in 2016, connects to a new, bright yellow building by Seattle-based architect Jim Olson. This is the Kirkland Museum of Fine & Decorative Art, with its stunning and comprehensive collections of international decorative arts and works by Colorado artists. The new location is a block from the Denver Art Museum and the Clyfford Still Museum in Denver's Golden Triangle Creative District.

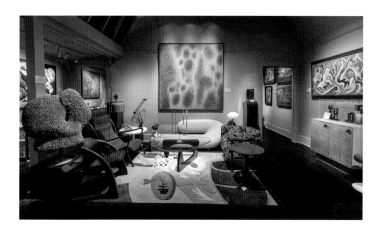

James Castle House
Boise City Department of Arts & History

James Charles Castle (1899–1977)

5015 Eugene Street, Boise, ID 83703
208-336-6610 **jamescastlehouse.org**

There is remarkable freedom in his work, a sense that each thing
he saw, and each moment of seeing, possessed by its very existence
a miraculousness worth registering.
—JOHN YAU, POET AND CRITIC

The myriad drawings James Castle made of his suburban Boise house, its interiors, the surrounding landscape, and the more rugged environs of his early childhood are lauded as iconic representations of Idaho's life and culture. Yet for all their collective meaning, these artworks are deeply personal reflections of Castle's experience of his home over forty-six years, from the time he and his family moved there from a rural Idaho farmstead in 1931 until his death in 1977. After his death and again during restorations, drawing after drawing of the interior was literally pulled out from behind the walls where, for reasons unknown, they'd been carefully bundled and hidden away by Castle himself.

Born deaf, Castle spent his life enveloped in silence. Although he'd attended the state's school for the deaf and blind, he remained largely illiterate. However, his love of drawing offered him a means of communicating with the world. Supported by his family, the artistically self-taught Castle was free to roam the property, collecting scrap materials

to incorporate into assemblages, committing the world around him to paper, and binding his creations into books. The resulting works form personal diaries of sorts, which one could easily imagine hiding under the bed—or inside the very walls, as Castle did—both to protect and preserve them. Remarkably, these intimate and intensely private works are now publicly displayed and actively collected.

The house exemplifies western vernacular architecture and offers a glimpse into early twentieth-century Idaho. Standing in these small and unassuming spaces where Castle lived and worked is a reminder that the imagination can thrive anywhere and does not require a specific set of physical attributes or natural grandeur for inspiration to emerge. Moreover, the restoration and opening of his house as a public museum are unique. Castle's example represents an exception to the many non-mainstream artists whose sites have not been preserved. It is also emblematic of the modest conditions in which so many artists, both historic and contemporary, have created, which are a stark contrast to, say, those dream spaces built by artists such as Frederic Church at Olana [p. 94] or Albin Polasek in Winter Park, Florida [p. 142].

In the unadorned and fairly stark environment of the larger main room of the house (now a primary exhibition space), one is confronted by silence both auditory and visual. Underneath the exposed board-and-batten construction overhead, the rehabilitated wood floors lack furniture and the spare white walls display artworks with minimal text and graphics. In this space, one instantly grasps a sense of what it means to live in silence and to communicate solely with visual cues.

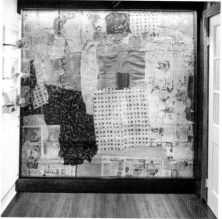

A doorway leads to a room that was originally a porch, where the interior of a wall has been exposed. Inside the wall is layer upon layer of fabric, newspaper, and magazine material, artfully arranged, possibly by Castle. This collage of detritus was used to insulate the space and was revealed during restoration. It includes the same types of cardboard he used in his drawings. An adjacent installation highlights the variety of materials and tools recovered during restoration and archaeological exploration, including matchboxes, pigment jars, bits of string, printed advertisements, and other materials. The artist had an ingenious ability to use anything on hand in his work. He even mixed household soot with his saliva to create a medium for his drawings (p. 237, bottom).

The back portion of the house is dedicated to the site's robust artist-in-residency program and is open to the public during open studio hours and other public events. During restoration, stucco was reapplied to the home's exterior with the same historic materials and process as the original. The site also includes a shed that served as Castle's studio for a time; another studio space, the smaller trailer that he dubbed Cozy Cottage, is off-site as it undergoes restoration. Today, Castle's work, all created within this modest crucible, is exhibited in major museums and exhibitions around the globe.

Visitors to Boise should visit the city's art museum and perhaps venture farther afield to the town of Garden Valley, where Castle first lived as a boy.

C. M. Russell Museum

Charles Marion Russell (1864–1926)

400 13th Street North, Great Falls, MT 59401

406-727-8787 **cmrussell.org**

My lodge is yours, the robe is spread and the pipe lit for you.
—CHARLES MARION RUSSELL

A rustic log cabin decorated with antlers presents a curious sight among the neat frame houses of residential Great Falls, Montana. Artist Charlie Russell built it in 1903, setting it nearby the utterly conventional home he and his wife Nancy had built just a few years earlier. Perhaps a free spirit's statement of nonconformity set within more posh surroundings, the building also references the background of this complex and multitalented painter and author, the great storyteller of the American West, who is said to have done his best work in cabins. The structure reminded the artist of his earliest days in Montana, and was fashioned after a cabin in the Utica basin, where he had lived on and off for a time with trapper Jake Hoover.

The Missouri-born Russell, who spent his childhood sketching the outdoors and dreaming of becoming a cowboy, moved to Montana when he was sixteen. He spent two crucial years apprenticing to Hoover, who taught him how to live and make his way in the wilderness. Russell also became an outspoken advocate for Native American rights, having had close contact with Northern Plains tribes throughout his adult life.

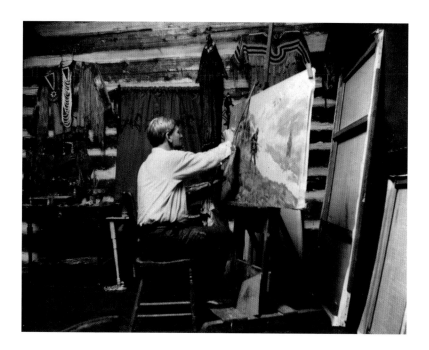

After eleven years as a cowboy and wrangler—all the while honing his artistic skills—he retired to pursue his art, eventually achieving international acclaim.

He and Nancy Cooper married in 1896 and settled in Great Falls a year later, where they built their home and the log cabin studio. Made of repurposed western red cedar telephone poles, the studio features a wooden bison silhouette on the door and an ample fireplace at one end. Most of Russell's more than four thousand works were painted inside, and for a time horses roamed in a corral out back. "That's going to be a good shack for me. The bunch can come visit, talk, and smoke while I paint," he remarked on the building's completion. Russell's work depicts the disappearing and rapidly changing Native American and cowboy cultures, the narratives of which are set within the sweeping grandeur of the landscape. He once explained, "Nature has been my teacher; I'll leave it to you whether she has been a good one." In his day, the place was chockablock with props and tools, including a vast array of Native American artifacts. Today, these are displayed in the adjacent museum, while replicas adorn the studio.

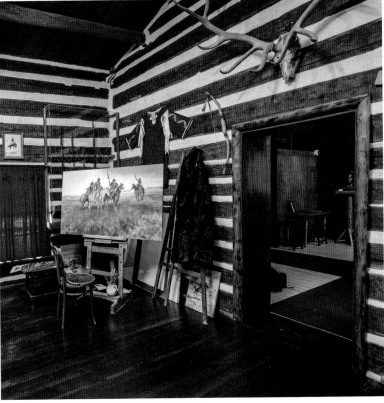

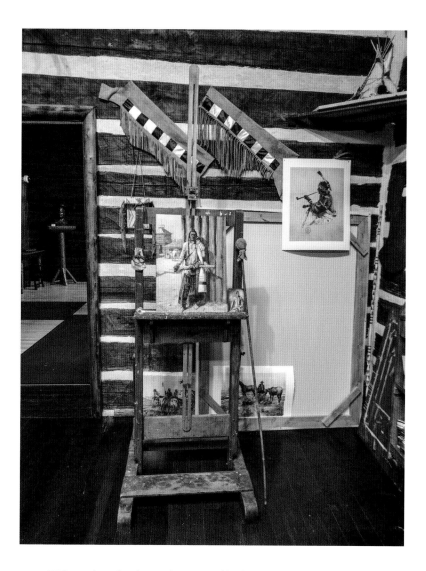

When they built it, the Russells' home was both modern and aspirational. Nancy hired builder George Calvert to help her design and execute a two-story Victorian house that was as much a home as an office for managing Russell's career. Its two entrances, one thought to be exclusively for clients, underscore this. Nancy, who was the artist's business manager and is credited with his financial success, worked out of the foyer. The living room, with its generous window, housed his studio

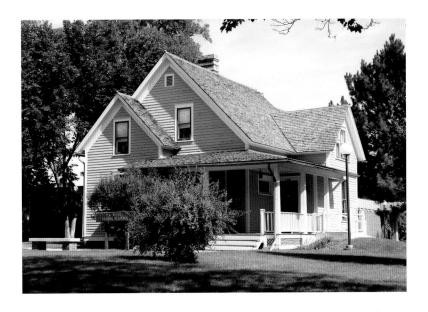

before the cabin was built. The dining room showcased Russell's art, and today a chair rail displays replicas of his small sculptural works. Although the downstairs rooms present the trimmings of gentility—wallpaper, decorative moldings, and rails—the more private upper floor, where the walls are paper thin, reflects the couple's modest means at the time they moved in.

The adjacent C. M. Russell Museum, opened in 1953, boasts a substantial collection of Russell's work and collected artifacts, along with rotating exhibitions featuring Russell, his contemporaries, and modern-day explorations of Native American culture and the American West and its wildlife. It is the country's first museum dedicated to the art of the American West. The museum's grounds also feature a contemporary sculpture park.

Giant Springs Park, also in Great Falls, includes one of the largest freshwater springs in the country, discovered by Lewis and Clark in 1805, as well as the Lewis and Clark National Historic Trail Interpretive Center. Some ninety minutes away in Helena, Russell's epic canvas *Lewis and Clark Meeting Indians at Ross' Hole* (1912) adorns the legislative chamber of the Montana State Capitol. At the time, the painting was the biggest commission ever awarded in the state of Montana.

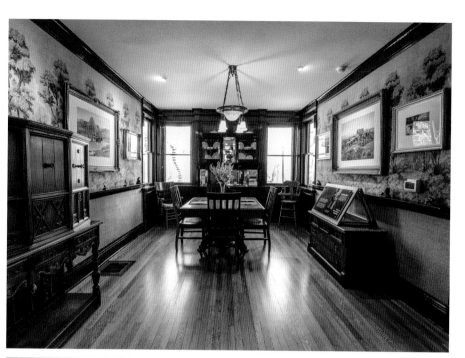

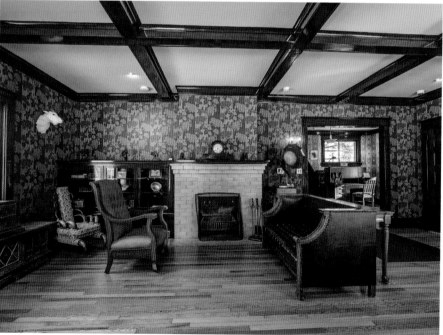

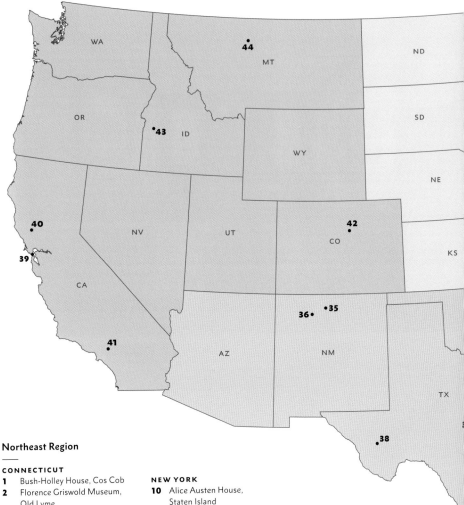

Northeast Region

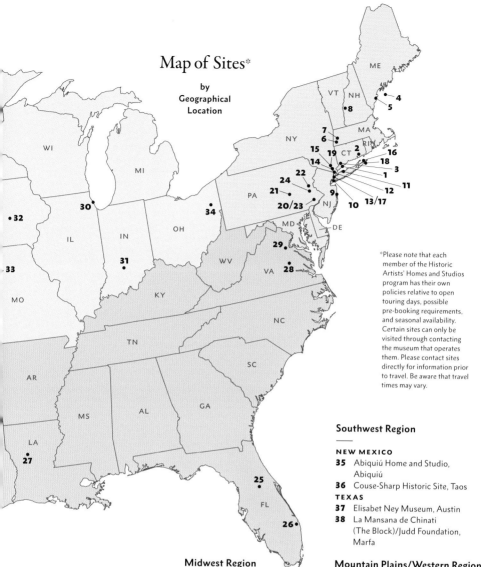

Map of Sites*

by Geographical Location

ME

VT NH
• 4
• 8
5

WI

7
NY
6
MA
15
19 CT 2
RI
16
14
18
3
22
24 21
9
11
12
MI
PA
20/23
NJ
10
13/17

• 32
30
34
MD
DE

IL
IN
OH
29

• 33
31
WV
VA 28

MO
KY

NC

TN

SC

AR

MS
AL
GA

LA
27

25
FL

26 •

*Please note that each
member of the Historic
Artists' Homes and Studios
program has their own
policies relative to open
touring days, possible
pre-booking requirements,
and seasonal availability.
Certain sites can only be
visited through contacting
the museum that operates
them. Please contact sites
directly for information prior
to travel. Be aware that travel
times may vary.

Southwest Region

NEW MEXICO
35 Abiquiú Home and Studio,
Abiquiú
36 Couse-Sharp Historic Site, Taos
TEXAS
37 Elisabet Ney Museum, Austin
38 La Mansana de Chinati
(The Block)/Judd Foundation,
Marfa

Midwest Region

ILLINOIS
30 Roger Brown Study
Collection, Chicago
INDIANA
31 T. C. Steele State Historic
Site, Nashville
IOWA
32 Grant Wood Studio,
Cedar Rapids
MISSOURI
33 Thomas Hart Benton Home
and Studio State Historic
Site, Kansas City
OHIO
34 Burchfield Homestead
Society, Salem

Southern Region

FLORIDA
25 Albin Polasek Museum
& Sculpture Gardens,
Winter Park
26 Ann Norton Sculpture
Gardens, West Palm Beach
LOUISIANA
27 Melrose Plantation,
Natchitoches
VIRGINIA
28 Edward V. Valentine Sculpture
Studio, Richmond
29 Gari Melchers Home & Studio,
Falmouth

Mountain Plains/Western Region

CALIFORNIA
39 500 Capp Street/The David
Ireland House, San Francisco
40 Grace Hudson Museum
& Sun House, Ukiah
41 Sam and Alfreda Maloof
Foundation for Arts and Crafts,
Alta Loma
COLORADO
42 Kirkland Museum of Fine &
Decorative Art, Denver
IDAHO
43 James Castle House, Boise
MONTANA
44 C. M. Russell Museum,
Great Falls

Index

Credits

Note: Image credits appear in order of image from left to right and top to bottom unless otherwise indicated.

FOREWORD: p. 8 Photograph Geoffrey Goss, courtesy Frelinghuysen Morris House & Studio, Lenox, MA
 INTRODUCTION: p. 14 Photograph Don Freeman; p. 16. Photograph Jeff Yardis, courtesy Florence Griswold Museum, Old Lyme, CT; p. 19 Photograph Capehart Photography, courtesy Ann Norton Sculpture Gardens, West Palm Beach, FL
 Northeast Region; pp. 20–21 Photograph © Peter Aaron/OTTO, courtesy of the artist
 CHAPTER 1: All images courtesy Greenwich Historical Society, Cos Cob, CT; p. 22 John Henry Twachtman with an unidentified student in the Palmer & Duff Shipyard, Cos Cob, CT, ca. 1897, Library & Archives; Elmer MacRae in his studio, ca. 1900, William E. Finch, Jr. Archives; p. 25 (bottom) Photograph © Durston Taylor
 CHAPTER 2: All images courtesy Florence Griswold Museum, Old Lyme, CT; p. 27 John R. Baynes, *Hot Air Club*, 1905, Lyme Historical Society Archives, Florence Griswold Museum; pp. 28–29 Photographs Joe Standart; p. 30 "Miss Florence" in her Dining Room, Collection Lyme Historical Society Archives, Florence Griswold Museum; Photograph Joe Standart; p. 31 Childe Hassam painting *Apple Trees in Bloom, Old Lyme*, 1904, Collection Lyme Historical Society Archives, Florence Griswold Museum; Childe Hassam, *Apple Trees in Bloom, Old Lyme*, 1904, oil on panel, 25 x 30 in., Collection Florence Griswold Museum, Gift of The Vincent Dowling Family Foundation in Honor of Director Emeritus Jeffrey Andersen, 2017.16
 CHAPTER 3: All images courtesy Weir Farm National Historic Site, Wilton, CT; p. 33 J. Alden Weir in front of an easel in his New York City studio, ca. 1913, Collection Weir Farm Historic Site; Mahonri Young working in his studio in Salt Lake City, Utah, ca. 1909, Collection Weir Farm Historic Site; pp. 34–37 National Parks Service, Weir Farm National Historic Site
 CHAPTER 4: p. 38 Rockwell Kent, 1939, Everett Collection Inc/Alamy Stock Photo; James Fitzgerald, Collection James Fitzgerald Legacy Archives, courtesy Monhegan Museum of Art & History, Monhegan, ME; Lorimer Brackett (1904–1992), *Alice Kent Stoddard Painting "Mending Nets" At Monhegan, Maine*, mid-20th C., 3 1/2 x 5 1/2 in., Collection Monhegan Museum of Art & History Archives, acc. no. 4773.01:2001.24.02; p. 40 Photograph John Lawrence, courtesy Fitzgerald Legacy Archives; pp. 41–43 courtesy Fitzgerald Legacy Archives; p. 42 Rockwell Kent, *Village at Night*, ca. 1950, oil on panel, 12 x 16 in., Collection Monhegan Museum of Art & History, Gift of Remak Ramsay

CHAPTER 5: p. 44 Unknown Artist, *Winslow Homer with "The Gulf Stream" in his studio at Prouts Neck, Maine*, ca. 1900, albumen print, 4 11/16 in. x 6 3/4 in., BCMA Accession #: 1964.69.179.9, Collection Bowdoin College Museum of Art, Brunswick, ME, Gift of the Homer Family; pp. 46–47 Photographs Trent Bell ©trentbellphotography, courtesy Portland Museum of Art, ME; p.47 (bottom) Winslow Homer, *Weatherbeaten*, 1894, oil on canvas, 28 · x 43 3/8 in., Collection Portland Museum of Art, Bequest of Charles Shipman Payson, 1988.55.1
 CHAPTER 6: All images courtesy Chesterwood, Stockbridge, MA; p. 49 Daniel Chester French at work on the full-size clay model of *Spirit of Life*, in the studio at Chesterwood, 1914, Chapin Library, Williams College, Gift of the National Trust for Historic Preservation; pp. 50–51, 52 Photographs Don Freeman; p. 53 Photograph Paul Rocheleau; p. 54 Photograph Don Freeman; p. 55 Photograph Paul Rocheleau
 CHAPTER 7: All images courtesy Frelinghuysen Morris House & Studio, Lenox, MA; p. 57 George L. K. Morris in His Studio, Collection Frelinghuysen Morris House & Studio; Suzy Frelinghuysen in Her Studio, Collection Frelinghuysen Morris House & Studio; pp. 58–59 Photograph Geoffrey Gross; p. 60 Photograph Gavin Pruess; Photograph Geoffrey Gross; Photograph Gavin Pruess; p. 61 Photograph Geoffrey Goss
 CHAPTER 8: All images courtesy US Department of the Interior, National Park Service, Saint-Gaudens National Historical Park, Cornish, NH; p. 63 Augustus Saint-Gaudens in front of a variation of the *Amor Caritas* sculpture, 1898, Collection Augustus Saint-Gaudens National Historical Park
 CHAPTER 9: All images courtesy John F. Peto Studio Museum, Island Heights, NJ; p. 69 Self-portrait photograph of Peto posed near the staircase in his studio, Collection John F. Peto Museum; p. 70 Photograph Andrea Coan; p. 71 Photograph Andrea Coan; Photograph Andrea Coan; John F. Peto, *Old Souvenirs*, ca. 1881–1901, 26 3/4 x 22 in, oil on canvas, Collection Metropolitan Museum of Art, New York, NY, Photograph Peter Horree/Alamy Stock Photo
 CHAPTER 10: All images courtesy Alice Austen House, Staten Island, NY; p. 73 Alice Austen Photographing an Auto Race., ca. 1908, photo by Alice Austen, Collection Historic Richmond Town, Staten Island, NY; p. 74 Photograph Floto + Warner 2015, © Floto + Warner; p. 75 Photograph Duggal Photography, 2019; Photograph Max Touhey; Alice Austen, *Shoeshine boys search for customers, City hall park (Three bootblacks)*, April 13, 1896, Collection New York Public Library, New York, NY
 CHAPTER 11: p. 77 Arthur Dove and Helen Torr, Ketewomoke Yacht Club, Huntington, Long Island, c. 1930, Photograph Estate of Arthur Dove, courtesy Heckscher Museum of Art, Huntington, NY; Photograph Holly Gordon; p. 78 courtesy Heckscher Museum of Art; Photograph Holly Gordon; p. 79 Arthur G. Dove, *Untitled, Centerport #2*, 1941,

watercolor and pencil on paper, Gift of Mr. William C. Dove, Collection Heckscher Museum of Art, 1977.1.2., courtesy Estate of Helen Torr; Helen Torr, *Oyster Stakes*, 1929, oil on paperboard, Gift of Mrs. Mary Rehm, Collection Heckscher Museum of Art, 1971.5A., courtesy Estate of Helen Torr

CHAPTER 12: p. 81 Edward Hopper's High School Graduation, 1899, courtesy Arthayer R. Sanborn Hopper Collection Trust; p. 82 Courtesy Edward Hopper House Museum & Study Center, Nyack, NY; Photograph Will Ellis Photography, courtesy Edward Hopper House Museum & Study Center; p. 83 Photograph Will Ellis Photography, courtesy Edward Hopper House Museum & Study Center; Edward Hopper, *Seven A.M.* [Nyack, NY], 1948, oil on canvas, 30 3/16 × 40 1/8 in., Collection Whitney Museum of Art, Purchase and exchange, 50.8, © Heirs of Josephine N. Hopper, licensed by the Whitney Museum of American Art

CHAPTER 13: p. 85 Paul Katz, *Donald Judd, 101 Spring Street, NY*, 1970, © Paul Katz, Paul Katz Archive, Department of Image Collections, National Gallery of Art Library, Washington, DC; p. 86 Exterior, 101 Spring Street, New York, Photograph Joshua White, © Judd Foundation, licensed by ARS; 3rd Floor, 101 Spring Street, New York, Photograph Charlie Rubin, © Judd Foundation, Donald Judd Art © Judd Foundation / Artists Rights Society (ARS), New York, licensed by ARS; p. 87 4th Floor, 101 Spring Street, New York, Photograph Charlie Rubin, © Judd Foundation, licensed by ARS; Frank Stella, *Gur II*, 1967, acrylic and graphite on canvas, 120 1/2 × 180 × 2 3/4 in., Collection Judd Foundation, © 2019 Frank Stella / Artists Rights Society (ARS), New York, licensed by ARS; pp. 88–89 5th Floor, 101 Spring Street, New York, Photograph Charlie Rubin, © Judd Foundation, Donald Judd Art © Judd Foundation / Artists Rights Society (ARS), New York, licensed by ARS; Claes Oldenburg, *Soft Ceiling Lights at La Coupole*, 1964–1972, canvas stuffed with kapok, pencil, ink, rubber stamp on wood support, 80 × 64 × 15 in.; 3 elements, each: 7 1/2 × 3 ft., Collection Judd Foundation, New York, courtesy Oldenburg van Bruggen Studio, © 1964–1972 Claes Oldenburg; Dan Flavin, untitled, 1970, blue and red fluorescent light, 14 units, each 96 × 96 × 3 1/2 in., Collection Judd Foundation © 2019 Stephen Flavin / Artists Rights Society (ARS), New York, licensed by ARS

CHAPTER 14: All images courtesy Manitoga/The Russel Wright Design Center, Garrison, NY; p. 91 Russel Wright ca. 1970s at Manitoga, unidentified photographer, Collection Manitoga/The Russel Wright Design Center; Photographs Vivian Linares; p. 92 Photograph Vivian Linares; Photograph Tara Wing; p. 93 Photograph Tara Wing

CHAPTER 15: p. 95 Attributed to Felix Bonfils, *Frederic Edwin Church and His Son, Frederic Joseph in Beirut*, 1868, cart-de-visite, 4 7/8 × 3 3/8 in., OL.1984.446, Collection Olana State Historic Site,

NYS Office of Parks, Recreation and Historic Preservation; p. 96 Photograph Carri Manchester, courtesy Olana State Historic Site; p. 97 Photograph © Nicholas Whitman Photography; Photograph © Kurt Dolnier, courtesy Olana State Historic Site; p. 98 Photograph © Nicholas Whitman Photography; p. 99 Photograph Diane Cook and Len Jenshel Photography, © 2019 Len Jenshel

CHAPTER 16: All images courtesy Pollock-Krasner House and Study Center, East Hampton, NY; p. 101 *Lee Krasner and Jackson Pollock in their Garden*, 1949, Photograph Wilfrid Zogbaum; Photograph Jeff Heatley; p. 102 Photograph Jeff Heatley; *Jackson Pollock at work on "Alchemy"* (detail), 1969, Photograph Herbert Matter; Lee Krasner painting *Portrait in Green*, 1969, Photograph Mark Patiky, used by permission of the artist; p. 103 Photograph Jeff Heatley

CHAPTER 17: All images courtesy The Renee and Chaim Gross Foundation, New York, NY; p. 105 Chaim Gross, Photograph Arnold Newman, Collection The Renee and Chaim Gross Foundation; pp. 106–9 Photographs Elizabeth Felicella

CHAPTER 18: p. 111 Thomas Moran, Mary Nimmo Moran, The Long Island Collection, East Hampton Library, East Hampton, NY; pp. 112–13 Photographs Jeff Heatley, courtesy East Hampton Historical Society, East Hampton, NY

CHAPTER 19: p. 115 Matthew Brady, *Thomas Cole*, Daguerreotype, Collection Library of Congress Prints and Photographs Division, Washington, DC; Photograph © Peter Aaron/OTTO, 2017; p. 116 Photographs ©Peter Aaron/OTTO, 2017; p.117 Photograph ©Peter Aaron/OTTO 2016; Photograph Rachel Stults, courtesy Thomas Cole National Historic Site, Catskill, NY

CHAPTER 20: All images courtesy Brandywine Museum of Art, Chadds Ford, PA; p. 119 *Andrew Wyeth*, Photograph © 1981 Peter Ralston, courtesy Ralston Gallery, ralstongallery.com; Photograph Carlos Alejandro; p. 120 Photograph Rick Echelmeyer; p. 121 Photographs Carlos Alejandro

CHAPTER 21: All images courtesy Demuth Museum, Lancaster, PA; p. 123 Unknown photographer, Possible Passport Photograph of Charles Demuth, n.d., Collection Demuth Museum, Lancaster, PA; Charles Demuth, *Pink Tulips*, 1930, watercolor and graphite on paper, Collection Demuth Museum; p. 125 Charles Demuth, *Augusta Wills Buckius Demuth*, oil on canvas, 32 3/8 × 23 5/8 in., Collection Demuth Museum, Gift of Gerald and Margaret Lestz, © 2012 Demuth Museum

CHAPTER 22: All images courtesy Mercer Museum & Fonthill Castle, Bucks County Historical Society, Doylestown, PA; p. 127 Henry Chapman Mercer and his dog Rollo on Fonthill Castle steps, Collection Mercer Museum Research Library, Bucks County Historical Society; Fonthill Castle Library Columbus Tile; Photograph Rosemary Taglialetela; pp. 128–29 Photographs Kevin Crawford Imagery, LLC

CHAPTER 23: All images courtesy Brandywine River Museum of Art, Chadds Ford, PA; p. 131 N. C. Wyeth in his Chadds Ford, PA, studio at work on *The Elizabethan Galleons*, mural for the First National Bank of Boston, c. 1924, Photograph Chester H. Thomas, Collection Brandywine River Museum of Art, N. C. Wyeth House and Studio Collection; p. 132 Photograph Dan Jackson; N. C. Wyeth, *The Last of the Mohicans*, endpaper illustration, 1919, oil on canvas, 30 x 43 in., Collection Brandywine River Museum of Art, Given in memory of Raymond Platt Dorland by his children, 1973; pp. 133–35 Photographs Dan Jackson

CHAPTER 24: All images courtesy Wharton Esherick Museum, Malvern, PA; p. 137 Wharton Esherick in his studio with his sculpture *Oblivion* (dated 1934; walnut; 76.4 in. high), Collection Wharton Esherick Museum, Photograph Emil Luks, c. 1934; p. 138 Photographs Charles Uniatowski; p. 139 Photograph James Mario

Southern Region: pp. 140–41 Photograph Charles LeRette, courtesy Albin Polasek Museum & Sculpture Gardens, Winter Park, FL

CHAPTER 25: All images courtesy Albin Polasek Museum & Sculpture Gardens, Winter Park, FL; p. 143 Albin Polasek working in his studio, Collection Albin Polasek Museum & Sculpture Garden, Winter Park, FL; pp. 144–47 Photographs Charles LeRette

CHAPTER 26: All images courtesy Ann Norton Sculpture Gardens, West Palm Beach, FL; p. 149 (left) Ann Weaver Norton working on *Seven Beings*, Collection Ann Norton Sculpture Gardens; p. 153 Photographs Capehart Photography

CHAPTER 27: All images courtesy Melrose Plantation, Natchitoches, LA; p. 155 *Clementine Hunter*, original color photograph Tom Whitehead, re-touched black and white copy image Sohn Fine Art, Lenox, MA, p. 156 (bottom) Clementine Hunter, *Funeral Procession*, ca. 1950, 457.2 x 330.2 in., oil paint on board, Collection Savannah College of Art and Design, Photograph Archivart/Alamy

CHAPTER 28: All images courtesy The Valentine, Richmond, VA; p. 159 Edward Virginius Valentine poses in his studio, Cook Collection, The Valentine

CHAPTER 29: All images courtesy Gari Melchers Home and Studio, Mary Washington University, Falmouth, VA; p. 163 *Gari Melchers*, ca. 1900, Photograph Frank Scott Clark, Macbeth Gallery records, Collection Archives of American Art, Smithsonian Institution

Midwest Region: p. 170–71 Courtesy T. C. Steele State Historic Site, Photograph Collection, Indiana State Museums & Historic Sites System, Nashville, IN

CHAPTER 30: All images courtesy School of the Art Institute of Chicago, Chicago, IL; p. 171 Roger Brown in Living Room, Photograph William H. Bengtson, c. 1976; Photograph Lisa Stone 2010; Photograph William H. Bengtson, 2018; pp. 172–73 Photographs William H. Bengtson, 2018

CHAPTER 31: All images courtesy T. C. Steele State Historic Site, Nashville, IN, Collection Indiana State Museums & Historic Sites System; p. 175 (top left) Unidentified Photographer, *Theodore Clement Steele in his Garden*; (top right) Theodore C. Steele, *Pergola in Early Spring*, 1918, oil on canvas, 30 x 40 in., Collection Indiana State Museum & Historic Sites System, T. C. Steele Historic Site; p. 179 Theodore C. Steele, *Selma in the Garden*, undated (ca. 1915), oil on canvas, Collection Indiana State Museums & Historic Sites System, T. C. Steele State Historic Site

CHAPTER 32: p. 181 John W. Barry, *Grant Wood at No. 5 Turner Alley standing next to painting of "Midnight Ride of Paul Revere"*, 1931, gelatin silver print, 10 x 13 in., Gift of Rural Artists Round Table, 70.6, Collection Cedar Rapids Museum of Art, Cedar Rapids, IA; p. 182 Photograph John W. Barry, courtesy Cedar Rapids Museum of Art; p. 183 Photograph John W. Barry, courtesy Cedar Rapids Museum of Art; Grant Wood, *Door to 5 Turner Alley* (detail), 1924, painted wood, fabric, glass and wrought-iron, Collection Cedar Rapids Museum of Art, Gift of Harriet Y. and John B. Turner II, 72.12.15; Grant Wood, *American Gothic*, 1930, oil on Beaver Board, 30 x 25 in., Friends of American Art Collection, 1930.934, Collection The Art Institute of Chicago, © VAGA at ARS, NY Photograph Collection The Art Institute of Chicago/Art Resource, NY

CHAPTER 33: p. 185 Thomas Hart Benton in his studio 1947, applying the finishing touches to his mural *Achelous & Hercules* for Harzfeld's Department Store, courtesy Missouri State Parks; pp. 186–88 courtesy Missouri State Parks; p. 189 Collection and courtesy Kenneth Winstead; Courtesy Missouri State Parks

CHAPTER 34: p. 191 Herbert Appleton (1896–1963), Portrait of Charles E. Burchfield in his Studio, c. 1942, gelatin silver print, 10 1/2 x 13 1/2 in., Collection Burchfield Penney Art Center, Buffalo, NY, Gift of Mr. Francis Valentine, 1975, Used with permission from the Charles E. Burchfield Foundation and the Burchfield Penney Art Center; Photograph The Image Works, courtesy Burchfield Homestead Society; p. 192 Charles E. Burchfield, *Sleet Storm (After the Ice Storm)*, 1920, watercolor, gouache, and graphite on paper, 18 x 24 13/16 in., Collection Burchfield Penney Art Center, Gift of John Clancy in memory of Winifred Clancy, 1979, Used with permission from the Charles E. Burchfield Foundation and the Burchfield Penney Art Center; p. 193 Photograph The Image Works, Courtesy Burchfield Homestead Society; Charles E. Burchfield, *Summer Garden*, 1916, watercolor on paper, 14 x 20 in., Collection Burchfield Penney Art Center, Gift of Mr. and Mrs. Armand J. Castellani, 1979. Used with permission from the Charles E. Burchfield Foundation and the Burchfield Penney Art Center

Southwest Region: pp. 194–195 La Masana de Chinati/The Block, Marfa, TX. Photograph © Elizabeth Felicella, courtesy Judd Foundation, New York, NY, and Marfa, TX, licensed by ARS

CHAPTER 35: p.197 Laura Gilpin (1891–1979), *Georgia O'Keeffe*, `953, gelatin silver print, 9 3/8 x 7 7/16 in., ©1979 Amon Carter Museum of American Art, Fort Worth, Texas, Bequest of the Artist, P1979.130.6; p. 198 Georgia O'Keeffe's Abiquiú House, Exterior from a Distance, 2007, Photograph Herbert Lotz, © Georgia O'Keeffe Museum, Santa Fe, NM; p. 199 Georgia O'Keeffe's Abiquiú House, Studio Interior, 2007, Photograph Herbert Lotz, © Georgia O'Keeffe Museum; Georgia O'Keeffe's Abiquiú Home and Studio, Sitting Room, 2019, Photograph Krysta Jabczenski, © Georgia O'Keeffe Museum; p. 200 Georgia O'Keeffe's Abiquiú House, Pantry Interior, 2007, Photograph Herbert Lotz, © Georgia O'Keeffe Museum; p. 201 Georgia O'Keeffe, *Mesa and Road East*, 1952, oil on canvas, 26 1/16 x 36 in., Collection Georgia O'Keeffe Museum, Gift of The Georgia O'Keeffe Foundation, © Georgia O'Keeffe Museum, [2006.5.234]; Georgia O'Keeffe's Abiquiu House, Bedroom Window View, 2007 Photograph Herbert Lotz, © Georgia O'Keeffe Museum

CHAPTER 36: All images courtesy Couse-Sharp Historic Site, Taos, NM; p. 203 Henry Sharp painting outdoors at Taos, Collection Couse-Sharp Historic Site; E.I. Couse in His Studio, Collection Couse-Sharp Historic Site

CHAPTER 37: p. 209 Elisabet Ney working on the clay bust of William Jennings Bryan, Formosa, 1900, courtesy Elisabet Ney Museum, City of Austin Parks and Recreation Department; pp. 210–11 Courtesy City of Austin Parks and Recreation Department with permission from the Harry Ransom Humanities Research Center, University of Texas at Austin

CHAPTER 38: All images courtesy Judd Foundation, New York, NY, and Marfa, TX; p. 213 Donald Judd at La Mansana de Chinati/The Block, Marfa, TX, 1982, Photograph Jamie Dearing, © Judd Foundation; p. 214 La Mansana de Chinati/The Block, Marfa, TX, Photograph © Elizabeth Felicella, courtesy Judd Foundation, licensed by ARS; Winter Bedroom, La Mansana de Chinati/The Block, Marfa, TX, Photograph © Elizabeth Felicella, courtesy Judd Foundation, licensed by ARS; p. 215 Kitchen, La Mansana de Chinati/The Block, Marfa, TX, Photograph © Elizabeth Felicella, courtesy Judd Foundation, licensed by ARS; South room, West building, La Mansana de Chinati/The Block, Marfa, TX, Photograph © Elizabeth Felicella, courtesy Judd Foundation, Donald Judd Art © Judd Foundation / Artists Rights Society (ARS), New York, licensed by ARS
Mountain Plains/Western Region: pp. 216–17 Photograph Aaron Echols, courtesy Sam and Alfreda Maloof Foundation for Arts and Crafts, Alta Loma, CA

CHAPTER 39: All images courtesy 500 Capp Street Foundation, San Francisco, CA; p. 219 David Ireland, *Dumbball Action*, 1986, Photograph Elisa Cicinelli; pp. 220–22 Photographs Henrik Kam; p. 222 (right) David Ireland, *Broom Collection with Boom*, 1978–1988, Collection San Francisco Museum of Modern Art; p. 223 David Ireland's desk, and Katharina Grosse, *Untitled*, 2017, acrylic on aluminum, 29 x 35 x 56 in., courtesy of the artist and Gagosian Gallery, Photograph Preston/Kalogiros

CHAPTER 40: All images courtesy Grace Hudson Museum & Sun House, Ukiah, CA; p. 225 Grace Hudson painting in her first Ukiah studio amid her collection of Pomo objects (detail), 1895, Photograph A. O. Carpenter, Collection Grace Hudson Museum; p. 226 Photograph Evan Johnson; p. 227 Photograph Evan Johnson; Grace Hudson, *The Tarweed Gatherer*, Painting #67, 1896, oil on canvas, 1896, Collection Grace Hudson Museum

CHAPTER 41: All images courtesy Sam and Alfreda Maloof Foundation for Arts and Crafts, Alta Loma, CA; p. 229 Sam Maloof in his workshop with horn-back chairs, c. 1960, Photograph © Sam and Alfreda Maloof Foundation for Arts and Crafts

CHAPTER 42: All images courtesy Kirkland Museum of Fine & Decorative Art, Denver, CO, p. 233 (top left) Vance Kirkland working on the last painting completed before his death titled *Forces of Energy from a Sun in the Open Star Cluster K 1*, 1981, Collection Kirkland Museum of Fine & Decorative Art; (top right) Vance Kirkland, *The Energy of Explosions Twenty-Four Billion Years B.C.*, 1978, oil paint and water on linen, 65 x 55 in., Collection Kirkland Museum of Fine & Decorative Art; Photograph Wes Magyar; p. 234 Photograph Ron Ruscio; p. 235 Photograph Wes Magyar

CHAPTER 43: p. 237 James Castle at desk in Cozy Cottage Trailer, Photograph Jack McClarty, 1963, Tom Trusky Papers, Special Collections and Archives, Boise State University; James Castle, *Untitled (house)*, n.d., found paper, soot, 7 x 9 in., CAS17-0669, ©2019 James Castle Collection and Archive, All Rights Reserved; pp. 238–39 Photographs courtesy Boise City Department of Arts & History, 2018

CHAPTER 44: All images courtesy C. M. Russell Museum, Great Falls, MT; p. 241 C.M. Russell Painting in His Studio, *Whose Meat?*, 1918, black-and-white photograph, Collection C. M. Russell Museum, Gift of Richard Flood II, (975-12-147.13); p. 242–43 Photographs Paris Bread; p. 244 Photograph Angie Windheim, p. 245 Photographs Paris Bread

Acknowledgments

This publication represents the celebration and culmination of twenty years of the Historic Artists' Homes and Studios program. We hope this will serve as a springboard for many more years of exploration of these sites of creativity and their great American artists, and as a vision for the vibrant future of the program.

This guide encompasses a tremendous joint effort among the National Trust for Historic Preservation, Chesterwood (the administrative home of Historic Artists' Homes and Studios), Princeton Architectural Press (PAP), and the staff and member sites of the Historic Artists' Homes and Studios program (HAHS). We express our gratitude to the staff at PAP for their tremendous support of and tireless work on this publication, in particular Abby Bussel, Hannah Fries, Kristen Hewitt, Lia Hunt, and Paul Wagner.

We wish to thank the Henry Luce Foundation whose generous support made this book possible. We are also grateful to the Wyeth Foundation for American Art for their additional contributions towards new photography for the publication and intern staff support. These institutions and their longstanding leadership in supporting American art and artists are crucial to endeavors such as the Historic Artists' Homes and Studios program, and we appreciate their sustained commitment to the places where artists lived, were inspired, and created their art.

Donna Hassler, Executive Director, Chesterwood and HAHS Administrator, who was instrumental in the initial concept of this publication and securing its funding, deserves special mention. We are grateful for her collegial spirit and continued leadership, oversight, and support throughout this project.

We wish to also thank staff at all forty-four member sites for contributing information and images to this effort. This book and its contents would not have been possible without their support and hard work.

For providing valuable and integral editing assistance during all stages of the manuscript and the publication layout, we wish to thank Alexandra T. Anderson, writer and consultant, who served as editor, working closely with author Valerie A. Balint.

For their longstanding advice, support, and encouragement of the publication and all HAHS initiatives, we want to recognize past and current members of the HAHS Advisory and Executive Committees, in particular Advisory Committee chair Wanda M. Corn, Robert and Ruth Halperin Professor Emerita of Art History, Stanford University; Executive Committee chair Jeffrey Andersen, Director Emeritus, Florence Griswold Museum; and members Linda Cook (Weir Farm National Historic Site), Allison Cross (Manitoga / The Russel Wright Design Center), Helen M. Harrison (Pollock-Krasner House and Study Center), Lisa Stone (Roger Brown Study Collection), and Karen Zukowksi (independent scholar). HAHS would like to make special mention of Dr. Stephen May, who was an early member of the advisory committee, an ardent researcher, and a passionate advocate of preserved artist spaces, whose papers have been donated by his family to the HAHS archives in his memory.

For their dedicated work and assistance to this publication, we wish to thank HAHS interns Isabella Browne Lörcher, Tianna Darling, Dorian Sanders, and Elizabeth Schanz.

For contemporary images of HAHS member sites, we would like to express our thanks to all the photographers who generously allowed for the inclusion of their images in this publication with reduced or waived fees: Peter Aaron, Carlos Alejandro, John W. Barry, William H. Bengtson, Paris Bread, Capehart Photography, Elisa Cicinelli, Andrea Coan, Diane Cook & Len Jenshel, Nick Cool, Kevin Crawford, Duggal Photography, Rick Echelmeyer, Aaron Echols, Will Ellis, Elizabeth Felicella, Floto + Warner, Don Freeman, Holly Gordon, Geoffrey Goss, Jeff Heatley, Krysta Jabczenski, Dan Jackson, Evan Johnson, Henrik Kam, John Lawrence, Charles LeRette, Vivian Linares, Herb Lotz, Wes Magyar, Carri Manchester, James Mario, Mark Patiky, Preston/ Kalogiros, Gavin Pruess, Peter Ralston, Paul Rocheleau, Ron Ruscio, Durston Saylor, Sohn Fine Art, Joe Standart, Lisa Stone, Rachel Stults, Rosemary Taglialetela, Max Touhey, Trent Bell Photography, Charles Uniatowski, Tom Whitehead, Nicholas Whitman, Angie Windheim, Tara Wing, and Jeff Yardis.

For additional support in providing images we thank: Amon Carter Museum, Archives of American Art, Smithsonian Institution, Art Resource, Art Institute of Chicago, Alamy, Arthayer R. Sanborn

Hopper Collection Trust, Artists' Rights Society, Boise State University, Bowdoin College Museum of Art, Chapin Library at Williams College, Charles E. Burchfield Foundation and the Burchfield Penney Art Center, East Hampton Library, Estate of Arthur Dove, Estate of Helen Torr, Harry Ransom Humanities Research Center, the University of Texas at Austin, Historic Richmond Town, James Castle Collection and Archive, Library of Congress Prints and Photographs Division, National Gallery of Art Library, New York Public Library, New York State Office of Parks, Recreation and Historic Preservation, Portland Museum of Art, San Francisco Museum of Modern Art, Ralston Gallery, VARGA, and the Whitney Museum of American Art. Special acknowledgment to artist Katharina Grosse and the Gagosian Gallery for the inclusion of her contemporary artwork in an image of 500 Capp Street/The David Ireland House, San Francisco, California. For the use of a photo from his personal archive, we thank Kenneth Winstead. For assistance with images relating to both Judd properties we thank Emma Whalen, Digital Content & Rights Coordinator, Judd Foundation, including for images by Jamie Dearing, Elizabeth Felicella, Paul Katz, Charlie Rubin, and Joshua White. We are also grateful to the studio of Claes Oldenburg for permission to use an image of the artist's work on view at the Judd Foundation.

For their thoughtful review of the final manuscript we thank Donna Hassler, executive director, Chesterwood, and HAHS Administrator; Julia Rosenbaum, associate professor of art history and chair, art history program, Bard College (Annandale-on-Hudson, New York); and Thayer Tolles, Marica F. Vilcek Curator, The American Wing, The Metropolitan Museum of Art (New York, New York). In addition, we acknowledge Shannon Vittoria, Research Associate, The American Wing, The Metropolitan Museum of Art for her insights on the Thomas and Mary Nimmo Moran Studio.

Finally, we wish to express our appreciation for the enthusiastic support of this publication by both our colleagues in Washington, DC, and those who we work with daily at Chesterwood. Collectively, they helped fuel the energy required to complete this endeavor. Thank you!

This publication was made possible through underwriting support from the Henry Luce Foundation.

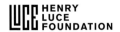